AUG 2 9 2005

W9-CBB-322

3 1170 00687 5466

THE WATERCOLORIST'S ANSWER BOOK
425 TIPS, TECHNIQUES AND SOLUTIONS

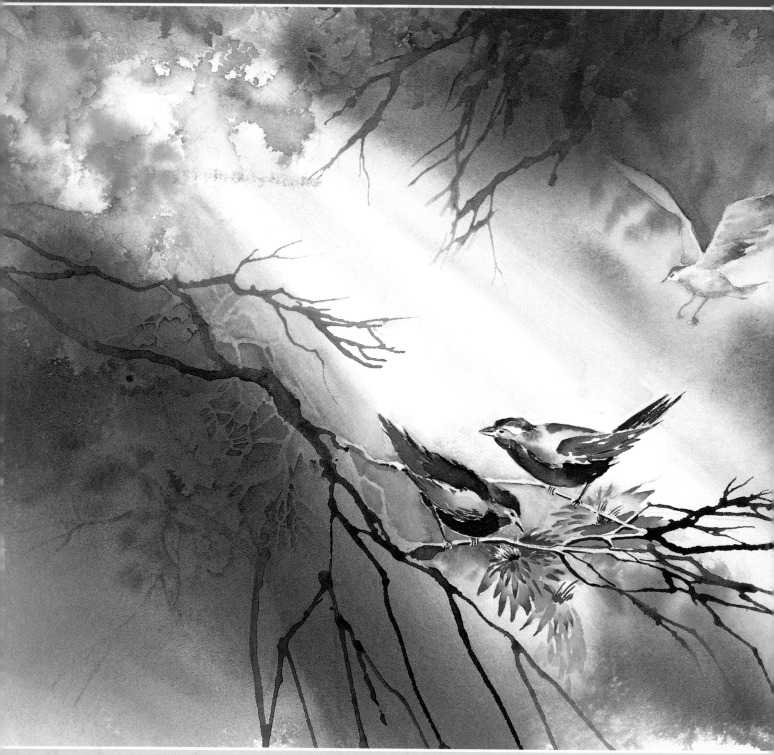

MORNING SONG Jan Fabian Wallake 16" × 22" (41cm × 56cm) Collection of the artist

THE
WATERCOLORIST'S
ANSWER BOOK

425 TIPS, TECHNIQUES AND SOLUTIONS

EDITED BY GINA RATH

NORTH LIGHT BOOKS
CINCINNATI, OHIO
www.artistsnetwork.com

GLENVIEW PUBLIC LIBRARY
1930 GLENVIEW ROAD
GLENVIEW, ILLINOIS 60025
847-729-7500

ACKNOWLEDGMENTS

The people who deserve special thanks, and without whom this book would not have been possible, are the artists whose work appears in this book. They are:

Betty Carr
Donald Clegg
Joe Garcia
Linda Stevens Moyer
Penny Soto
Jan Fabian Wallake
Pat Weaver
Mark and Mary Willenbrink

METRIC CONVERSION CHART

To convert	to	multiply by
Inches	Centimeters	2.54
Centimeters	Inches	0.4
Feet	Centimeters	30.5
Centimeters	Feet	0.03
Yards	Meters	0.9
Meters	Yards	1.1
Sq. Inches	Sq. Centimeters	6.45
Sq. Centimeters	Sq. Inches	0.16
Sq. Feet	Sq. Meters	0.09
Sq. Meters	Sq. Feet	10.8
Sq. Yards	Sq. Meters	0.8
Sq. Meters	Sq. Yards	1.2
Pounds	Kilograms	0.45
Kilograms	Pounds	2.2
Ounces	Grams	28.4
Grams	Ounces	0.04

The Watercolorist's Answer Book. Copyright © 2005 by North Light Books. Manufactured in China. All rights reserved. No part of this book may be reproduced in any form or by any electronic or mechanical means including information storage and retrieval systems without permission in writing from the publisher, except by a reviewer who may quote brief passages in a review. Published by North Light Books, an imprint of F+W Publications, Inc., 4700 East Galbraith Road, Cincinnati, Ohio, 45236. (800) 289-0963. First Edition.

Other fine North Light Books are available from your local bookstore, art supply store or direct from the publisher.

09 08 07 06 05 5 4 3 2 1

Library of Congress Cataloging in Publication Data

The watercolorist's answer book / edited by Gina Rath.
p. cm
Includes index.
ISBN 1–58180–633–7 (pbk : alk. paper)
1. Watercolor painting—Technique. I. Rath, Gina.

ND2420.W364 2005
751.42'2—dc22 2004056811

Editor: Gina Rath
Designer: Wendy Dunning
Production artist: Barb Matulionis
Production coordinator: Mark Griffin
Production editor: Jennifer Ziegler

F+W PUBLICATIONS, INC.

The following artwork originally appeared in previously published North Light Books (the initial page numbers given refer to pages in the original book; page numbers in parentheses refer to pages in this book):

Carr, Betty. *Seeing the Light: An Artist's Guide* © 2003. Pages 14, 15, 17, 19, 22–26, 30–32, 34, 36–39, 51–53, 64–67, 84–88 (36–38, 44—45, 112–132, 134–136, 187)

Clegg, Donald. *Celebrating the Seasons in Watercolor* © 2003. Pages 24–25, 28–29, 39, 49, 61, 69, 75, 86–87, 97, 111, 117 (133, 142–154, 188)

Garcia, Joe. *Mastering the Watercolor Wash* © 2002, pb 2003. Pages 36–41, 44–47, 50–53, 56–59, 120–121, 124, 125–129, 132, 135, 138 (6, 48–65, 172–177, 183–184, 187)

Moyer, Linda Stevens. *Light Up Your Watercolors Layer by Layer* © 2003. Pages 12, 16, 17, 20–21, 23–25, 29, 39, 62, 64–65, 76–77, 79, 92, 52, 126 (9, 16–18, 24, 26–27, 30–35, 80–81, 102, 110–111, 155, 186)

Soto, Penny. *Painting Glowing Colors in Watercolor* ©2003. Pages 5, 33–35, 38, 75, 92, 93, 111–112 (8, 47, 94–95, 97–101, 107, 186)

Wallake, Jan Fabian. *Watercolor: Pour It On!* © 2001. Pages 13–17, 21–22, 28, 43, 52, 55–62, 65–68, 71–73, 76–77, 86, 94, 122–123, 124 (2–3, 7, 10–15, 19–21, 28, 79, 137, 156–171, 178–182, 186)

Weaver, Pat. *Watercolor Simplified* © 2003. Pages 13, 16–17, 24–29, 70, 72–74, 76–79, 82–83, 86–87, 109 (5–6, 22–23, 82–93, 138–141, 188)

Willenbrink, Mark and Mary. *Watercolor For The Absolute Beginner* © 2003. Pages 15, 18–19, 21–28, 38, 45, 48, 52–54, 80–89, 100–103 (7, 14, 25, 29, 39–43, 46, 66–78, 96, 103–106, 108–109, 188)

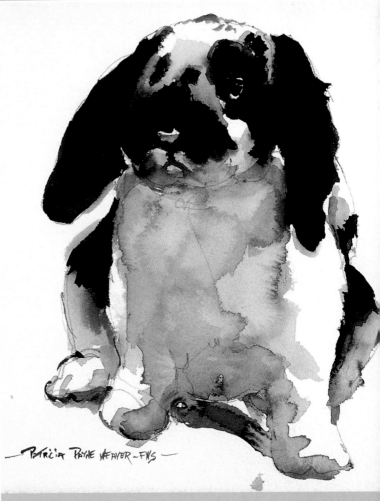

FLOPPY EARS Pat Weaver 11" × 15" (28cm × 38cm)
Collection of Carolyn Kelso

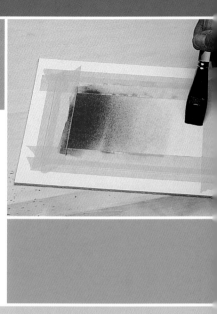

TABLE OF CONTENTS

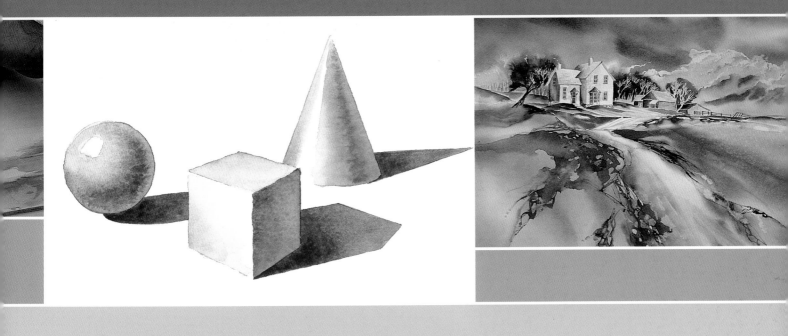

SUMMER SHADOWS Penny Soto 15" × 22" (38cm × 56cm)

INTRODUCTION

Learn from eight veteran watercolor painters in one book! *The Watercolorist's Answer Book* is packed with over four hundred tips, techniques and solutions to help you become a better painter. This inspiring book is a compilation of eight North Light books that encompass the many facets of watercolor painting. Their authors are knowledgeable, talented artists who generously share the methods and ideas that have worked for each of them in their successful careers.

You will learn how to choose the best materials for a variety of projects. You will also learn how to master the wash, how to work with color, value and light, and how to use good design principles to strengthen the compositions of your paintings. You'll find fun and creative techniques that you can try, as well as tips and solutions for almost any challenge you might face as a painter.

I hope you will think of this book as a kind of gathering place where fellow artists share their wisdom and experience. While each artist's approach to watercolor painting may differ, they have a common love for watercolor and a desire to create exciting and beautiful art. At times, information may appear to be conflicting, but this is simply one artist's interpretation of the medium. You should try the different approaches and methods presented throughout the book to learn what's best for you, then incorporate them into a style you can call your own.

I hope this book will inspire, teach and direct you as you step into the exciting world of watercolor painting!

Gina Rath

1 MATERIALS and BASIC TECHNIQUES

"When you're prepared, sitting down to paint a watercolor is exciting."

— Mark Willenbrink

FEATHER LIGHT NO. 6 Linda Stevens Moyer 40" × 60" (102cm × 152cm)
Collection of Dr. and Mrs. David Tonnemacher Photograph by Gene Ogami

BRUSH **TIPS**

by Jan Fabian Wallake

When you visit your local art store and find a section for paint-brushes, you may see a sign that reads "watermedia brushes." Is there a difference between a watermedia brush and a watercolor brush? Watermedia refers to any medium that is dissolvable in water. That could include watercolors, acrylics, gouache and even water-soluble oil paints. However, brushes made specifically for watercolor have dispersion qualities that oil and acrylic brushes do not. Moreover, other watermedia brushes do not have a sharp point with the springback action we watercolorists look for. Check your own brushes. Do the flat brushes have a sharp, natural point (as a good watercolor brush should), or are they chopped off (as an oil brush would be)?

1 Natural Brushes

The very best watercolor brushes are made from pure Kolinsky sable, a member of the Asian mink family. I have tried every brush available and can attest to the fine performance of these beautiful brushes. When you flick the hairs back and forth with your finger, they bounce right back to their natural position. The body of the brush is full, and the tip has a naturally sharp point (not chiseled or cut to shape). The full body of the brush holds a lot of water and pigment. It will afford you a long, continuous painting stroke. The naturally pointed tip will spring back into position after each use and is a good tool for fine lines and detailed work.

The reason that Kolinsky sable makes the best watercolor brushes is that the hairs start growing thin, become thick in the middle, and then thin down again at the base. This natural shaping of each hair occurs only on the tail of the winter coat of the male Kolinsky sable, a kind of marten that lives in Siberia and Manchuria. When many of these tail hairs are gathered together, the resulting brush forms a thick, full body and a natural, thin point. The thick body holds a lot of water and pigment, and dispenses paint at an even rate all the way across the paper, giving you maximum carrying power. The point will stay sharp and will spring back naturally.

You will see a variety of other natural hairs used in brushes. Red sable is of a lesser quality than Kolinsky, but is fine for most watercolor work. You may see squirrel hair, ox hair and goat hair. Camelhair brushes are not actually made of camel hair; this is a generic term meaning that a variety of hairs were blended into the brush.

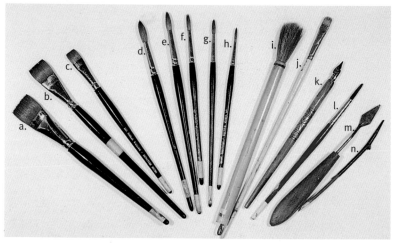

Jan Wallake's Favorites

Here are some of my favorite brushes: pure Kolinsky sable 1-inch (25mm) bright (a), ¾-inch (19mm) bright (b), ½-inch (13mm) bright (c), no. 9 round (d), no. 8 round (e), no. 6 round (f), no. 5 round (g), no. 3 round (h). Additional tools for specific purposes: Floppy Oriental brushes (i) are good for spattering or throwing paint onto the paper (Winsor & Newton brush shown). An old oil painting brush (j) can lift paint once it has dried on the paper. You can use a dip pen (k) to draw fine lines with watercolor paint. A no. 12 Grumbacher round synthetic brush (l) is useful for mixing paint in my paint cups. A palette knife (m) is excellent for pulling fine lines of paint or masking fluid. A sharpened twig (n) is an excellent homemade tool for making fine lines.

2 Synthetic Brushes

Synthetic brushes drop water quickly at first contact with the paper. Some are very well made, but they simply cannot disperse water as well as a good Kolinsky sable. White sable is a synthetic product and is stronger than natural sable. A white sable brush has a lot of spring in the tip and will push color around well, but it cannot carry a wash of color across the paper like a Kolinsky sable.

3 Caring for Your Brushes

Once you have made your choice of brushes, take special care in using, washing and storing them. New round brushes often come packaged with a clear plastic sleeve over the hairs to protect the tip during shipping. Remove the sleeve, and do not attempt to resleeve the brush. You might catch a few hairs and bend them back, causing permanent damage to your new brush.

The best way to wash your brush is to tap it against the inside of your water container, but not the bottom. Then, holding the brush with the handle up, pinch the tip of the hairs and move the brush in small circles. This will create an osmotic effect, drawing water up under the ferrule. Tap the brush against the inside of your water container again and then squeeze the hairs dry. Repeat this process until the water running out of the brush is clear. Your brush will be free of all pigment right up to the ferrule. If you follow this procedure, you will never need a brush soap or cleaner, both of which can damage natural hairs.

4 Storing Your Brushes

The best way to store a brush is to hang it with the hairs pointing downward. This will allow gravity to pull the moisture away from the ferrule. If this isn't possible, lay it flat to dry. If you store your brushes upside down (hairs pointing up) in a container, the water and any residual pigment will collect near the ferrule and eventually ruin your brush.

5 Buying the Best Brushes

Brush hair quality and construction will affect the performance of your painting strokes. Buy the best brush you can afford. Look for a sharp, springy point; a natural, full body; and a seamless nickel ferrule. Avoid purchasing any brush with a seamed ferrule. Water will seep into the seam and stay trapped inside the ferrule, loosening the adhesive that holds the brush in place. The end of the wood handle that enters the ferrule will expand and eventually break down the brush. Proper care in washing and storing your brushes will give you a lifetime of use.

6 Keep a Variety of Brushes on Hand

My paint box holds an array of Kolinsky sable brushes, from a 1-inch (25mm) flat to a no. 3 round, but I also have a few synthetic brushes for mixing colors and even some old oil brushes for lifting paint or adding texture.

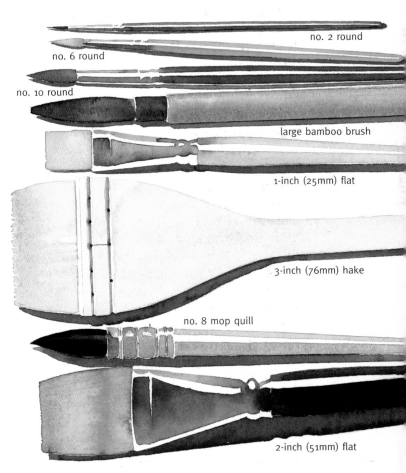

no. 2 round

no. 6 round

no. 10 round

large bamboo brush

1-inch (25mm) flat

3-inch (76mm) hake

no. 8 mop quill

2-inch (51mm) flat

Standard Brushes
Mark Willenbrink's brushes (above) include the most common types used for watercolor painting. Try different types and brands until you find your own favorites.

WATERCOLOR PAPER **TIPS**

by Jan Fabian Wallake

Watercolor papers come in a wide variety of finishes, surface textures and qualities. Each offers unique opportunities to enhance your painting. The following are tips to help take the mystery out of purchasing the right watercolor paper for your artwork. (See the chart on page 15 for more information on choosing the right paper for your work.)

7 Surface Finish

There are three main surface finishes for watercolor papers: *hot-press*, *cold-press* and *rough*. A standard-sized sheet is 22" × 30" (56cm × 76cm).

Hot-Press A smooth finish is called hot-press. The newly made sheets are pressed between calender rollers to smooth the surface. Hot-press paper has a glossy, hard, even finish that's ideal for detail work. It gives a characteristically mottled look to watercolors.

Cold-Press Cold-press paper (also called *not* or *not hot*) has a moderate surface texture, referred to as *tooth*. The tooth results when cotton pulp passes through the cylinders of a papermaking mould next to a sheet of felt. The impression left by the felt creates the surface texture of that sheet. Cold-press papers have a visible yet unobtrusive finish that is good for broad, even washes as well as detail work.

Rough The dramatic "pebble" appearance of rough-surfaced paper makes a loud statement. As you brush a wash across this surface, the pigment will drain off the hills and settle into the valleys of this finish, creating a slightly impressionistic effect. Use this paper when you want a dramatic surface pattern to create an impact in your painting.

8 Texture

There are many surface textures among the various brands of watercolor paper. A cold-press from one manufacturer, for example, can be quite different from that of other papermakers. This surface landscape of pattern and texture gives each brand its unique characteristics. Try painting on several sheets from various manufacturers. You will find that the personality of each sheet flavors your work in distinctive ways and may even offer you the initiative to paint differently than you have before.

9 Weight

Paper thickness is important to watercolor painters. Like any paper, watercolor paper will buckle and curl when wet. Thicker paper will buckle less than thinner sheets.

You can determine the thickness of a paper by its weight, which indicates what five hundred sheets (a ream) of that specific paper weigh. Five hundred sheets of 140-lb. (300gsm) paper weigh 140 pounds. Five hundred sheets of 300-lb. (640gsm) paper weigh 300 pounds.

You can buy watercolor paper by the single full sheet (22" × 30" [56cm × 76cm]) and in packs of five, ten or twenty-five sheets or more. You can also buy rolls of paper and cut off whatever you like. You can get a 40"× 60" (102cm × 152cm) sheet for large-scale work. These sheets are called *double elephant*.

Watercolor paper is also sold in a block. This is a tablet of paper that has been bound on all four sides with a rubberized seal. Although manufacturers claim that these sheets are stretched, the sheets are not really stretched but merely bound together. They will buckle when wet, they will stay damp longer than a single sheet because the underlying sheets retain moisture, and they are expensive. However, smaller blocks can be useful for on-location painting. When your painting is completed, simply insert a palette knife under the top sheet (there is a break in the seal at the top center of the block) and run it around the edge to release your work.

10 Solution for Working on Smooth Paper

When I started painting on a smooth-textured paper, I was energized by the unpredictable slipping and sliding of the paints on this smooth surface. I made adjustments in my painting techniques and loosened my control so that the paper could perform. For example, I use more water when I apply a wash on hot-press (smooth) paper than I do with cold-

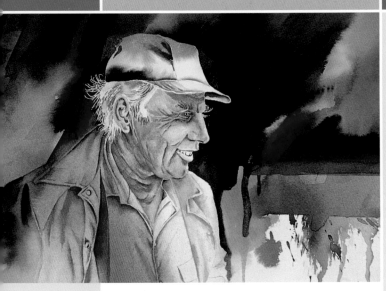

FARMER FRANK Jan Fabian Wallake
9" × 13" (24cm × 33cm) Collection of the artist

press. Water evaporates unevenly on a smooth surface, so using more water and more intense pigments allows a little more time to work before hard edges begin to dry around puddles of paint. These edges form interesting designs that do not occur on a more textured paper. Do not try to control the puddling. Choose smooth-textured paper when it will enhance the image you want.

11 Deckle Edge

A deckle edge is a slightly ruffled edge resulting from the actual papermaking process. When paper is made by hand, a frame, called a deckle, is placed over a screen to prevent pulp from going back into the vat. As the paper is formed, the edges become uneven. Some paper mills mechanically produce this edge on their machine-made or mouldmade sheets. It is a beautiful characteristic of fine papers.

I like to retain the deckle-edged quality, so I always tear my watercolor papers instead of cutting them. To do this, I carefully fold the sheet where I want it to separate, first folding it in, then out. I repeat the folding several times, then I dip my fingers into clear water and run them along the seam on both sides. This softens the crease, so I can easily pull the two sections apart. The tear has a pseudo-deckle edge and is in keeping with the original edges.

12 The Right Side

Quality papers often have a watermark. Paper mills use a screen surface to transform the paper pulp into the finished sheets. At the same time, they impress their company logo onto one or more corners of the newly formed paper. You know you are using the right side (the side the manufacturers intend for you to use) if you can read the watermark correctly.

If I intend to tear a large sheet of paper into four smaller sheets, I put a small *X* on each corner of the paper. This way, I can easily tell which side is the right side even on the pieces that have no watermark.

13 Papermaking Processes

The three basic types of papermaking processes are *handmade*, *machine-made* and *mouldmade*.

Handmade This is a slow process of forming one sheet at a time. It allows for great subtlety and character.

Machine-made The Fourdrinier papermaking machine was invented at the turn of the nineteenth century. It allowed paper to be produced in large quantities. The paper surface is very even, and the integrity of the paper is dependable.

Mouldmade In this process, a vacuum is created in a large cylinder that rotates in a vat of pulp or rag. The vacuum pulls the material onto a screen, and this forms the paper sheets. Most of today's watercolor papers are made with this process.

14 Toughness

Some watercolor papers are capable of taking a lot of abuse, such as scrubbing or sponging, while the surface remains viable. Other softer papers cannot withstand overuse.

15 Absorbency

This factor is important to watercolorists. Fine watercolor paper will absorb just enough water to allow the pigment to sit on the surface without feathering out. The amount and application of *sizing* determines the absorbency of a sheet of paper.

16 Sizing

Sizing is an organic gelatin, a gluelike substance that helps the paper hold paint in place and keeps paint from running. Sizing is applied to paper fibers during the papermaking process.

Paper can be either *hard sized* (a lot of sizing applied) or *light sized* (less sizing applied). The more sizing that is on the paper, the more strength and durability it has. Whether a paper is hard sized or light sized also determines how the paint will settle on the paper. For example, on hard-sized paper the paint will not settle into the paper fibers as much as it will with light- or soft-sized paper. Without sizing, watercolor paper would be like a blotter.

17 Tub Sizing

In tub sizing, organic gelatin is added in a separate stage. The newly formed paper is put back through a sizing bath.

Tub sizing yields a deeper-sized paper. This reduces the overall absorbency of the paper and makes a very resilient sheet. The best fine art papers are tub sized.

18 Whiteness

You will notice a wide range of white tones when you compare various manufacturers' watercolor papers. Lanaquarelle and Winsor & Newton, for example, each produce nice white papers that are especially good for brilliant colors and luminosity. Arches, which I use often, has a slightly less white coloration, but it has other superior qualities I like: good surface texture and a stretchable, harder, more durable surface that resists tearing.

19 Acidity

Acidity yellows paper over time. It can cause paper to crumble and disintegrate. Choose a paper that is acid free, and be sure to store it flat and in a dark place, away from the harmful effects of ultraviolet rays.

20 Surface Fibers

An important characteristic of fine watercolor paper is the formation of the fibers that lie on the surface. Avoid laying anything down on your watercolor paper. Anything that touches the surface will depress the fibers and compromise the reflective quality of the paper. Light bouncing off the even surface texture gives the transparent glow we all love about watercolors.

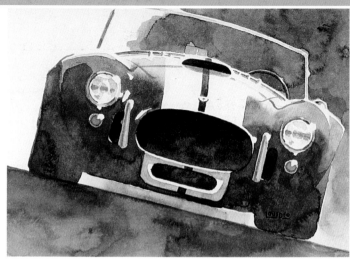

Hot-Press Paper

What makes hot-press watercolor paper so much fun for Mark Willenbrink is the unique water patterns that result when the paint interacts with the smooth 140-lb. (300gsm) hot-press surface. This surface may make the paper a bit harder to work with, but as you gain experience, you'll be able to predict these effects and feel more in control. They can add so much to your artwork. To keep the feel of this type of painting loose, use a large round brush as much as possible. The effect of the water patterns on the front of the car blends the fenders and tires together.

COBRA Mark Willenbrink 6" × 9" (16cm × 23cm)

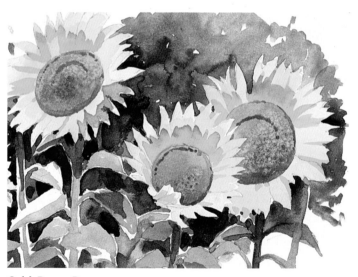

Cold-Press Paper

When Mark Willenbrink wants a smoother, cold-press paper, he uses Strathmore Aquarius watercolor paper. It's less prone to wrinkling than other cold-press papers because it's made from a blend of cotton and synthetic fibers. At 80-lb. (170gsm), it's thinner than most watercolor papers and easier to see through for tracing. However, because the surface is not as soft as others, paint often doesn't seem as lively and removing pencil lines can be difficult.

SUNBATHERS Mark Willenbrink 6" × 8" (15cm × 20cm)

21 Paper SOLUTIONS

by Jan Fabian Wallake

	Typical Characteristics	Best Suited For	Not Well Suited For
Arches 140-lb. (300gsm) cold-press	Versatile Nice even surface texture Durable	Pouring glazes Scrubbing and lifting paint Most watercolor techniques	
Arches 140-lb. (300gsm) hot-press	Smooth surface texture Absorbent	Detail work Watery drips and puddles	Reworking and lifting paint Soft edges
Arches 140-lb. (300gsm) rough	Nubby texture	Impressionistic textures Drybrush	Detail work
Arches 300-lb. (640gsm) cold-press	Heavy, uneven texture Highly durable Leaves speckled highlights when swept with pigment Stretching not required Takes a long time to dry	Direct painting Plein air painting	Poured glazes
Fabriano Artistico 140-lb. (300gsm) cold-press	Light sized Absorbent Off-white Needs stretching Only two deckle edges	Painting that needs a lot of pigment without losing luster and translucency Colors that will remain dark when dry	Reworking paint
Fabriano Uno 140-lb. (300gsm) soft-press	Even surface Bright white Hard sized Velvety texture (between hot- and cold-press)	Reworking and lifting paint Glazing	
Lanaquarelle 140-lb. (300gsm) cold-press	Bright white Soft texture Hard sized Odor free Less buckling when wet Easy to use and control	Glazing Washes of paint that will glide easily over surface	Reworking paint
Saunders Waterford 140-lb. (300gsm) cold-press	High quality Hard sized White Good surface strength and texture No odor when wet	Reworking and lifting paint Glazing Detail work Achieving translucent colors	Achieving deep values
Strathmore Imperial 500 140-lb. (300gsm) cold-press	Light sized Absorbent	Glazing over opaques Drybrush	Reworking paint Soft edges Smooth transitions
Strathmore 140-lb. (300gsm) hot-press	Even, smooth surface White	Detail work Achieving translucent colors	Reworking paint
Whatman 140-lb. (300gsm) cold-press	Bright white Light sized Absorbent: colors even out and soften Colors tend to bleed	Drybrush	Reworking and scrubbing paint Hard edges

22 TECHNIQUE
Stretching Your Paper
by Linda Stevens Moyer

Watercolor paper tends to buckle when you paint on it. This may become quite problematic if you are using one of the lighter weights of watercolor paper. It is difficult to paint on paper that is buckling as the paint tends to run down into the valleys.

There are two ways of avoiding this problem. First, you can buy paper that is of greater weight. I work on 300-lb. (640gsm) paper to avoid much of this effect. Second, you can stretch your paper. Do this by wetting the paper so that it expands and then taping it down so that it will remain in the stretched position. Paper that is under 260-lb. (550gsm) should probably be stretched before you work on it.

This demonstration will show you how to properly stretch your paper. You may become proficient enough

to get a good stretch with only the brown paper tape, but the tacks or staples help ensure good results. Don't give up if your paper doesn't stretch well the first few times. Most people don't get a perfect stretch the first time around.

MATERIALS

Watercolor paper | Varnished or shellacked drawing board at least 4" (10cm) bigger than the paper (in each direction) | Sink or water container larger than the paper's dimensions | Sponge | Four pieces of brown paper tape (with water-soluble adhesive, not self-stick), cut at least 2" (5cm) longer than each side of the paper | Paper towels | Thumbtacks or a staple gun (I prefer a staple gun) | Scissors

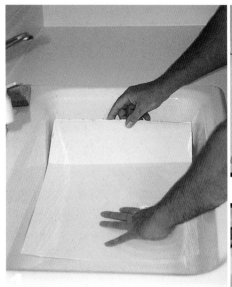 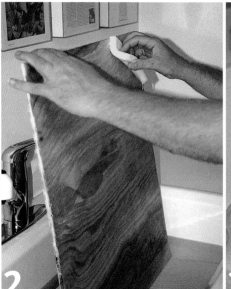 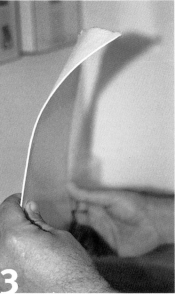

1 | Soak the Paper
Completely submerge the paper in clean water. Let it soak for a few minutes.

2 | Prepare the Board
Sponge over the board so that it is clean and a bit damp.

3 | Test the Paper
Lift the paper part-way out of the water and gently bend one corner over. If the corner snaps back into the original position, it hasn't soaked enough. If the corner stays where you have bent it, as in the illustration, you have soaked it just the right amount. After you have soaked a number of sheets of a given paper, you will know how many minutes to leave it in the water.

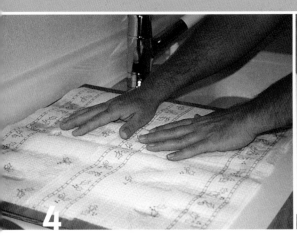
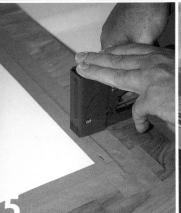
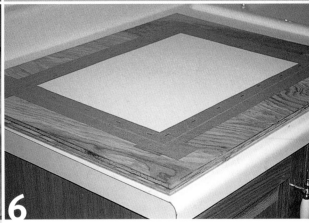

4 | Place the Paper on the Board

Lay the watercolor paper on top of the board. Pat both the board and the paper with paper towels to remove any excess water and to eliminate any bubbles that may have formed. Don't rub the watercolor paper. Rubbing will disturb the surface fibers of the paper, and you won't be happy with what happens when you begin to paint on it.

5 | Secure the Paper to the Board

Moisten the glue on the pieces of tape with your sponge. Moisten only one strip at a time, and then apply this strip so that half is on your paper and half is on the board. With a paper towel, run your thumb over the tape (not the paper) to make sure it is firmly attached to both the water-color paper and the board.

Staple (or tack) every 2" (5cm) all around the board. Make sure that the staple goes through the center of the portion of the tape that overlays the watercolor paper. It must penetrate both the tape and the watercolor paper to hold.

6 | Allow the Paper to Dry

Lay the board flat to dry. Do not place it near a heat source. As the paper dries, it will try to contract but won't be able to since it is held firmly with the tape and staples. After the paper is completely dry, you may begin to paint. Do not remove the paper from the board before you complete your painting. Also, be sure that the finished painting is completely dry before you remove the paper from the board.

23 When the Tape Doesn't Stick:

To the Paper

- You haven't blotted enough water from the watercolor paper before applying the tape.
- You have washed off too much of the adhesive from the tape before applying it.
- The paper dried unevenly. Perhaps you dried it with the board standing up, or placed it too near a heat source.

To the Board

- You have not blotted enough water from the board before applying the tape.
- You washed off too much of the adhesive from the tape before it was applied.
- Using tacks or staples should also eliminate the above problems.

24 Eliminating the Buckle

You may still have a little buckling in the finished painting, even if you follow these steps or use 300-lb. (640gsm) paper. Flatten your completed paintings by evenly wetting the back of the painting with a sponge. (Make sure the water doesn't go over the edges and onto your painted surface.) Then sandwich your painting between two drawing boards and place heavy objects on top. Leave this in place overnight or until the painting has thoroughly dried.

PAINT **TIPS** AND **SOLUTIONS**
by Linda Stevens Moyer

25 **Check Labels**

Be sure to buy paint that is labeled *transparent watercolor*. There are many different kinds of water-soluble paints: designer colors, gouache, casein, tempera, acrylics and more. These are not used for transparent watercolor paintings.

26 **The Best Watercolor Paints**

The best transparent watercolors come in tubes, are finely ground with granite rollers and have very saturated (or intense) color. The ground pigment is combined with gum arabic to make the paint adhere to the paper surface. Glycerine, honey or various sugars are added to keep the paints moist and water-soluble.

27 **Grades of Paint**

A number of manufacturers have two grades of paint: professional and student. The professional paint is, of course, much more expensive. The beginning artist will do fine with the student-grade paint for a while. You will discover, however, that once you begin to use professional colors, you can never go back to the less expensive grade. Professional watercolors are more finely ground; the color is more intense. You will find that these qualities make the color in your paintings more vibrant. The paint will actually go farther because of the greater saturation of color, and perhaps, over time, save you money.

28 **Colors of Paint**

There are many different colors of paint that you can buy. It is best to look at the chemical formula name on the paint tube rather than going by the manufacturer's name in order to buy the appropriate color. The palette on this page shows a good selection of colors to begin with. Later, you may wish to expand your palette to include some of the other beautiful colors in a product line.

29 **Don't Be Stingy**

I suggest that you buy the large, 15-ml tubes of paint. These are more economical; therefore you won't be tempted to put too little paint in your palette. Your palette should have a good

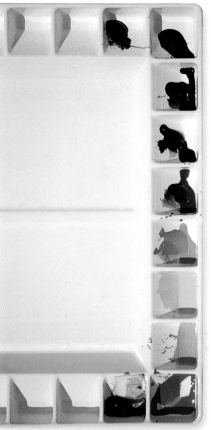

Payne's Gray

Ultramarine Blue (aka French Ultramarine)

Phthalo Blue

Phthalo Green

Burnt Sienna

Yellow Ochre

Cadmium Yellow Pale

Cadmium Orange

Quinacridone Red

Alizarin Crimson

squeeze of each color needed for a painting. Because the paint is water-soluble, even if it dries out in your palette, you should be able to reconstitute it by adding a few drops of water.

I don't recommend that you squeeze an entire tube of paint into the individual wells. Some instructors have their students do this, but as time passes, the color will leach out from the upper layers of the paint and leave a crusty residue that will not provide the pure paint colors you need in your paintings.

30 **Linda's Palette Solution**

I always organize my palette with the paint colors grouped in this order: warm colors first, earth colors in the middle and then the cool colors. Having the colors in the same place on your palette each time you work will allow you to work more efficiently. You won't have to search for them; you will always know exactly where they are.

MORE TIPS AND SOLUTIONS
by Jan Fabian Wallake

31 Mix Large Pools of Paint

When I first began painting with watercolors, I was very concerned by the cost of quality paints. I chose a number of Winsor & Newton colors, filled my John Pike palette and trotted off to my first workshop. Worried about wasting my paints, I made tiny dime-sized puddles of the colors I needed for the day's painting. The instructor noticed my frugal ways and awarded me the "skimpy palette" award.

I knew I had to change my outlook on mixing large pools of paint, yet I was still worried about waste. That is when I discovered the butcher tray. It is an 11" × 15" × 1" (28cm × 38cm × 3cm) enamel tray. The bottom is slightly convex. I squeeze out approximately ten colors onto preplanned locations on the palette floor (some colors, like Winsor Red, I place up onto the inside wall of the palette because they are so strong they would contaminate the other colors on the palette floor). I allow these globs of colors to dry out completely. When I am ready to paint, I activate the palette with a spray of clean water.

32 Create Color Harmony

I mix large pools of paint by simply dragging my brush over various colors until I get the desired color and amount and the right consistency of paint. The paint sits on the palette floor for a while, eventually running off to the sides and down to the bottom edge. (I place a thin sponge under the top edge of the palette to elevate it and encourage the paints to run downward.) As these paints run to the bottom edge, they mix with any other colors I use in that particular painting. I cleverly call this my "dark" color. It is different with every painting. It is a unique, dark pigment that is color harmonized with each painting.

Often I dip my brush into this dark color instead of my water pail. Every time you rinse your brush in the water pail you lose paint. By wetting my palette with a spray bottle and utilizing my dark color, I conserve almost all of my paint. The only time I rinse my brush in clean water is when I need a clean, pure color. This palette forces me to mix colors and blend large pools of paint, and as a bonus, it creates color harmony.

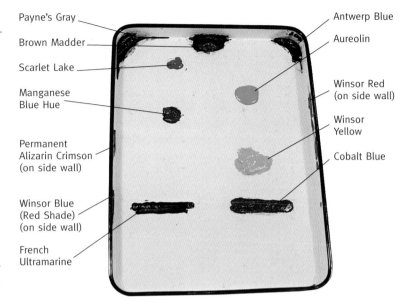

Payne's Gray — Brown Madder — Scarlet Lake — Manganese Blue Hue — Permanent Alizarin Crimson (on side wall) — Winsor Blue (Red Shade) (on side wall) — French Ultramarine — Antwerp Blue — Aureolin — Winsor Red (on side wall) — Winsor Yellow — Cobalt Blue

33 Allow Paint to Dry

Do not cover your watercolor palette. This will cause the pigments to mildew. When you finish painting, allow the pigments to dry out, then re-wet them when you are ready to use them.

34 Jan's Palette Solution

I have several butcher tray palettes, each with a different combination of Winsor & Newton colors. This is the one I use most often (pictured above). I have arranged the colors in specific areas. The earth colors, Brown Madder, Scarlet Lake, Aureolin and Antwerp Blue, are grouped at the top. Winsor Red, Cobalt Blue and Winsor Yellow are my purest primary colors. I use them for atmospheric colors. They are grouped on the lower right side. The reds are placed up on the sides of the tray because they are strong reds and will contaminate the other color pools. I simply brush over the red and pull the color down when I need it.

TECHNIQUE
Pouring a Glaze

by Jan Fabian Wallake

Glazing is a method of overlaying transparent layers of pigments. Watercolors lend themselves particularly well to glazing. If we layer transparent, analogous colors of paint, the effect is an incomparably smooth, glowing light that is unique to this medium. You can use glazing at the beginning of your painting in the first wash of color or during the process of developing your image. You can glaze color over parts of the finished painting to add atmosphere, to light up the scene or to simply tone down a secondary portion of the picture.

Pouring is the most unobtrusive way to apply color. It preserves the pristine condition of the surface fibers. This is important for the maximum intensity and transparency of your glazing. Those tiny surface fibers refract light, and they can do that best if they are left standing.

There are many methods of glazing. You can use a brush to lay down one color, then when it has dried, brush another color over it. For example, if you paint an area with blue (primary color) then overpaint with yellow (primary color), you will have an interesting green (secondary color). It will be a more exciting green than if you use a green pigment from a tube. You might continue to layer other blues and yellows to develop a deeper green. However, this method of layering colors with your brush has a distinct disadvantage: Each time your brush sweeps across the paper, it depresses the tiny surface fibers that refract light. It also grinds some particles of pigment into the paper. These two very important factors diminish the overall transparency of the glaze.

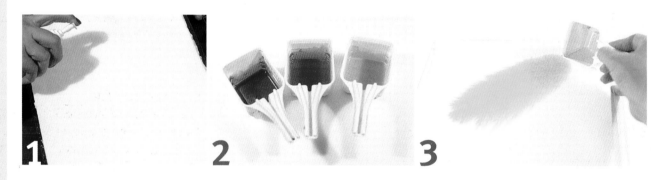

1 | Wet Your Paper

Using a pump sprayer, saturate your paper until there is a complete sheet of water on it. The pump sprayer eliminates the need for dragging a brush or any other device across the paper. Check the overall wetness of the paper by tipping the sheet up to the light. Watch to see if the water runs off in a sheet. If it catches on a dry spot, spray that area again. Then run off the excess water. The paper should be wet, but there should not be any standing pools of water.

2 | Mix Your Colors

In separate cups, mix transparent colors to a light creamy consistency (I use the plastic cups included in boxes of laundry detergent).

3 | Pour Your First Color

Gently pour a manageable amount of one color onto your damp paper. The color should easily slip across the surface of the paper. Tilt the paper to encourage the paint to swim in a direction you choose. You can guide the color, but do not try to control the flow. The beauty of this process is the free-flowing quality.

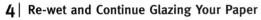

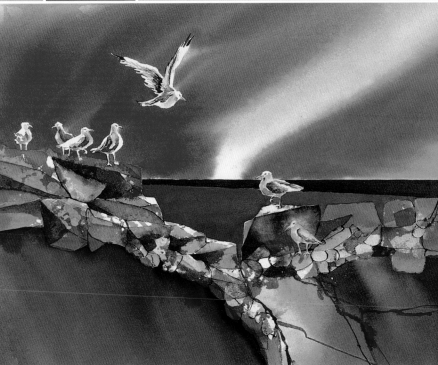

SEA WALL Jan Fabian Wallake 16" × 22"
(42cm × 57cm) Collection of the artist

4 | Re-wet and Continue Glazing Your Paper

You could pour on another color now, but I recommend that until you are comfortable with glazing, you take time to assess this first glaze. Let this first layer dry, re-wet the paper and then pour your second color. If, for example, you want a glowing pink-orange sky, pour Winsor Yellow, let it dry, re-wet and pour Winsor Red over the yellow. When that dries, evaluate the color and the glow. Maybe a glaze of Permanent Rose will heat things up. As long as you choose analogous colors (side by side on the color wheel), your glazes will be clear and radiant.

5 | Tilt Your Paper

Tilt the paper to encourage the color to flow. Use analogous colors for clear, radiant glazes.

36

Finishing Solution

I glazed alternate layers of Winsor Red and Winsor Yellow on the sky in *Sea Wall*, above. Finally, I glazed on a layer of Quinacridone Gold and continued to tilt the paper toward the upper right to create movement in the flow of colors. In the foreground, I used the same glowing orange as the sky until the final stage of painting. It needed to be dulled a bit so that it would not pull attention away from the sky and birds. I glazed over the lower portion of the painting with blue to dull it slightly.

MATERIALS **TIPS**
by Pat Weaver

37 Eliminate Clutter

Since my approach to painting is very direct and simple, I stick to the essentials. You may find that you require some extras to help you in your own endeavors, but I prefer as few extras as possible, eliminating any unnecessary clutter.

The supplies I use are:
Board supports
Bulldog clamps
Kneaded erasers
Masking tape
Mat with 4" × 6" (10cm × 15cm) opening
Mat with 8" × 10" (20cm × 25cm) opening
No. 2 pencils
Sharpie Twin Tip double-ended marker
Single-edge razor blades
Sketchbook 8½" × 11" (22cm × 28cm)
Soft paper towels
Template
Terry cloth rag
Toothbrush
Water bucket

Studio Essentials
Here are just some of the tools I use when painting. Most of the items you can find around your home or at your local art supply store.

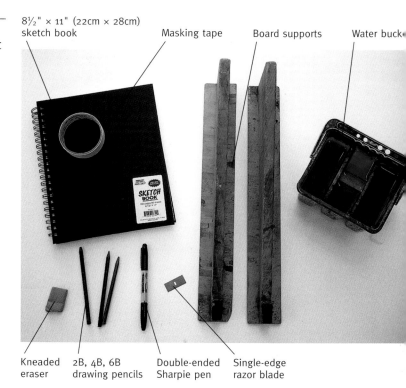

8½" × 11" (22cm × 28cm) sketch book — Masking tape — Board supports — Water bucket

Kneaded eraser — 2B, 4B, 6B drawing pencils — Double-ended Sharpie pen — Single-edge razor blade

Paper towels — Bulldog clamps — Terry cloth rag — Toothbrush — 4" × 6" (10cm × 15cm) mat opening

Template with openings in multiple sizes — 8" × 10" (20cm × 25cm) mat opening

STUDIO **TIPS**

by Pat Weaver

38 Setting Up Your Studio

The place you choose for a studio or workspace might be your kitchen table, an extra bedroom or a well-lit, large studio space. However large or small, plain or fancy, make the best of the space you have. I painted for many years on a back porch and then in a very small bedroom. Having a well-organized work area that is free of clutter helps. Everything that you need for painting should be within easy reach. I am right-handed, so my palette, water container, brushes, tubes of paint, paper towel, terry cloth rag and pencil are on my right. Generally, reference material such as a photo or value sketch is in my left hand while painting. Other essentials are to the left of the support board.

39 Get Into the Zone

Find a subject that is compelling, put on some classical music, shut the door to outside disruptions, and wonderful things can begin to happen in the studio. The best of everything happens in painting when you move into "the zone." This is not an everyday occurrence—rare in fact. It happens only when you become so immersed in painting that you become totally oblivious to everything. It's as if someone else were holding the brush and you are the observer. This is hard to explain unless you've experienced it—and hopefully you will.

When you choose your studio space, whether it is simply a corner or a full room, look for these qualities and equipment:

40 Privacy

A place where you can work uninterrupted; a place that is yours, is essential.

41 Good, Natural Light

A bright area with good natural light; north light is ideal.

42 Water Source

An easily accessible supply for mixing paints and cleaning brushes is necessary.

43 Daylight-Balanced Lamps

For those late nights painting, daylight-balanced lamps are a must.

44 Cabinet or Taboret

A cabinet or taboret is required to hold and organize your equipment.

45 Work Surface

Large enough to accommodate your painting, palette, brushes, water container and so on.

46 Large Mirror

Viewing your painting in a mirror often reveals trouble spots you may not otherwise see, such as weak value patterns.

Studio Setup
The north end of the studio houses my sink, refrigerator, closet, office space and, of course, those all important windows letting in light from the north.

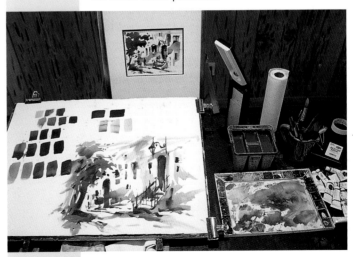

Convenience Is Key to My Setup
The board is slightly elevated. The brushes, paint, water, paper towels, etc., are placed to the right for easy access.

47 TECHNIQUE
Transferring an Image to Watercolor Paper
by Linda Stevens Moyer

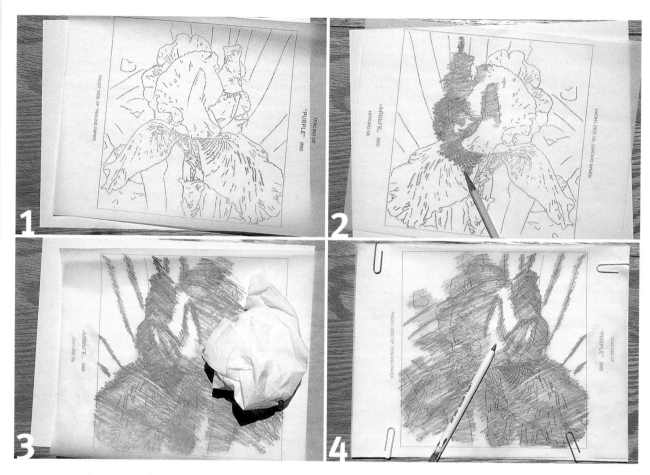

1 | Make a Drawing on Tracing Paper

A drawing of an iris was made on tracing paper in preparation for its transfer to watercolor paper. Make your drawing the same size that you want the finished painting to be. You may want to go over your pencil lines on the tracing paper with a ballpoint pen so that you can easily distinguish them once the graphite has been added to the back of the paper.

2 | Blacken the Back of the Paper

Turn over the tracing paper and blacken the back of the paper with a soft no. 2 graphite pencil wherever lines occur in the sketch.

3 | Remove the Excess Graphite

To eliminate some of the excess graphite from the paper, gently rub the paper with a tissue. Some artists use a tissue that has been moistened with rubber cement thinner or a nonoily lighter fluid. This will set the graphite and prevent smudging during the tracing process.

4 | Transfer the Drawing to Watercolor Paper

The tracing paper has now been treated so that the back of it will act as a carbon. Make sure that the side with the treated graphite is in contact with your watercolor paper. Fasten the tracing paper to your watercolor paper with paper clips so it won't move while you are tracing the image. Using a different colored pencil or a pen will help you to see where you have gone over the lines. Press hard enough to transfer the graphite onto the watercolor paper, but not hard enough to emboss the paper. You have now transferred your drawing to the watercolor paper and are ready to begin painting.

TIPS FOR MIXING PAINT AND HANDLING BRUSHES

by Mark Willenbrink

48 Mix With Water

Unlike other mediums, watercolor paints are supposed to be used transparently to utilize their luminescent qualities, so you have to mix the paint with water before applying it to paper. Whenever I talk about a color, I'm referring to a mixture of water and paint. The ratio of paint to water that you should use depends on how light or dark you want a color to be. Only hands-on experience can teach you how much water and paint to use to get the results you want.

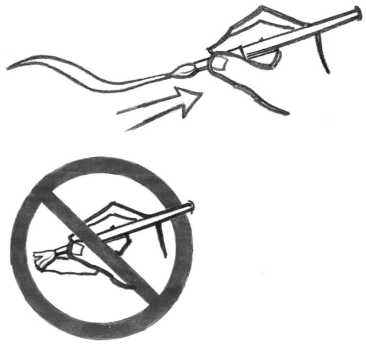

49 Start With a Base Color

The idea behind mixing colors is to start with a base color, or the lightest color, and then add small amounts of the darker color or colors until you get the color you want. If two colors are equally dark, think back to the color wheel. For example, green and blue can be equally dark, but green is made up of yellow and blue. Yellow is lighter than blue, and green has yellow in it, so yellow should be the base color. Start with green and add bits of blue until you get the color you want. Then add water until you get a good, working consistency.

Handle Brushes Correctly

50 Handle Brushes Correctly

Watercolor brushes can be pricey. Handle them carefully to get the most mileage out of them. A good round brush has bristles that come to a fine point. To maintain the point, gently pull or draw the brush away from the hairs toward the handle as you paint. Pushing or scrubbing with a brush can ruin the fine point that your brush once had.

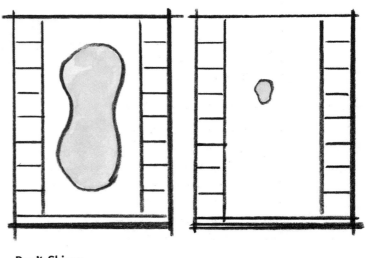

Don't Skimp

51 Don't Skimp

Don't worry about using too much paint. Beginners often mix too little and then try to stretch what they have. This means your paint application will be weak and pale or you'll spend lots of time trying to make another mixture of the exact color and value to finish your painting. The mixture at left (above) is much more realistic than the mixture at right (above). Fresh-squeezed paints from the tube are more soluble than paints that have dried on your palette. Use fresh paints to avoid pale colors.

BRUSH **TECHNIQUES**
by Linda Stevens Moyer

It is important to learn how to use the brush in a sensitive, expressive and economical way. The following exercises will provide you with the opportunity to begin learning how to do this. They will also teach you how to control the brush so that it doesn't control you!

All you need to follow along are a no. 12 or no. 14 round brush, your watercolor paper, a palette with paint and a water container. You may want to try these exercises on less-expensive newsprint first. Placing a sheet underneath the one you are working on will help you control the bleed of the paint.

52 Drawing Thin Lines

Mix a large pool of a medium gray paint in your palette using Payne's Gray diluted with water. Hold your brush straight up, perpendicular to the paper, with the bristles barely touching the surface. Keeping your fingers and wrist rigid, move the brush across the paper. This should result in a very thin line. Experiment to see how thin this line can be made. A very thin line can be made even with a large brush.

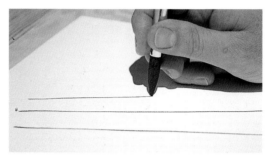

Drawing Thin Lines

53 Creating Shapely Lines

You can create shapes as well as lines by varying the pressure on your brush. Hold your brush as you would normally hold a pencil. Drag the brush toward you and alternately apply more and less pressure to the brush. This should result in a line that varies from thick to thin. Experiment to see how thick and how thin you can make a single line. How many times can you go from thick to thin with a fully loaded brush?

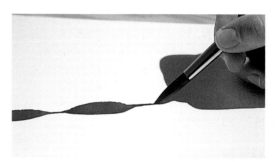

Creating Shapely Lines

54 Making Wide Brushstrokes

Now hold your brush so that the handle is parallel to the bottom of the paper. Drag the brush toward you. What kind of a line does this make? How long of a line can you make in this way without reloading your brush? Holding your brush in this position will create a very wide brushstroke.

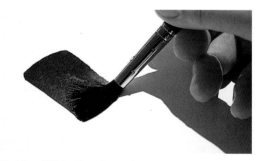

Making Wide Brushstrokes

55 Rolling Your Brush

Try rolling your brush on the paper. What kind of pattern does this make?

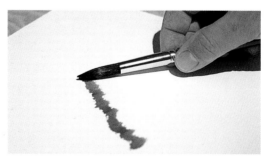

Rolling Your Brush

56 Flatten Your Brush, Take One

After loading your brush, squeeze some of the paint out of the bristles and flatten your brush with your thumb and forefinger. Then drag the resulting flat brush toward you. What happens?

57 Flatten Your Brush, Take Two

Flatten the bristles of your brush again, and then divide them into several groupings. Pull the brush toward you. What kind of mark does this make?

58 Double Load Your Brush

First, load your brush with Cadmium Yellow Pale. Next, dip the tip of the brush into a very dark mixture of Payne's Gray and water. Then hold the brush so that the handle is parallel to the lower edge of your paper. When you drag the brush toward you, the resulting stroke will look shaded—in this case, from gray to yellow. You can also triple load the brush using light, medium and dark mixtures of color.

59 One Brush Makes Many Strokes

Your large, round watercolor brush will make many kinds of marks. All of these brushstrokes (below, right) were done with a no. 14 round. Experiment to see how many different kinds of strokes you can make.

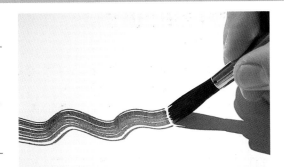

Flatten Your Brush, Take One

Flatten Your Brush, Take Two

Double Load Your Brush

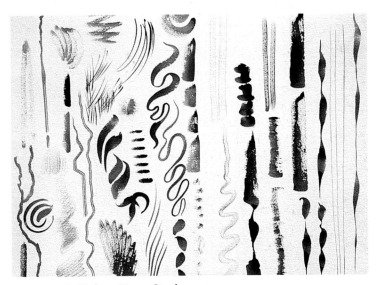

One Brush Makes Many Strokes

TIPS FOR DRAWING LINES

by Jan Fabian Wallake

60 Uses of Lines

Each single line has two dimensions: length and width. It also has the ability to express emotion. It can dance. It can be limp, rigid, nervous or angry. Lines can be either straight or curvilinear, continuous or intermittent. Use lines to separate shapes or areas. Use them to join areas and to direct visual movement in your painting.

61 The Character of a Line

The character of a line is as varied as your imagination. Artists can take advantage of the fact that every line has two sides. One side might be hard-edged, while the other side is soft-edged. I often use this varied-edge application when painting. The hard-edged side will describe a shape. The soft edge eases out to a vignette.

A line divides space. It describes an image and tells us how it relates to its surroundings.

Two lines that become closer in the distance tell us that there is depth in the painting. A soft line conveys an easy peacefulness, restfulness. My favorite way to use lines in a design is to create movement. Dramatic linear markings that swirl, skip or glide across a painting take a viewer on a visual rhythmic trip. Sometimes, I use a combination of marks to activate an emotional response and to direct an eye path at the same time. Lines do not have to do all the work, however. Combine them with shape for an effective attention-grabbing design.

62 Implied Lines

Implied lines are also effective. Rather than describing an entire shape with a line, rely on the viewer's imagination to carry a line. Offer just enough information to get your point across.

LINE VARIATIONS

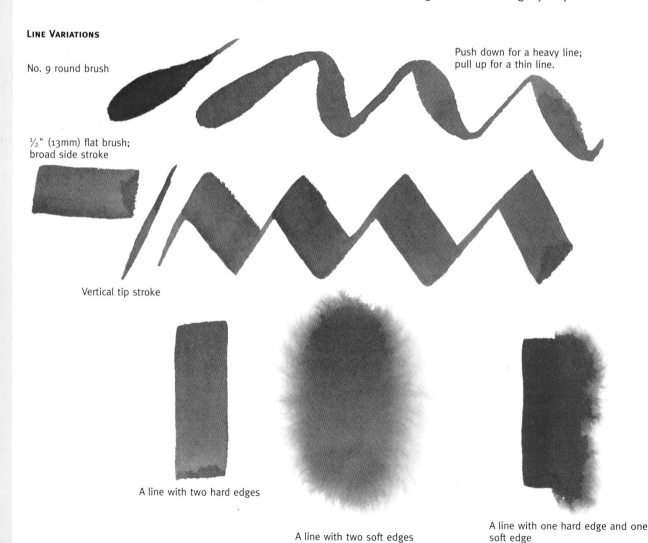

No. 9 round brush

Push down for a heavy line; pull up for a thin line.

½" (13mm) flat brush; broad side stroke

Vertical tip stroke

A line with two hard edges

A line with two soft edges

A line with one hard edge and one soft edge

WATERCOLOR TECHNIQUES
by Mark Willenbrink

Wet-into-wet, wet-on-dry and dry-brush tech-niques are synonymous with watercolor. Often, all three are used in one painting.

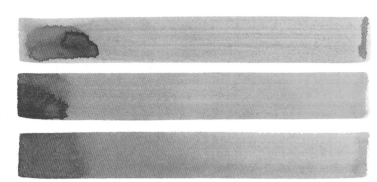

63 Painting Wet-on-Dry

To paint wet-on-dry, apply a wet brush loaded with paint to dry paper. Because there is no water on the paper to help the paint disperse, wet-on-dry painting produces defined strokes with hard edges. Different papers react similarly to the wet-on-dry technique. However, the smooth surface of hot-press paper allows cleaner edges.

Wet-on-Dry Painting on Different Papers
Examples of this technique used on different papers appear above. The papers are, from top to bottom, hot-press, cold-press and rough.

64 Dry-Brush Technique

The dry-brush technique uses dry paper and a dry brush loaded with a mixture that has very little water. Hot-press paper lets very little tex-ture show through after you've painted over it. Rough paper shows plenty of texture. If you want to use wet-on-dry or dry-brush tech-niques, make sure the area is completely dry before painting.

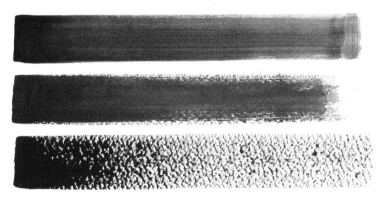

Dry-Brush Painting on Different Papers
Examples of this technique used on different papers appear above. The papers are, from top to bottom, hot-press, cold-press and rough.

65 A Dry-Brushing Solution

Use very little water for dry brushing. Mix the paint with just enough water to allow the mix-ture to transfer from the brush to the dry paper. The example at the far left shows that too much water was used.

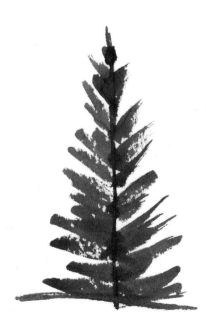

A Dry-Brushing Solution

TECHNIQUE
Introduction to the Wash
by Linda Stevens Moyer

Perhaps the most important technique in watercolor is the wash. Most of your work will involve applications of various kinds of washes to the surface of your paper. A wash is simply wet paint applied to the surface of dry paper in an area larger than can be painted by a single brushstroke. I will introduce two types of washes: the flat wash and the gradated wash.

Let's begin with the flat wash. A flat wash is an area painted uniformly in the same color and value. For this exercise, your watercolor paper should be attached to a drawing board that is inclined 30 to 45 degrees. Start with a medium-value mixture of a dark pigment such as Payne's Gray, Ultramarine Blue or Alizarin Crimson.

1 | Begin at the Top

A wash is started at the top of the desired shape. With a fully loaded brush, paint a horizontal stroke near the top of your paper. Be sure that you have loaded your brush so that a generous bead of paint will be left at the bottom of the stroke.

2 | Overlap the Previous Stroke

Dip your brush back into the mixed paint and immediately paint another horizontal stroke that partly overlaps the bottom of the first stroke. The excess paint from each stroke should continue to collect in a bead at the bottom of the shape you are creating. Continue reloading your brush after each stroke, overlapping horizontal strokes and allowing the paint to puddle at the bottom. Allow gravity to help you blend the different strokes as it gradually pulls the paint down.

3 | Remove the Excess Paint

When your shape is complete, rinse the brush and squeeze it gently. Use your brush as a sponge to remove the remaining bead of paint at the bottom of your completed wash. Be sure that your brush is not too wet when you do this or you will get a backwash (the wet portion will bleed back into the drier part), ruining your smooth, flat wash. I usually dry the completed shape with a hand-held hair dryer to avoid this.

Notice that the shape of the wash has a definite boundary. This is called a hard edge.

Warning!
Don't go back over the wash with your paintbrush. This will create streaks.

The Gradated Wash

Your objective in painting a gradated wash is to create a gradual change of value from the top of the shape to the bottom. You will follow much the same procedure as you did to create the flat wash. Start with a medium-value mixture of any of your darker pigments. Mix enough of this value to cover an area at least 3" × 3" (8cm × 8cm).

1 | Paint a Horizontal Stroke

With a fully loaded brush, paint a horizontal stroke near the top of your paper.

2 | Overlap the First Stroke

Dip your brush into clean water and immediately paint another horizontal stroke, partly overlapping the first stroke. Repeat this process, continuing to dip your brush back into the clear water before each stroke. As in the flat wash, the excess paint from each stroke will collect at the bottom of the shape you are creating.

It is important to work as quickly as possible or the strokes of water may bleed back into the color that you've added and cause the backwash effect that is seen in this step.

3 | Finish the Wash

As the painted area continues down the surface of the paper, the paint is progressively more diluted with clean water and the value becomes lighter. You will learn more about, and have more opportunities to practice, the flat wash on pages 50–53, as well as the gradated wash on pages 54–57.

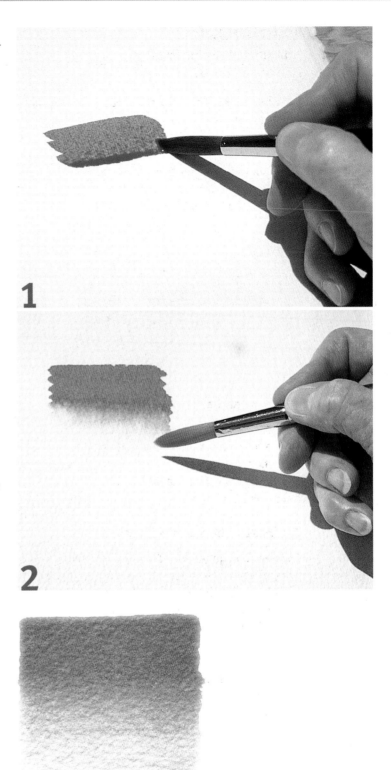

1

2

3

68 TECHNIQUE
Using Masking Fluid
by Linda Stevens Moyer

Art masking fluid may be used to save the white of the paper. This is especially helpful if the shapes to be saved are quite small.

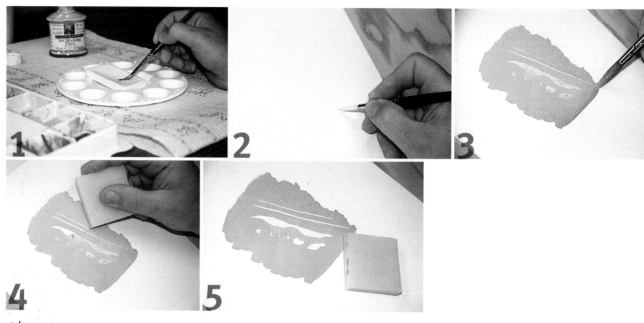

1 | Apply Soap to the Brush

Use an inexpensive brush that comes to a good point. Dip the brush in clear water and then rub it on a bar of hand soap until slightly soapy. (This will make it easier to wash the masking out.)

2 | Apply Masking Fluid to the Paper

Dip your brush into the masking fluid and paint the shapes you wish to save as the white of the paper. Be sure that the masking fluid is completely dry before you go on to the next step. You may use a hair dryer for this.

3 | Apply Paint

Apply a wash of color over and around the area that has been masked, and let the paper dry.

4 | Remove the Masking

Once the paint is completely dry, remove the masking with a rubber cement pickup or by rubbing your finger over the surface.

5 | Admire Your Finished Result

The white of the paper has been retained in the areas where the masking was applied.

MASKING TIPS

69 Wash Out Your Brush

Wash out your brush a number of times while applying the masking fluid so that the fluid doesn't dry in the brush while you're working. If it dries, the brush will be ruined. Each time you clean your brush, dip it in clear water and then rub it on a bar of hand soap until it is slightly soapy.

70 Keep Brushes Separate

Don't let masking fluid come into contact with your good painting brushes. Use a separate water container for washing out the brushes you use for masking.

71 Watch for Hard Edges

Masking fluid leaves a very distinctive hard-edged shape in the finished painting. For this reason, I use masking only on small shapes that would be very difficult to paint around. Some artists use a damp, stiff-bristle brush to soften the shapes left by masking.

ADDITIONAL MASKING **TECHNIQUES**

by Linda Stevens Moyer

The following examples show additional ways of using masking, not only to save the white surface of the paper but also to create texture. I remove masking fluid with a rubber cement pickup when the painting is completed.

Drafting tape and similar materials may also be used to save the white of the paper.

72 Working Wet-Into-Wet

The traditional way of using masking fluid is to apply it to dry paper. Hard-edged shapes result. Masking fluid can also be applied to moist paper. Soft-edged shapes will be formed and saved by applying the masking fluid in this way. Note that shapes formed with masking fluid on damp paper will be more difficult to control as they tend to bleed over the wet surface.

Try this technique for cloud shapes in the sky and moss on rocks.

73 Spattering

Dip a toothbrush into masking fluid, tap the brush on a hard surface to remove the excess, then drag a piece of cardboard or your finger along the bristles to spatter the fluid onto the paper. After the spatters are dry, the surface can be painted. Remove the masking fluid once the paint is dry. This process can be repeated in layers (working light to dark) to build a complex area of color and texture. Remove all of the masking fluid when the painting is complete.

Try this technique for sand on a beach, texture on rocks or sea spray. Paint spatters on a wet surface look like bubbles.

74 Masking Fluid for Printing

Masking fluid can also be applied to various objects. The objects are then pressed on the paper, leaving an imprint of the shape.

Try this technique for incorporating the prints of real objects (e.g. leaves, bark) into your paintings when working on location.

Working Wet-Into-Wet **Spattering**

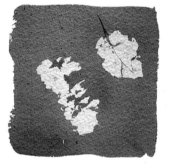

Masking Fluid for Printing **Using Drafting Tape**

75 Using Drafting Tape

Shapes can be cut from drafting tape or a similar product and applied to watercolor paper. These shapes should be burnished (firmly rubbed) with your thumbnail so that all of the edges are sealed. Then you can apply watercolor and the areas covered by the tape remain protected. After the paint has dried, the tape is removed, leaving a white surface.

Try this technique for fence posts and sails on sailboats.

TECHNIQUES FOR LIFTING PAINT
by Linda Stevens Moyer

There are times when an area of a painting needs to be lightened after the paint has already been applied. There are a variety of effective methods for lifting paint that can be used.

76 Scratching

With the point of a sharp utility knife, scratch the surface of dried paint to make white lines across the surface. The kind of white line created will depend on the paper surface. This example was done on rough watercolor paper.

The scratching will raise tiny portions of the paper. Usually you will want to use your thumbnail to flatten these so that they will not cast shadows in the finished work.

Try this technique for weathered wood, telephone lines, fishing lines or tiny highlights that you discover are needed after a painting has been completed.

77 Scraping

The blade of a nonserrated knife created the lighter shapes in this example. I held a knife at an angle to the surface of the paper, drawing the blade toward me, pressing out some of the wet paint and allowing the white of the paper to come through the wet paint. (The handles of some watercolor brushes are cut off at a slant providing a tool to create this effect.) This technique is best done after the paint begins to lose its gloss; if the paint is too wet, the color will flood back into the scraped area.

The darker lines were created by using the point of the knife. When the point is used to scratch into the wet paint, it roughens the surface of the paper and allows more paint to flow into this area, leaving a darker value. Try using various tools to get a variety of effects.

Use this technique for grass, feathers, fur or regaining a lighter area in your painting after a wash has been applied.

Scratching

Scraping

Cutting Out Shapes

78 Cutting Out Shapes

Sometimes as you work on a painting, you will find that you need a completely white shape in your composition (one that you had not previously planned). In this example, a utility knife was used to cut a shape through the top ply of the paper. The cut shape was then peeled off, exposing the white paper underneath. This technique works best on heavier paper such as 300-lb. (640gsm).

Try this technique for working back into heavily stained areas to regain the white of the paper.

79 Wet Lifting

Wet lifting is done while the paint is still moist. It is most effective if done while the painted surface has only a slight sheen. Use a clean, wet brush that has had most of the moisture squeezed out of it. Make a stroke of the desired shape on the surface of the previously applied wash. The brush will act as a sponge, removing the paint.

The amount of paint removed (or lifted) will depend on the characteristics of the paint used (e.g. staining or nonstaining, dye or sedimentary). If the paint is too wet, it will flow back into the area that has been removed. This technique creates soft-edged shapes.

Try this technique for soft edges of water ripples.

80 Dry Lifting

Dry lifting is done on a dry painted surface. Use a wet brush to apply clean water in the desired shape to be lifted. Then use a paper towel to mop up the water by briskly drawing the towel toward you with a firm pressure. Once or twice should be enough. Do not scrub as this may remove some of the paper's surface. It is also important to use this only on paper that has a durable surface. The effectiveness will depend on the characteristics of the paint to be removed. If the paint is a staining color, very little change will occur.

Try this technique for putting highlights or reflected light back into objects in your paintings.

81 Using Sandpaper

Use sandpaper on a dry painted surface to expose a lighter value. This example was done on rough watercolor paper. The lines were created by folding the sandpaper and then using the folded sandpaper to reveal the white of the paper. The technique can also be used to create texture.

Try this technique for rocks, sand or the light side of an orange.

82 Adding Salt to a Wet Surface

When table salt is sprinkled on a wet, painted surface, it absorbs the paint and creates a unique texture. If the surface is quite wet, large shapes will emerge as the paint dries. Sprinkle the salt lightly! If the salt is applied too densely, it will interfere with the shapes that are cre-

ated by this process. The salt should be removed after the paint has thoroughly dried. This leaves interesting designs where the paint has been absorbed by the salt and lifted.

Try this technique for dappled sunlight on water or a forest floor.

83 Adding Salt to an Almost-Dry Surface

If salt is applied to paint that has almost lost its sheen, small star-like shapes will result. Remember to remove the salt only after the paint has thoroughly dried.

Try this technique for sparkles in snow.

Wet Lifting

Dry Lifting

Using Sandpaper

Adding Salt to a Wet Surface

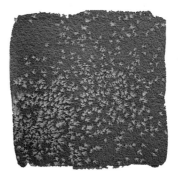

Adding Salt to an Almost-Dry Surface

BRUSHWORK **TECHNIQUES**
by Betty Carr

Confident brushwork makes a tremendous difference in a painting. From the largest wash to the smallest brushstroke, it's obvious that the artist knew what to do with the brush and where to put the paint.

Practicing various brush techniques enables you to gain the necessary confidence to make your work look effortless. Get to know your brushes and what they are capable of doing. Remember that your whole body should be involved in the brush action, not just your fingers. Consider painting as an athletic event, and do it with gusto.

Whatever appears in a painting is the result of action done by you, the artist. Experimenting with different tools can be exciting and will add variety to your work. Practice the following techniques and develop your personal way of using them.

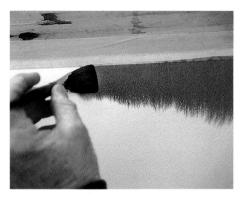
Using a Flat Brush

Making a Flat Wash

Making a Gradated Wash

84 Using a Flat Brush
Flat brushes are ideal for large washes because they can cover a lot of paper in just a few strokes.

85 Making a Flat Wash
Tilt your moistened paper, then with a loaded brush start at the top and gently pull strokes from one side to the other. Allow a bead of paint to continue down your paper. The less water in the mixture, the darker the wash will be.

86 Making a Gradated Wash
Begin with a loaded brush of color and float the hue at the top. As you proceed down the paper, add more water to the paint. Let the value of the pigment gradually go from dark to light. Tilt the paper so that gravity can help create a smooth transition.

87 Dry-Brushing Techniques
You can create a great variety of effects with watercolor brushes. Using different types of brushes, vary the amount of pigment and water along with the speed at which you move the brush over dry paper. Use the handle of your brush to scrape into the paint.

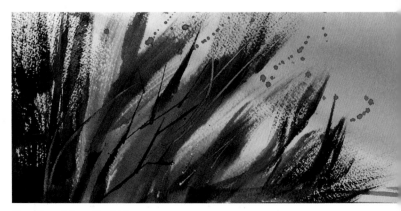
Dry-Brushing Techniques

88 Applying Salt
Try sprinkling a little salt on a painted surface that has a dull shine to it.

89 Admire the Effects
Once the paint has dried, brush the salt off and notice the interesting effects that result.

90 Spattering Paint With a Loaded Brush
Tap a loaded brush against the handle of another brush to spatter paint on your paper. Spatters can be done on wet or dry paper creating different effects. Below, spatters were applied to a moist area.

91 Painting Wet-Into-Wet
When you apply different mixtures of pigments to moist paper, the colors blend and move around pleasantly.

92 Spattering Paint With a Toothbrush
Try putting paint on a toothbrush and spattering it onto damp paint.

93 Lifting Paint
Dip a Fritch scrubber or a stiff bristle brush in water. Scrub on dried paint, then dab with a paper tissue to lift the pigment off the surface.

94 Combine Techniques
The wet-into-wet technique, shown below, is very effective in creating a distant background or soft textural effects. Wet most of the paper and drop heavy paints here and there, allowing them to flow; this will create a spontaneous result. Lifting and spattering can also be added to create a number of different textures.

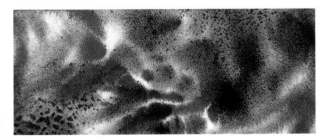

Applying Salt

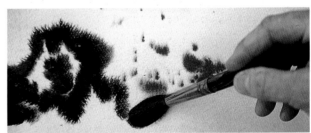

Admire the Effects

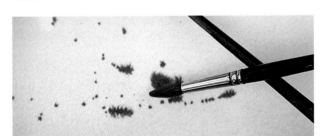

Spattering Paint With a Loaded Brush

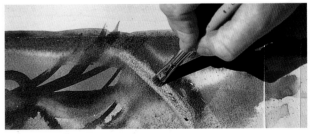

Painting Wet-Into-Wet

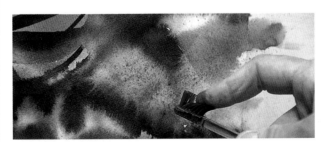

Spattering Paint With a Toothbrush

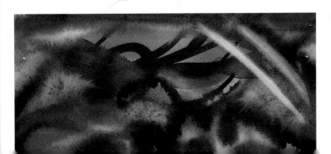

Lifting Paint

Combine Techniques

95 Using Masking Fluid and Tape

Use masking tape to create an interesting torn-edge effect. Use masking fluid to paint thin lines and spatter spots, then after the fluid has dried paint with gusto. Remove the masking fluid with a rubber cement pickup. Remove the tape and paint the area that was masked.

96 Painting With a Palette Knife

Put paint on a palette knife and rub it lightly over the paper. This is a great technique for giving texture to such elements as granite, rock or weathered wood.

97 Linework With a Palette Knife

Linework can be done effectively by applying paint with the side of a palette knife and gliding it over the paper.

98 Scraping With a Palette Knife

When the pigment on the surface of the paper is slightly moist, scrape into and remove paint. This technique is great for natural forms such as grasses and twigs.

99 Combine Techniques

Combine brushwork and palette knife techniques for realistic effects. Vary the direction of a loaded brush on the paper. Vary the size of your brushes when doing this exercise.

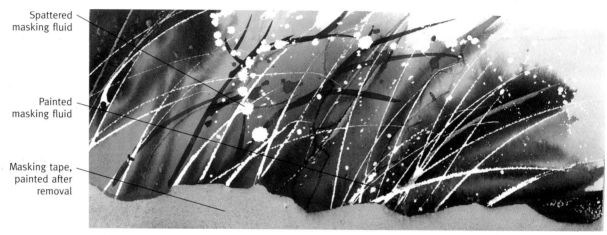

Spattered masking fluid

Painted masking fluid

Masking tape, painted after removal

Using Masking Fluid and Tape

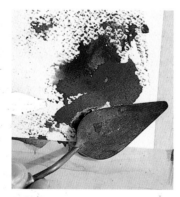

Painting With a Palette Knife

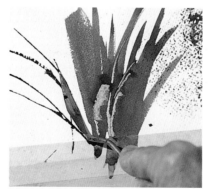

Linework With a Palette Knife

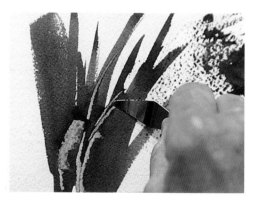

Scraping With a Palette Knife

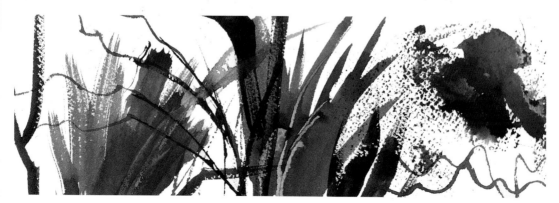

Combine Techniques

STRUCTURAL DRAWING **TIPS**

by Mark Willenbrink

100 Everyone Can Learn to Draw

To create a successful painting, you need a solid foundation. Create an accurate drawing of the shapes and elements in a scene before you begin to paint. Structural drawing may seem too scientific or monotonous, but it's essential for creating beautiful art. Structural drawings include basic shapes without shading and provide the right starting point for every painting. You may think you can't draw, but everyone can learn.

101 Loosen Up With a Gesture Drawing Exercise

by Betty Carr

Pick a shape near you and give yourself thirty seconds to draw it using pen, pencil or brush. Try another for sixty seconds. Every form has a gesture, and by forcing a speedy drawing, you will find that you'll zoom in on it.

Say you choose to draw a pine tree. Is it proud and upstanding, or droopy and forlorn? Are the branches parallel to the earth? Perhaps those branches closer to the sky bend upward while the heavy branches near the ground are affected by gravity. Sensing the way a form grows will greatly assist in your gesture drawing, and in turn, your painting.

Look for Basic Shapes
Look for basic shapes such as circles, squares, triangles, ovals and rectangles.

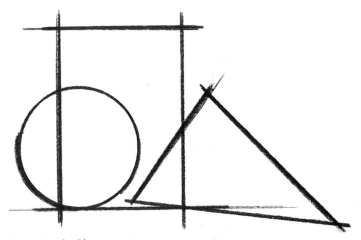

Draw Basic Shapes
Put the big, basic shapes together.

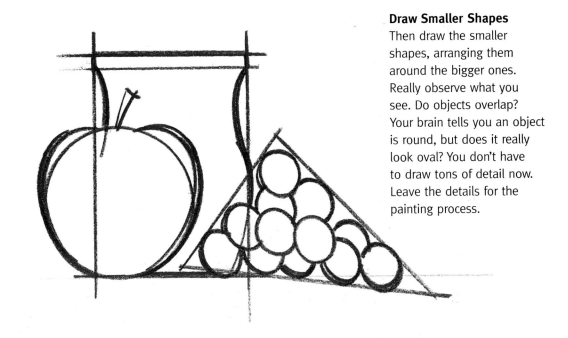

Draw Smaller Shapes
Then draw the smaller shapes, arranging them around the bigger ones. Really observe what you see. Do objects overlap? Your brain tells you an object is round, but does it really look oval? You don't have to draw tons of detail now. Leave the details for the painting process.

MEASURING **TIPS**

by Mark Willenbrink

102 Compare and Align

Making art is a creative process, but that doesn't mean you should ignore the facts. To get the proportions right and to draw an accurate, believable object or scene you need to measure. You can measure using something as simple as a pencil; just compare and align elements.

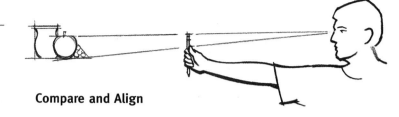

Compare and Align

103 Keep It Straight

Lock your arm in a straight position, holding the pencil straight, and look at the pencil and the object you're measuring through one eye. Don't bend your arm. If you bend your arm, you'll end up with inaccurate measurements because you might bend your arm a bit differently each time. By measuring with a straight arm, your scale stays consistent from one measurement to the next.

Keep It Straight

104 Measure With a Pencil

In this scene, the height of the apple equals the distance between the top of the pencil and the tip of the thumb.

105 Compare Measurements

Compare the measurement of the height of the apple to the width of the top of the vase. They're about the same. Comparisons like this help produce accurate drawings, especially when objects are arranged at angles.

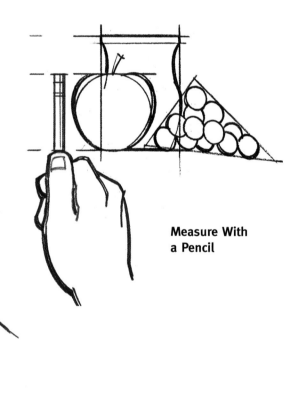

Measure With a Pencil

Compare Measurements

106 Getting the Proportions Right

Capturing the correct proportions in a painting is the first step in achieving a realistic drawing. This building's width (below) is twice that of its height.

107 Sewing Gauge

A sewing gauge is an inexpensive measuring device that gives more accurate results than a pencil.

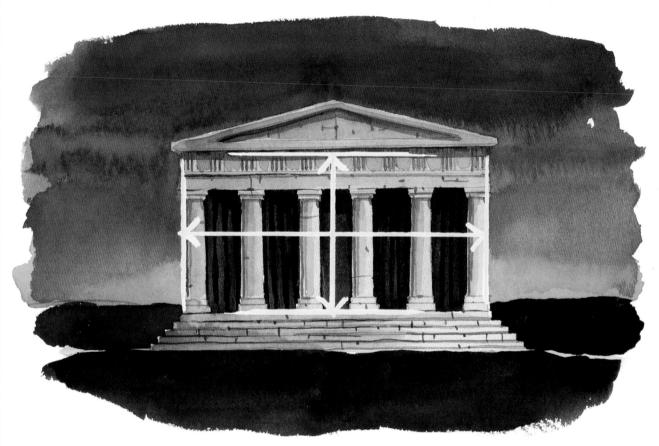

Getting the Proportions Right

Sewing Gauge

LINEAR PERSPECTIVE **TIPS**

by Mark Willenbrink

108 Perspective Creates Depth

Perspective gives an impression of depth. Employing the principles of perspective can make an image on a two-dimensional surface appear three-dimensional. Linear perspective uses converging lines and objects of varied relative sizes to create this illusion.

The secret to creating perspective is finding the horizon. Land and sky meet on a horizon line. Somewhere on this line is at least one vanishing point where parallel lines, such as the rails of a railroad track, seem to converge.

109 One-Point Perspective

One-point perspective is the simplest form of linear perspective, with only one vanishing point. Use one-point perspective when you're looking at an object head on.

110 Drawing From a Certain Viewpoint

Observe one-point perspective while looking straight down a set of railroad tracks. Just make sure there's not a train in the way! The parallel tracks converge in the distance at the vanishing point. If a building or other structure is parallel to the tracks in reality, it will share a vanishing point with the tracks. If you extend the structure's line to the horizon, it will meet the others at the vanishing point rather than actually running parallel on the paper. Notice that objects of equal size in reality appear larger the closer they are to the viewer. Drawing things in perspective means drawing them not as they are in reality, but as they look from a certain viewpoint.

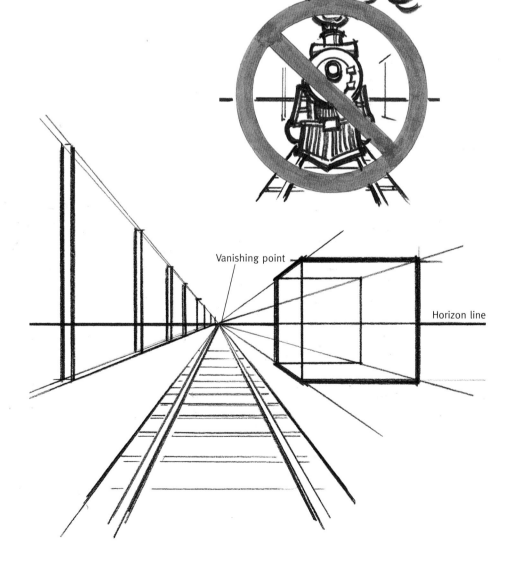

Drawing From a Certain Viewpoint

Vanishing point

Horizon line

111 Two-Point Perspective

Let's look at the same railroad tracks from the side to get a glimpse of two-point perspective.

112 Find the Hidden Vanishing Point

This scene (at the right, top and bottom) may look simple, but it required some planning ahead and getting factors like perspective right to make the scene look accurate and believable. Even though you can't actually see the horizon in this cityscape, you should determine its location and figure out where your vanishing point will be. Notice that all of the lines—the road, the windows and even the roofs—disappear at the vanishing point.

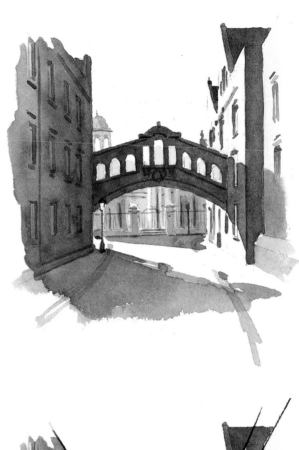

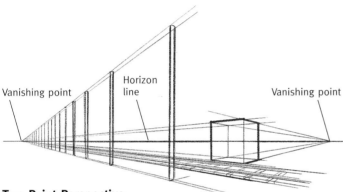

Two-Point Perspective

The most common form of linear perspective is two-point perspective, in which two vanishing points land on the horizon.

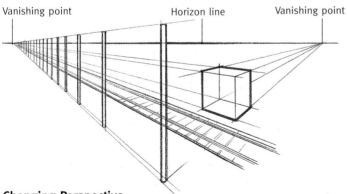

Changing Perspective

By raising the horizon on this two-point perspective scene, the viewer now seems to be looking down on the same scene.

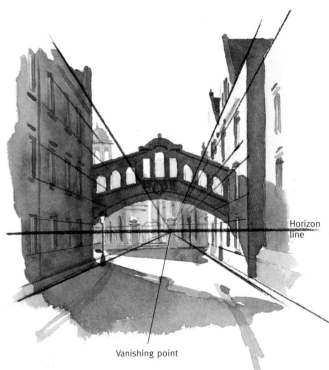

Find the Hidden Vanishing Point

TIPS FOR UNDERSTANDING PERSPECTIVE AND POINT OF VIEW

by Betty Carr

A realistic painter must depict volume and space: depth on a flat surface. Without a basic knowledge of perspective, your artwork will be at risk.

Linear perspective takes an analytical approach; it describes the illusion of distance created when parallel lines seem to converge at a point on the distant horizon, referred to as a vanishing point.

113 Find the Horizon Line

Before starting any painting, decide where the horizon line should be in relation to the eye-level. The eye level is the height of your eyes when looking straight ahead. If your eye level is low, place the horizon line lower on the paper; if your eye level is high, place the horizon line higher. All parallel lines below your eye level will slope upward toward the vanishing points, and all parallel lines above it will slope downward.

114 Using One-Point Perspective

In one-point perspective, objects appear smaller as they recede and converge toward a single vanishing point. You may want to place this point on your horizon or eye-level line before you begin drawing or painting.

115 Using More Than One Perspective Point

When you look at your subject and observe two or more sides receding—for example, a corner of a building—you'll use two-point perspective, or possibly multiple-point perspective. Parallel lines will appear to converge at more than one vanishing point.

116 Using One-Point Perspective to Create Depth

In this one-point perspective painting (*Spring's Response*, above right), the viewer sees the horizon line (eye level), where the ocean meets the sky. All the lines or receding planes below that line, such as the tile work on the patio, angle up toward it. All the lines or receding planes above that line, such as the awnings, angle down toward the horizon. Everything comes together to create the illusion of depth.

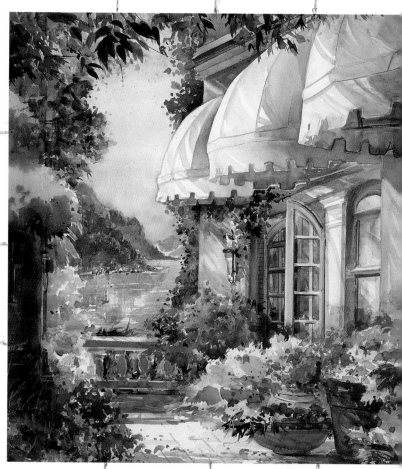

SPRING'S RESPONSE Betty Carr 27" × 21" (69cm × 53cm)

Learning How Your Point of View Affects Shapes, Shadows and Light

117 Using Basic One-Point Perspective

You can't help but move directly to a vanishing point in the tree-lined road, below. As more buildings, trees and other elements clutter a scene, it may appear more complicated, but look for the basics.

118 Seeing Two-Point Perspective

Imagine that the three cubes (below, right) are connected to form a building. Since you see two sides of the cubes, or imaginary building, each side's parallel lines converge at two separate vanishing points. Notice that all parallel lines above the eye level go down and all parallel lines below the eye level go up.

119 Making Ellipses in Perspective

Just as the cube can be examined in terms of analytical perspective, so can the cone, cylinder and sphere. Put a glass on the floor and stand over it, looking down into the opening. You will see a perfectly round circle. As you raise the

glass, approaching your eye level, notice that the circle changes and becomes an ellipse. It is still a circle, but seems tilted. By drawing your ellipses through (in the round) and remembering that the ellipse widens the higher or lower you go from your eye level, you'll create correct dimensional forms in space.

120 Learning How Your Point of View Affects Shapes, Shadows and Light

These photos (above) of the same subject illustrate various eye levels: looking up, looking down and looking straight ahead. It is crucial to determine your point of view before you begin to paint.

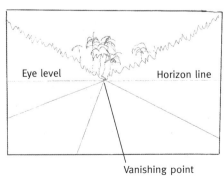

Using Basic One-Point Perspective

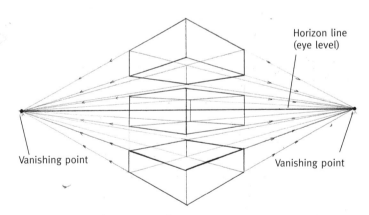

Seeing Two-Point Perspective

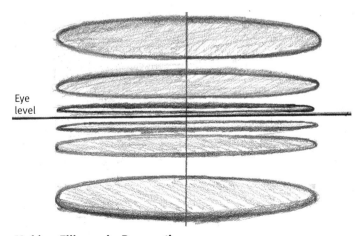

Making Ellipses in Perspective

PLANNING **TIPS**
by Mark Willenbrink

121 Plan Ahead and Embrace the Unpredictable

Watercolors are said to be unforgiving because once you've applied them to paper, they're difficult or even impossible to change. Artists can easily become overly cautious and timid with their paints, which results in a pale, stiff and unexciting painting. Instead, embrace the unpredictability of watercolors and incorporate it into your painting.

There's more to the painting process than simply applying paint to paper. To maintain control over your painting and to give yourself confidence, plan ahead. If you plan your painting well, you won't need to worry about the fact that there are no "do-overs" in watercolor. Decide on the structure, values and colors you'll use before you start painting.

122 Plan With Thumbnail Value Sketches

Draw a few thumbnail sketches of the scene you're going to paint on sketch paper with a 2B pencil. These small, quick sketches show different approaches to value, composition and cropping. I prefer my first sketch (below, top) because the composition and values lead the eye to the focal point while producing a balanced and interesting scene.

123 Make Color Sketches for Reference

Now work up some different color schemes using the thumbnail value sketch you chose. On scrap watercolor paper, draw the structural lines without the values. Then try different color schemes, paying attention to the values of the colors you're auditioning. I prefer the direction and balance created by the use of warm and cool colors in my second color sketch (bottom). I'll use this as a reference for my final painting.

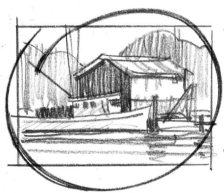 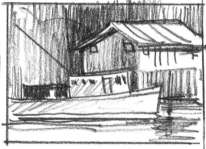 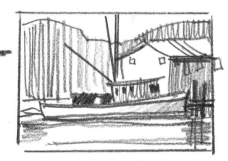

Plan With Thumbnail Value Sketches

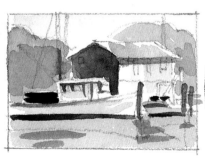 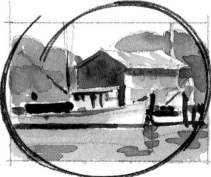

Make Color Sketches for Reference

WASH ANSWERS

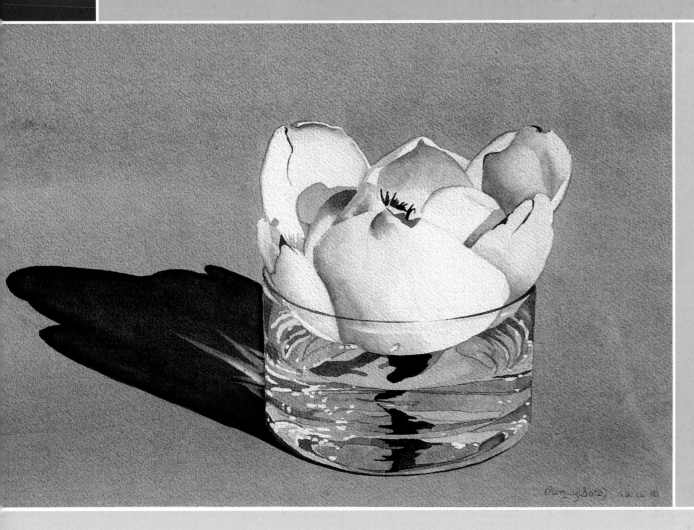

> "I often call my paintings controlled accidents.
> I just don't tell my clients where the accidents are."
>
> — Joe Garcia

FLOWER IN A GLASS Penny Soto 15" × 22" (38cm × 56cm)

THE FOUR BASIC WASH **TECHNIQUES**
by Joe Garcia

There are four basic washes that are important for you to know. Once you understand the process of each wash, the world of watercolor painting opens up to you. These four washes are: flat, gradated, wet-into-wet and streaked. Painting each one requires a slightly different approach.

124 Make Washes Work for You

Washes come in a variety of sizes, shapes and colors. A wash can cover the entire paper or the smallest of areas. There is no rule on how washes should be used. It is up to you, the artist, to make them work for you.

125 Practice is the Key

Also, practice is the key to success. I have spattered paint on the walls, puddled pigment on the floor, and splashed color across my tabletop—all in quest of the perfect wash!

126 Smaller is Easier

I find the smaller the wash, the easier it is to control. My samples are 2" × 4" (5cm × 10cm) on 140-lb. (300gsm) cold-press Arches paper, mounted on acid-free board. Mounting prevents any buckling or warping of the surface. 300-lb. (640gsm) cold-press Arches will also work. Arches is the only paper I have found that will not tear when the tape is removed.

127 Flat Wash

The flat wash looks like the name implies. There is no gradation from top to bottom or side to side. It has one value. This is a great wash for skies or buildings where a flat value is needed.

128 Gradated Wash

This wash is one that gets progressively lighter in value. The gradated wash starts with the desired color and value and more water is added as the wash continues. It's a great wash for landscapes where mountains fade into the mist or dark, rich skies fade into the horizon.

129 Wet-Into-Wet Wash

The wet-into-wet technique is the wash most often used. Colors are placed side by side on a wet surface and allowed to flow together. Soft blending is the result of this wash. Because of the wet surface there is less control. I find this is a great wash for my "controlled accidents."

130 Streaked Wash

The streaked wash is a good tool to get you to think about washes and texture. Place the color on a wet surface, then pick up your drawing board and tilt it in the direction you want the texture to run. I often use this technique when I want to show the wind blowing the clouds or rain.

Flat Wash

Gradated Wash

Wet-Into-Wet Wash

Streaked Wash

FLAT WASH **TIPS**
by Joe Garcia

131 Create Dimension
Flat washes can be used to create a distinctive style of painting. A lot of detail is eliminated and patterns of light and dark are constructed. When used as a glaze, especially for shadows, flat washes make a painting dimensional.

132 Create a Graphic Look
The flat wash should have an even value. Try to keep the saturation consistent, whether it is 10 percent or 100 percent. A very wet surface is the key. Pick up your board and let gravity take out the uneven areas. Flat washes can give your paintings a graphic look—great to use when painting inanimate objects such as buildings.

133 Use a Flat Wash as the Background
Raw Sienna with a little Permanent Rose were used for this background wash (right). As the foreground was painted, Permanent Rose and Cobalt Blue were added. Highlights were lifted from the trees in the foreground.

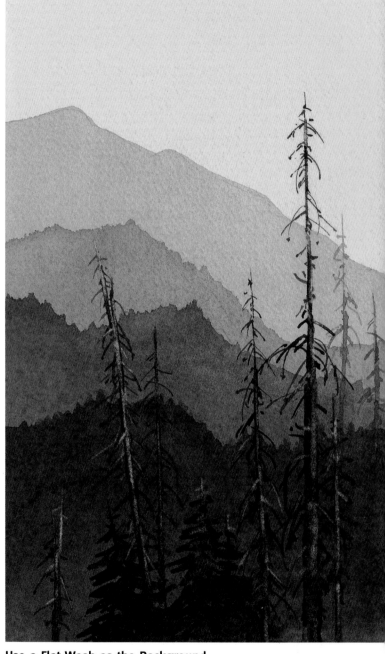

Use a Flat Wash as the Background

EVENING GLOW Joe Garcia 5" × 8" (13cm × 20cm)

134 TECHNIQUE
Practice the Flat Wash

by Joe Garcia

The flat wash (introduced on page 30) looks deceptively easy. I find the most important part of this wash is to mix a lot of paint on your palette—much more than you think you will need. Decide on what saturation the wash will be. Saturation is the ratio of pigment to water in the wash. At 100-percent saturation the color or hue is at the richest value possible while still remaining transparent. Anything greater than 100-percent saturation creates an opaque color or hue. You want to avoid oversaturation.

Draw a number of 3" × 6" (8cm × 15cm) rectangles on 140-lb. (300gsm) cold-press Arches paper. 300-lb. (640gsm) Arches is great but is slower to dry. Tape off the rectangles. The tape will act as a barrier to your wash.

MATERIALS

PAPER 140-lb. (300gsm) cold-press Arches

PAINT Sap Green

BRUSHES Flats | 1½-inch

OTHER Drawing board | HB to 2B pencil | Masking tape | Palette | Paper towels or tissues | Ruler | Water

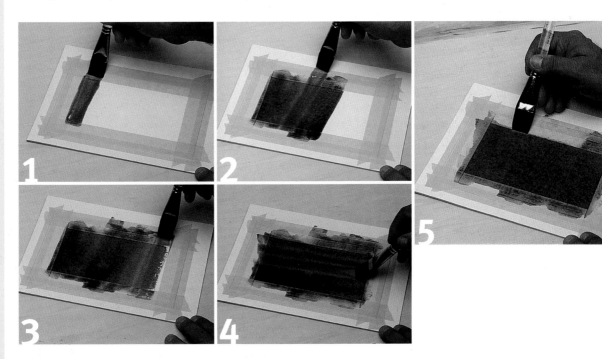

1 | Load the Brush

Load the brush with paint. Start the wash with a rich, wet brushstroke.

2 | Paint Down the Rectangle

Continue down the rectangle. Keep the strokes wet and loaded with paint. It's important!

3 | Clean the Edges

Clean the edges of your wash if necessary. When you reach the bottom of the wash, make sure the covered area is still very wet. If you see any weak areas, repaint them.

4 | Paint in the Opposite Direction

Load the brush with paint and apply the color in the opposite direction. Remember, you still have to keep the transparency of the wash.

Pick up your board and tilt it back and forth and up and down. This will eliminate any unwanted texture and create a beautiful flat wash.

5 | Finish Your Wash

If a bead develops along the edge of your painting due to too much wash, use your brush to pick it up. Rinse your brush and squeeze the excess water out. Touch the damp brush to the bead and it will act as a sponge, pulling the moisture off the surface. Lay the wash flat and allow it to dry on its own.

TECHNIQUE
Master the Flat Wash

by Joe Garcia

I find subjects like buildings and landscapes are perfect for flat washes. This old barn was on a back country road near Mendocino, California. I did some sketches and took photos for a future painting.

MATERIALS

PAPER 140-lb. (300gsm) cold-press Arches

PAINTS French Ultramarine Blue | Olive Green | Permanent Rose | Winsor Green

BRUSHES Flats | ½-inch (12mm)
Rounds | No. 2

OTHER Drawing board | HB to 2B pencil | Masking tape | Palette | Paper towels or tissue | Ruler | Water

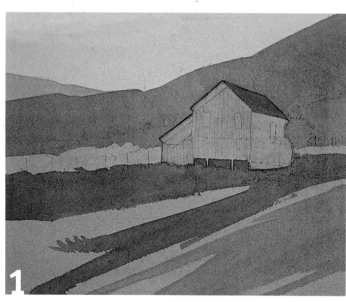 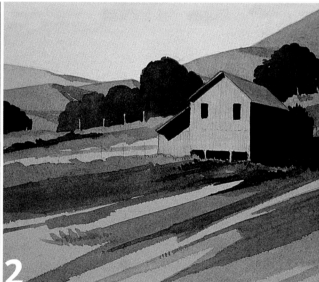

1 | Begin Your Painting

Start with a basic drawing, using the finished painting as a reference. Keep the drawing simple; do not add much detail. Use a ½-inch (12mm) flat to wash in the color of the building. Do this as evenly as possible, and let it dry completely. Start with your lightest background value and wash it in as evenly as possible top to bottom.
I used a light Olive Green and worked quickly with a very wet brush. It is important to let each wash dry thoroughly. If the underlying wash is not dry the color will begin to lift. As you move into the foreground, change the value or hue of each wash. I used some middle-value greens. Leave areas of the original background wash visible. It will help brighten and tie the painting together.

2 | Begin to Add Shadows

Complete all the flat washes in your painting. Use no detail, but wash or glaze all areas. Note the washes in the foreground. The shadows will add dimension or volume to your painting. Use a French Ultramarine Blue and Permanent Rose mixture for the shadow wash on the building and ground. Now do the shadows of the trees. Add a little Winsor Green to these shadows. Check your light source and keep the shadows on the same side as the building. Let everything dry completely.

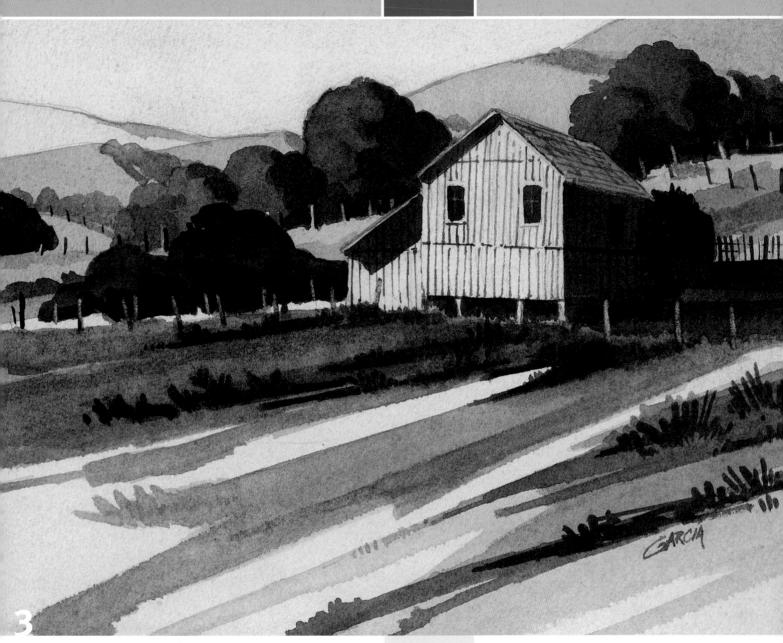

ROAD TO MENDOCINO Joe Garcia 6" × 9" (15cm × 23cm)

3 | Add Texture

Finishing your painting is like adding frosting to the cake. Add the texture on the roof and face of the building. A no. 2 round will work well. Use the same brush to lift or scrub out some of the fence posts from the dark areas and add a few posts in the light areas. Now paint some of the grass texture in the foreground. Your painting is ready to be signed!

136 Finding Unexpected Solutions

I had a drawing on my desk and was getting ready to start the painting. As I turned to wet my brushes I knocked over my coffee. Because the contents spilled across the surface of my drawing, I had no choice but to take my largest flat brush and start my background wash. Two lessons were learned: I should keep my coffee off the table, and coffee is a great staining color!

GRADATED WASH **TIPS**
by Joe Garcia

137 Making a Beautiful Wash

The gradated wash is one of the basic techniques of watercolor painting. Learning to control this wash opens the door to many successful watercolor paintings. I will show you how to start with a rich brushstroke of color, and by diluting each successive brushstroke, create a beautiful gradated wash.

138 Tilt Your Painting Surface

Start your first gradated wash on dry paper. Your first stroke should have the strongest color you want to use. Before each additional stroke, dip your brush into clean water. This will dilute the pigment in your brush. Continue this technique to the bottom of the paper. The last stroke should be clear water. If the wash does not have an even flow, start the process over before it dries. Picking up your painting and tilting it back and forth or side to side will help eliminate unwanted texture.

139 Pick Up Excess Paint

It is important to clean the edge of your wash with a paper towel or tissue. This will eliminate water or color bleeding back into your painting. Use your brush to pick up excess paint along the edge of your wash.

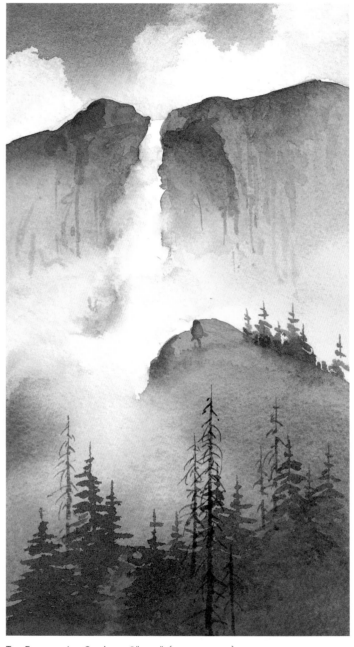

THE FALLS Joe Garcia 8" × 4" (20cm × 10cm)

140 TECHNIQUE
Practice the Gradated Wash

by Joe Garcia

The gradated wash should have a nice transition from dark to light. Start the wash on a dry surface, then try it on a wet surface. I find I have better success with a wet background when the painting is larger. After you have learned to control this first wash, try a second color going the opposite direction. This wash becomes a glaze and creates wonderful color variations.

Draw a number of 3" × 6" (8cm × 15cm) rectangles on 140-lb. (300gsm) cold-press Arches paper. 300-lb. (640gsm) Arches is great but is slower to dry. Tape off the rectangles. The tape will act as a barrier to your wash. Now you are ready to practice, practice, practice.

MATERIALS

PAPER 140-lb. (300gsm) cold-press Arches

PAINT Rose Madder

BRUSHES Flats | 1½-inch (38mm)

OTHER Drawing board | HB to 2B pencil | Masking tape | Palette | Paper towels or tissues | Ruler | Water

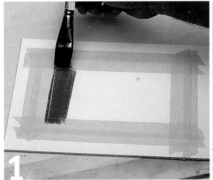 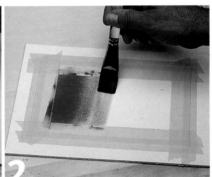 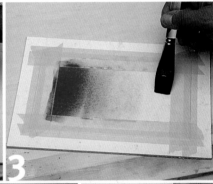

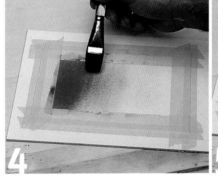 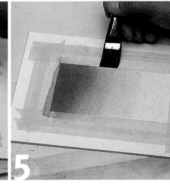

1 | Load the Brush

Load your brush with color. This first brushstroke will be the richest and strongest application of color.

2 | Dilute Your Brush

Quickly dip your brush into clean water. This will dilute the color in your next brushstroke.

3 | Pull Down the Wash

Continue to bring the wash to the bottom of the rectangle. With each stroke, dip your brush back into the water. When you reach the bottom of the wash, it should have little or no color.

4 | Rework the Wash

Look at the wash. Is the gradation gradual and even? If not, rework the wash by repeating the same strokes. Start at the bottom with clear water and work upward, adding more color as you go.

5 | Clean the Edges

This is really a continual step. Clean the edges of your painting by using a paper towel or tissue to soak up the excess water and color. If the paint of the wash beads up along the edge of the tape, use your brush to lift this excess color. Rinse and squeeze the extra moisture from your brush. This will soak up the bead of paint like a damp sponge.

TECHNIQUE
Master the Gradated Wash

by Joe Garcia

Gradated washes are a little more difficult to paint than the other washes, but once you have gained control over them, the world of watercolor begins to open up to you. As washes, they require more control and timing. You may start with dry or wet paper. In general, I find that starting with a dry background works more easily when the painting is small. The gradated wash is wonderful for still water, peaceful skies or mountain ranges moving into the foreground.

MATERIALS

PAPER 140-lb. (300gsm) cold-press Arches

PAINTS Alizarin Crimson | Brown Madder | Cobalt Blue | French Ultramarine Blue | New Gamboge | Winsor Green

BRUSHES Flats | 1½-inch (38mm) | 1-inch (25mm) | ¾-inch (19mm) | ½-inch (12mm) Rounds | *Nos. 2, 4, 6 and 8*

OTHER Craft knife or single-edge razor blade | Drawing board | HB to 2B pencil | Masking tape | Palette | Palette knife | Paper towels or tissues | Ruler | Water

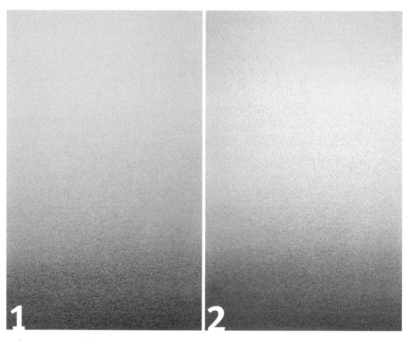

1 | Create Your Background

Use a mixture of French Ultramarine Blue, Cobalt Blue and Brown Madder on wet paper to create the background. The wet background dilutes the color, so start with more pigment in your first stroke. Begin at the bottom and work up, after each horizontal stroke add more water to your brush.

2 | Paint Your Second Wash

Start the second wash on dry paper using New Gamboge. Once again, with each stroke dip your brush into clean water, this time beginning at the top. As you reach the middle of the paper, the wash should be clear. Pick up your painting and tilt it back and forth and side to side to smooth out any brushstrokes.

STILL WATERS Joe Garcia 8" × 5" (20cm × 13cm)

3 | Finish Your Painting

The subject should be bold and strong in this painting. Use French Ultramarine Blue, Alizarin Crimson and Winsor Green for the dark silhouette. Add more color to brighten your subject. Next lift some of the water with a damp brush. The sparkle is achieved by scraping with the point of a craft knife or single-edge razor blade across the surface. Now stand back and decide how you want to frame your painting.

WET-INTO-WET WASH **TIPS**
by Joe Garcia

142

The Most Versatile Wash
The wet-into-wet wash is the most versatile of washes in watercolor. This wash is what comes to mind when I think of loose, flowing, spontaneous watercolors. While flat, gradated and streaked washes all have specific characteristics, the wet-into-wet wash may incorporate all of these characteristics. For example, two gradated washes running into each other may be thought of as wet-into-wet.

143

Be Creative
The wet-into-wet wash should have a nice transition from one color to another. How gradual the transition will depend on the amount of moisture on the surface and if the wash is tilted back and forth and side to side. This is where spontaneity and creativity come into play. Experiment and see what you come up with.

CACTUS APPLES Joe Garcia 8" × 4" (20cm × 10cm)

144 TECHNIQUE
Practice the Wet-Into-Wet Wash
by Joe Garcia

I generally start my wash with the paper totally saturated with water. I may cover the wash area two or three times to make sure it is totally soaked. I closely study the surface of the wet paper. If it is shiny I know it's very wet. If the surface is dull or soft looking it is beginning to dry. The amount of moisture on the surface will greatly influence how the wash works. A very wet surface causes the pigments to flow freely. A damp surface causes the pigments to gently blend. To accentuate the wash, pick up the drawing board and tilt it back and forth and side to side.

Draw a number of 3" × 6" (8cm × 15cm) rectangles on 140-lb. (300gsm) cold-press Arches paper. Tape off the rectangles. The tape will act as a barrier to your wash.

Keep the edges clean as you practice. Do some washes on a very wet surface, then try some on a damp surface. Study the differences. Now imagine how these washes can be used in a painting.

MATERIALS

PAPER 140-lb. (300gsm) cold-press Arches

PAINTS Alizarin Crimson | Cobalt Blue

BRUSHES Flats | 1½-inch (38mm)

OTHER Drawing board | HB to 2B pencil | Masking tape | Palette | Paper towels or tissues | Ruler | Water

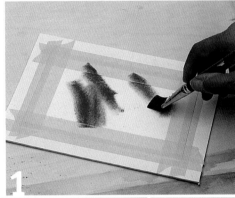

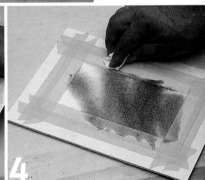

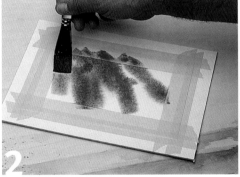

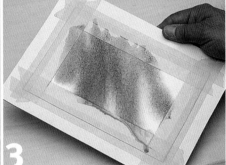

1 | Apply Your First Wash

Wet the paper thoroughly. Clean the edges of excess water. Use Cobalt Blue for the first color. Apply the pigment but leave room for additional colors to be added. Check the surface of the paper. Is it very wet or just damp? This will influence how the second color reacts in the wash.

2 | Add the Second Color

Use Alizarin Crimson for the second color, adding it as soon as possible.

3 | Blend the Pigments

The pigments will now start to flow together because of the wet surface. Pick up the drawing board and let gravity accentuate the flow, or leave the board flat to let the wash dry on its own. Once you are satisfied with the wash, allow it to dry thoroughly.

Personally, I prefer not to use a hair dryer for drying. I have found that the force of the air from a hair dryer moves the moisture on the surface, therefore not allowing the surface to dry evenly.

4 | Clean Your Edges

Clean the edges of the wash or painting. Excess moisture can run back into the painting, creating an unwanted texture.

145 TECHNIQUE
Master the Wet-Into-Wet Wash
by Joe Garcia

Wet-into-wet washes are exciting to paint. You make decisions such as how wet you want the paper, how much pigment and water to load into the brush, and how much to allow the colors to run together. The textures, the blending of color and the spontaneity of a wet-into-wet wash never lets watercolor painting become boring. I like to call these washes controlled accidents. I wait expectantly for the results, never sure exactly what is going to happen. Wet-into-wet washes are wonderful for sunset skies or misty forests. This wash can be used for subjects where the colors and textures gently blend together. This is your chance to loosen up and let the paper and color do the work for you!

MATERIALS

PAPER 140-lb. (300gsm) cold-press Arches

PAINTS Alizarin Crimson | Aureolin Yellow | Cobalt Blue | Scarlet Lake

BRUSHES Flats | *1½-inch (38mm)* | *1-inch (25mm)* | *¾-inch (19mm)* | *½-inch (12mm)* | Rounds | *Nos. 2, 4, 6 and 8*

OTHER Drawing board | HB to 2B pencil | Masking tape | Palette | Palette knife | Paper towels or tissues | Water

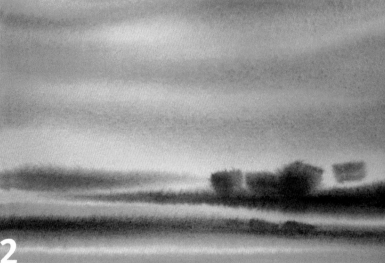

1 | Soak Your Paper and Apply Color

Saturate the paper with clean water. You may need to brush water two or three times onto the paper to soak it evenly. This allows the wash to dry evenly. When the surface of the paper has a shine, apply the first brushstrokes of color. The shine means your paper is very wet and will allow your colors to run or flow freely. Use Aureolin Yellow and Scarlet Lake for the warm colors, and Cobalt Blue for the cool colors. Pick up the drawing board and tilt it back and forth and side to side to help the blending.

2 | Apply the Second Wash

Mix the dark value of Cobalt Blue and Alizarin Crimson on your palette for the second wash. It is important to remember that the surface of the paper is damp and will dilute the pigment. Look closely at the paper. If it looks soft, it is beginning to dry, so this dark second wash will not flow freely. At this stage, timing and practice are important for success. If the paper is too wet, the dark wash will float away; if it is too dry you will have hard-edged brushstrokes.

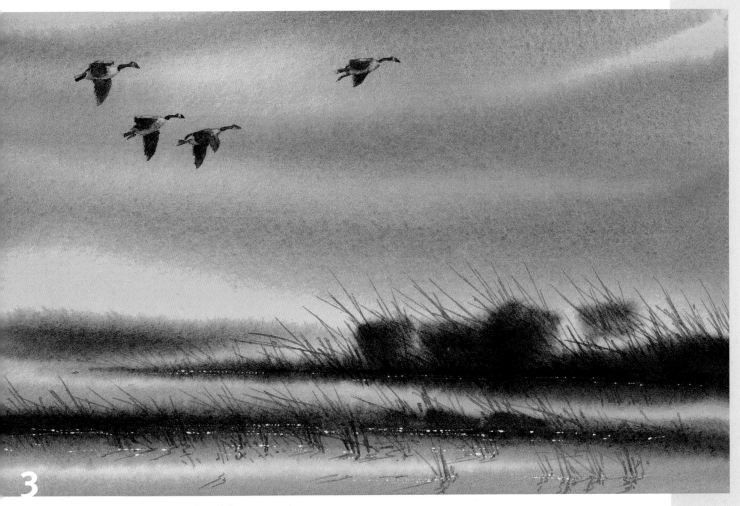

EVENING ARRIVAL Joe Garcia 5" × 8" (13cm × 20cm)

3 | Finish Your Painting

Look at your painting and critique what you have done to this point. The background should be very soft and have that wet-into-wet feel. The midground should be darker in value with a soft blending of color. This value change helps bring the dark area forward. Use a wash of Cobalt Blue and Alizarin Crimson for this dark area. Use the same color to paint the reeds and Canadian geese. Lift out a little color from the shoulder and chest of the birds by gently rubbing the area with a damp brush. Touch the area with a paper towel or tissue and the color will lift. Sign your finished painting. Place your signature in an area that does not disturb the composition of the painting.

TIPS FOR USING THE STREAKED WASH
by Joe Garcia

146 Learn Control and Timing

Practicing a streaked wash teaches you control and timing. A streaked wash has a very definite direction of flow. This direction often becomes an important part of the composition of the painting. The flow or texture may be used to lead the viewer through the painting or to highlight or accent the main subject.

147 Use an Underpainting for Textures

The streaked wash may also be the underpainting for textures. This wash also could be called wet-into-wet or gradated, depending on how it is applied to the surface of the paper. The texture created by the directional flow is what determines its name.

148 Make a Pencil Sketch

Learning to paint a streaked wash would seem quite easy. Just wet your paper, brush a few strokes of color on and let it run. If only it was that simple! Before you start your painting you must have a mental image of how you will use the wash. A small pencil sketch may help.

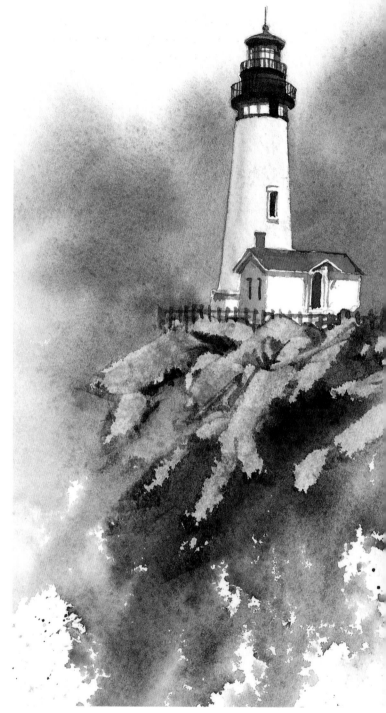

LIGHTHOUSE Joe Garcia 4" × 7" (10cm × 18cm)

149 TECHNIQUE
Practice the Streaked Wash

by Joe Garcia

Back to the prepared rectangles. The 3" × 6" (8cm × 15cm) area is easy to control, but you may use any size. Many artists are not comfortable painting small, even when practicing. Use 140-lb. (300gsm) cold-press Arches paper. The 300-lb. (640gsm) paper stays wet too long. Remember to keep the edges clean. An important distinction between the streaked wash and a wet-into-wet wash is mixing the colors on the palette. With the wet-into-wet wash, the colors are mixed or allowed to run together on the paper.

Cover the wash area three or four times with clean water. This will assure complete saturation. Mix a wash of Olive Green paint on the palette. Practice the streaked wash to develop control and timing. Learning how to use the correct amount of moisture on the surface of the painting is essential to a successful watercolor painting.

1 | Apply Pigment to the Wet Paper

Wet the surface of the paper using clean water. Use the largest brush possible to apply the color.

2 | Tilt the Paper

Pick up your drawing board and tilt it. Allow the wash to run in the desired direction. Soak up the excess paint and water on the outside edge of the wash. Set the wash on a flat surface and allow it to dry.

3 | Add More Color

This is an optional step. If you would like to add an additional or a second color, try this step. With a spray bottle that has a fine mist, evenly spray the painting. Check to see how much water is now on the surface. Add the additional color and tilt the painting again. This second wash should disappear into the initial wash.

4 | Continue Developing Your Composition

The streaked wash should have an obvious direction of flow. This wash can be used to develop composition and movement in a painting. As always, timing and control are essential in the success of this wash. Remember, practice makes perfect.

MATERIALS

PAPER 140-lb. (300gsm) cold-press Arches

PAINT Olive Green

BRUSHES Flats | *1½-inch (38mm)*

OTHER Drawing board | HB to 2B pencil | Masking tape | Palette | Paper towels or tissues | Ruler | Spray bottle with a fine mist (optional) | Water

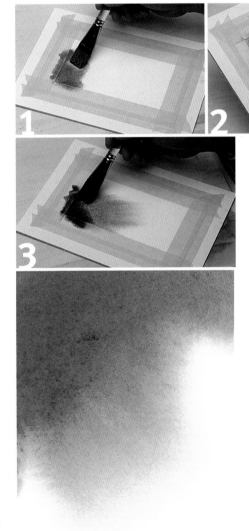

4

150 TECHNIQUE
Master the Streaked Wash

by Joe Garcia

The benefits of mastering a streaked wash are learning more than the control of wetness, paint saturation and drying time—you can begin to use the wash as part of the composition and design of the painting. The spontaneity and freshness is still there, but an added dimension is brought into the picture. The streaked wash gives you one more tool to meet this challenge. Streaked washes are great for skies, rain, clouds and vignettes. Grab your brush, wet your paper, apply a couple of brushstrokes, and let's see what happens!

MATERIALS

PAPER 140-lb. (300gsm) cold-press Arches

PAINTS Brown Madder | Cobalt Blue | French Ultramarine Blue | Viridian

BRUSHES Flats | *1½-inch (38mm)* | *1-inch (25mm)* | *¾-inch (19mm)* | *½-inch (12mm)*
Rounds | *Nos. 2, 4, 6 and 8*

OTHER Drawing board | Masking fluid | Masking tape | Old synthetic brush | Palette | Paper towels or tissues | Spray bottle with a fine mist | Rubber cement pickup | Ruler | Water

1

2

3

1 | Prepare Your Wash

Sky and water are perfect subjects for this wash. Complete your drawing first. Use a masking fluid to save the white areas of the sail and boat. Allow the masking agent to dry thoroughly. Now soak the surface with clean water.

2 | Apply the Wash

When you are satisfied that the paper is saturated, add the wash. For this lesson, mix large puddles of paint on the palette. Use Viridian and Cobalt Blue for the sky. Add French Ultramarine and Brown Madder to the puddle before you paint the wash behind the boat and sails.

Check the surface of the painting for water content. If it is drying too quickly use the spray bottle to add moisture.

3 | Tilt the Paper

Pick up your painting and tilt it in the direction you want the wash to run. When you are satisfied with the wash, lay it flat and allow it to dry completely. Now remove the masking agent using a rubber cement pickup.

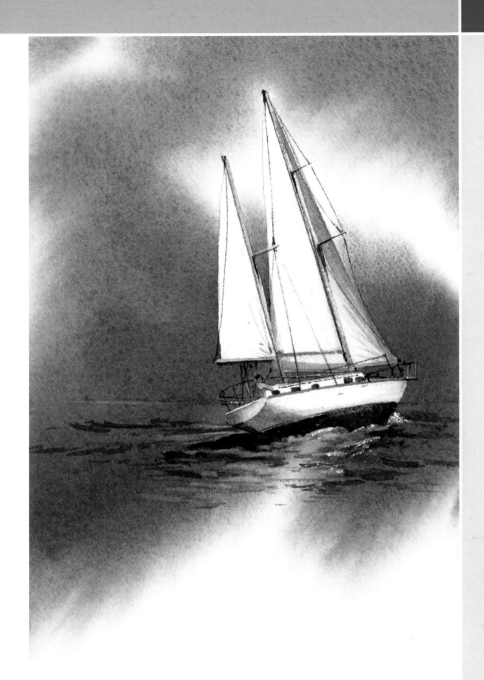

4

INTO THE WIND Joe Garcia 5" × 8" (13cm × 20cm)

4 | Finish Your Painting

Add Brown Madder to the background color mixture to paint the shadows on the boat and sails. Lift out color on the water to indicate the horizon and swells. Add the small details to the subject and your painting is finished.

WASH **SOLUTIONS**
by Mark Willenbrink

So you've been practicing, and your wash just didn't turn out like you thought it would. Here are some pitfalls artists often fall into. Once you've identified the problem, keep practicing until you learn to prevent it.

151 Preventing Unwanted Streaks and Lines

Unwanted streaks and lines appear if you try to cover a large area with a brush that is too small. Work quickly with as large a brush as possible so the wash won't start to dry before you're finished.

152 Preventing Unevenly Dried Paint

Starting in the middle of the area you want to cover makes your job harder than it has to be. The paint on the outer edge starts to dry before the paint in the middle. If you overlap the edge with a stroke of wet paint, the edge of the first stroke will show. Each area should dry at the same time. Start at a corner and work outward so you won't have to overlap old strokes.

153 Eliminating Watermarks From Backruns

Puddles of excess fluid left at the edges of a wash can run back into the area starting to dry and cause watermarks. Touch the tip of a dry brush (sometimes called a thirsty brush) to the puddle while the paper is still wet to lift the extra fluid from the paper. Dry the brush with a rag and repeat as many times as necessary. Be careful not to smear any paint that has begun to settle.

154 Avoiding Paint Smears

Watercolors are not like oils or acrylics. Brushing the paint once it begins to settle can smear the paint. Once watercolor paint starts to dry, it's out of your hands. Don't overwork it.

155 Preventing Problems With Your Second Wash

Applying another wash before the previous one has dried may smear or repel the color from the first wash. Make sure each wash is completely dry before starting another one.

156 Preventing UFO Invasions

"Unwanted Foreign Objects" such as dust, lint, cat hair and oil from fingerprints cause streaks and spots if they end up in your wash before it dries. Make sure anything that comes in contact with the paper, such as paint, a rag or brushes, is clean before you use it, and don't handle the surface of the paper any more than you have to.

Preventing Unwanted Streaks and Lines

Preventing Unevenly Dried Paint

Eliminating Watermarks From Backruns

Avoiding Paint Smears

Preventing Problems With Your Second Wash

Preventing UFO Invasions

POSITIVE AND NEGATIVE PAINTING **TECHNIQUES**
by Mark Willenbrink

Negative painting

Positive painting

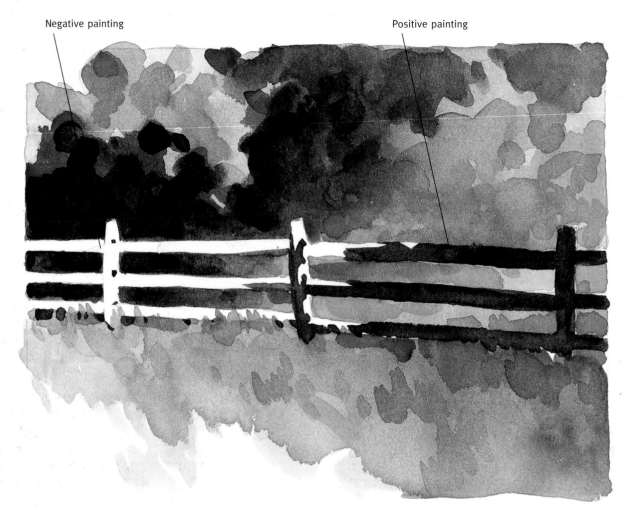

157 Plan Ahead

Negative painting is an easy technique to learn when painting with watercolors; you just need to plan ahead. You might paint the negative space of an object around a white area or over a previous wash of color. It's easy to plan what areas to leave untouched if indicating a white object, such as white water in rapids. I like to imply the shapes of daisies on a dark background using negative painting.

Use negative painting as a way to present an ordinary image in a unique way. Take the challenge of painting an object that is normally brown, such as a fence, by leaving the fence white and painting the shapes around it. With this technique, you can make a dull, drab fence into an interesting part of your composition.

158 Imply Shapes

Positive painting simply means painting the object. In contrast, negative painting implies an image by painting the shapes around it. To paint a fence using negative painting, for instance, you'd leave the white of the paper for the fence and define the fence's shape by painting the colors of the foliage behind it. To paint the fence positively, the brushstrokes themselves should indicate the fence posts and rails. Carefully plan your composition before painting negatively. Draw all of the shapes in lightly, then paint around the object, only implying its shape.

159 TECHNIQUE
Master Positive Painting
by Mark Willenbrink

This demonstration provides an easy, fun way to make graceful, interesting trees using the positive painting technique. Trees are beautiful to paint, and each one has its own character. A tree can add to the composition of an outdoor scene or stand alone in its own painting.

I chose to paint the trees void of leaves as stark silhouettes against a flaming sunset. I love to paint trees during all four seasons because each season seems to bring out a different aspect of trees. These trees are set in autumn. The analogous warm colors of the background contrast with the stark, cold feeling of the tree. I also angled the wet-on-wet background strokes to add interest.

MATERIALS

PAPER 12" × 16" (30cm × 41cm) 300-lb. (640gsm) cold-press watercolor paper

PAINTS Alizarin Crimson | Cadmium Orange | Cadmium Red | Cadmium Yellow (professional grade) | Cerulean Blue | Prussian Blue

BRUSHES Rounds | *Nos. 2, 6 and 10* | *3-inch (76mm) hake* | *Large bamboo brush*

OTHER Spray bottle | Pencil

DEMONSTRATION **TIPS**

160 Be Prepared
The paper will need to be wet for steps 1 through 4. Make sure you have all of your supplies at hand, and be ready to work quickly.

161 Save Time
Use a large brush to apply the wet-into-wet washes to save time.

162 Anticipate Color Changes
After you've finished laying down your wet-into-wet washes and the paint has dried, you'll notice that the colors have become much more muted. After gaining some experience, you'll learn to anticipate and plan for these changes.

163 Create Interest
Draw the trunks of the trees first, then all the large limbs, the medium-size branches next, then the smallest ones. This yields a more natural, pleasing composition. Placing the tree trunks to the side of the painting and overlapping the branches also aids the composition, creating interesting negative space and making the trees look more natural.

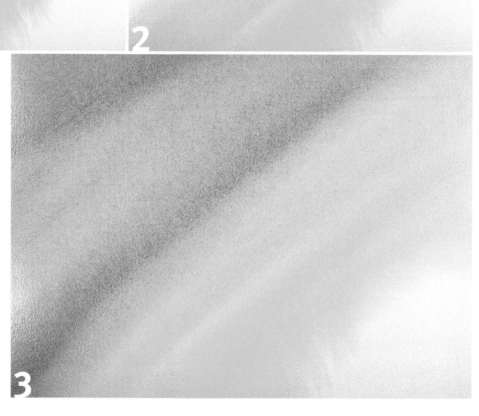

1 | Begin the Background

Because you'll be painting the first four steps wet-into-wet, you'll need to work quickly before the paper or paint starts to dry. Make the following mixtures of paint and water before wetting your paper: Cadmium Yellow, Cadmium Orange, Cadmium Red, and a purple mixture of Alizarin Crimson and Cerulean Blue.

Now wet down the paper with water from a spray bottle, and even it out with a 3-inch (76mm) hake brush so the paper is covered with an even sheen of water. Try to avoid puddles of water. Apply angled streaks of Cadmium Yellow with a 3-inch (76mm) hake brush.

2 | Add the Orange

Add Cadmium Orange with a 3-inch (76mm) hake brush using the same angled strokes. Once the colors have dried, notice how similar the orange and yellow appear. Colors are more vivid when the paint is wet. Keep that in mind as you paint.

3 | Add the Red

Add Cadmium Red.

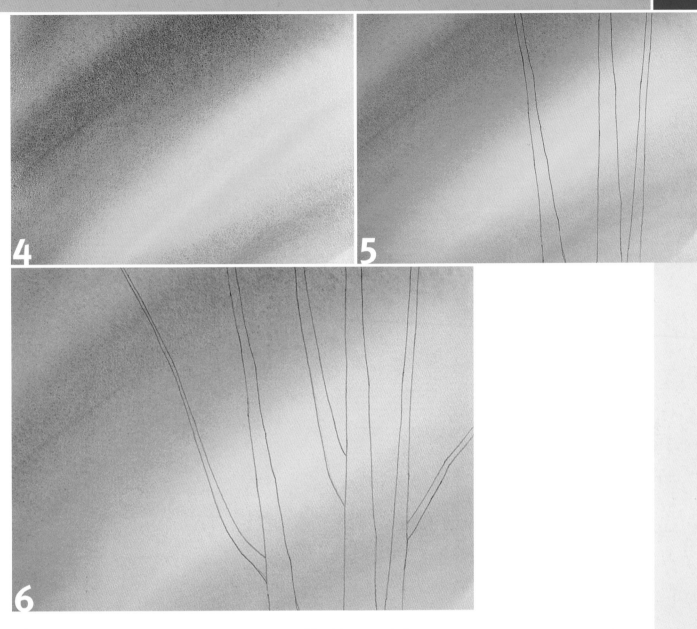

4 | Add Some Interest

Add the purple color that you mixed from Alizarin Crimson and Cerulean Blue with a 3-inch (76mm) hake brush. Then sit back and take a deep breath. You've finished the wet-into-wet part of the painting.

5 | Draw the Trees

After the paint has dried, lightly draw the thickest parts of the trees. Sometimes it's hard to erase pencil lines after you lay a wash of paint over them, so it's easier to draw the structure of the tree over the background washes. Notice that each tree is thicker at the bottom and thinner at the top.

6 | Add Some Limbs

Add limbs, again making sure they taper as they grow away from the trunks.

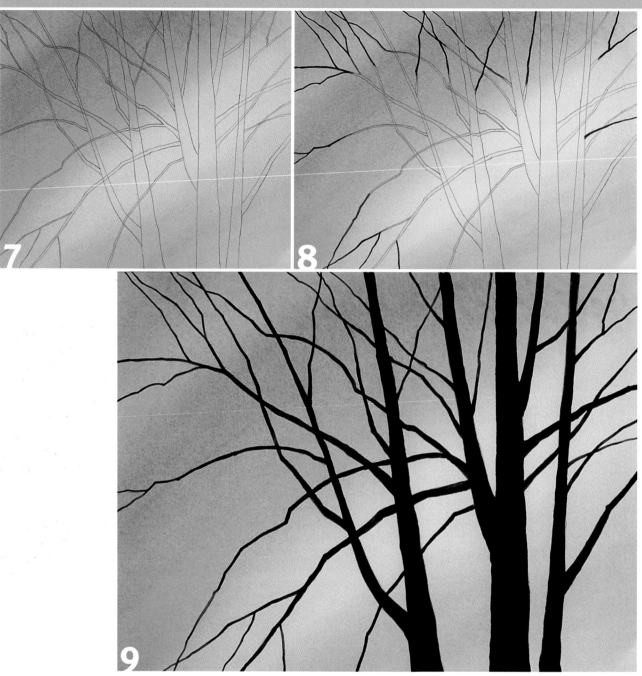

AUTUMN SUNSET Mark Willenbrink 11" × 14" (28cm × 36cm)

7 | Finish the Structural Drawing

Add the rest of the branches.

8 | Paint the Smallest Branches

Paint the thinnest branches with a no. 2 round and a dark mixture of Prussian Blue with a slight amount of Alizarin Crimson.

9 | Finish the Trees

Paint the medium-size branches with a no. 6 round, the largest branches with a no. 10 round and the trunks with a bamboo brush. When the paint has dried completely, erase any visible pencil lines and sign and date the painting.

164 TECHNIQUE
Master Negative Painting
by Mark Willenbrink

Painting around an object to imply its shape is a pleasant change of pace. If you enjoy doing this painting, try to incorporate negative painting into a composition of your own. Whether you use it in most of your paintings, some of them or just as a creativity exercise, negative painting enhances your composition skills and techniques. I used hot-press paper for this painting because the sharp, clean edges that result work well with the subject matter.

Remember: You don't need a bad attitude to produce a negative painting!

MATERIALS

PAPER 7" × 10" (18cm × 25cm) 140-lb. (300gsm) hot-press watercolor paper

PAINTS Burnt Sienna | Prussian Blue | Yellow Ochre

BRUSHES Rounds | *Nos. 2, 6 and 10*

OTHER Table salt | Palette | Paper towels or tissues | Ruler

DEMONSTRATION **TIPS**

165 Try Working Small
For a beginner, negative painting can seem intimidating and time-consuming. Try working small when you are learning the technique.

166 Use the Right Brushes
This demonstration requires detail painting. Make sure you're using brushes that form good points.

167 Practice the Salt Technique First
Practice dropping salt into wet washes on a scrap piece of paper before trying it on your painting. Dropping salt into paint that is too dry, too wet or too thick will have little effect. Be patient; the results may be most noticeable once the paint and salt are almost dry. But don't use a hair dryer to make this part of the painting dry more quickly; it will block the salt's effect.

168 Be Careful When Layering
If you're painting over another color, let the paint dry before moving on to the next step. If you're not careful, the colors will bleed and you won't have a tree anymore.

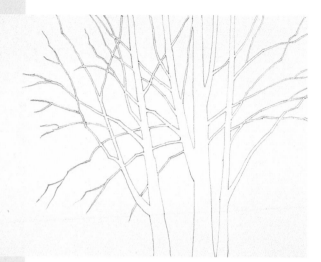

Avoid Large, Unbroken Spaces

Don't draw your trees like this. Instead, continue the branches beyond the image area. The branches on the left of this image end within the dimensions of the painting. I would have to paint the entire area on the left at once, which might leave unwanted lines if I paint over an area that has already started to dry. Instead, plan medium-size, easy-to-paint areas in the drawing stage. The drawing in step 1 (below, left) provides an easier guide to follow as you lay paint down.

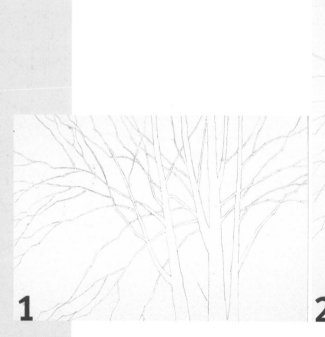

1

2

1 | Draw the Structure

Draw the trees as you did in the previous demonstration, starting with the thickest parts and moving on to the thin, tapered branches.

2 | Paint the Trees

Make separate pale mixtures of Prussian Blue, Burnt Sienna and Yellow Ochre. To make a pale mixture, touch the paint with the very tip of your brush and put the paint on the palette. Add enough water to make a good-size puddle. With so much water and so little paint, the mixture should be a very light value. Paint the trees with a no. 6 round, starting with blue at the bottom, fading up to a warm, light brown, then to the Yellow Ochre and finally to the white of the paper. The trees should be mostly white with just a bit of color.

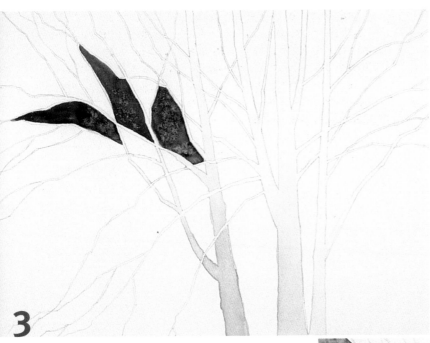

3

3 | Begin the Background and Add Salt

Make a variegated mixture of Prussian Blue and Burnt Sienna on your palette so you can pick up a variety of these two colors as you paint. Wipe other puddles of color off your palette. Make a large, dark mixture of Burnt Sienna at the bottom and another large, dark mixture of Prussian Blue at the top of your palette. Blend the two colors in the middle. Begin to paint in the background around the trees with the no. 6 and no. 10 round brushes. Because the tree trunks will draw the viewer's attention to the right, balance the composition by concentrating the strongest contrasting values, especially the dark blue, on the left. You'll notice that the background uses darker values of the same colors used to accent the trees. After painting a few segments of the background, drop salt into the wet paint to add more texture.

4 | Add Yellow Ochre to the Mix

To bring in some of the yellow from the trees, add Yellow Ochre to the middle of the variegated mixture on your palette and continue painting the background. Add salt as you go.

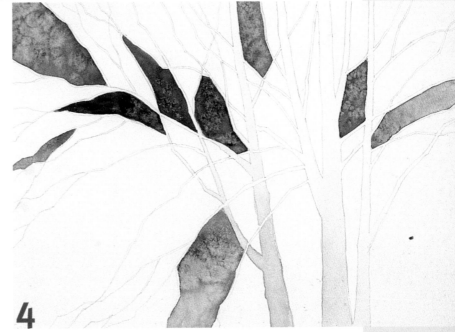

4

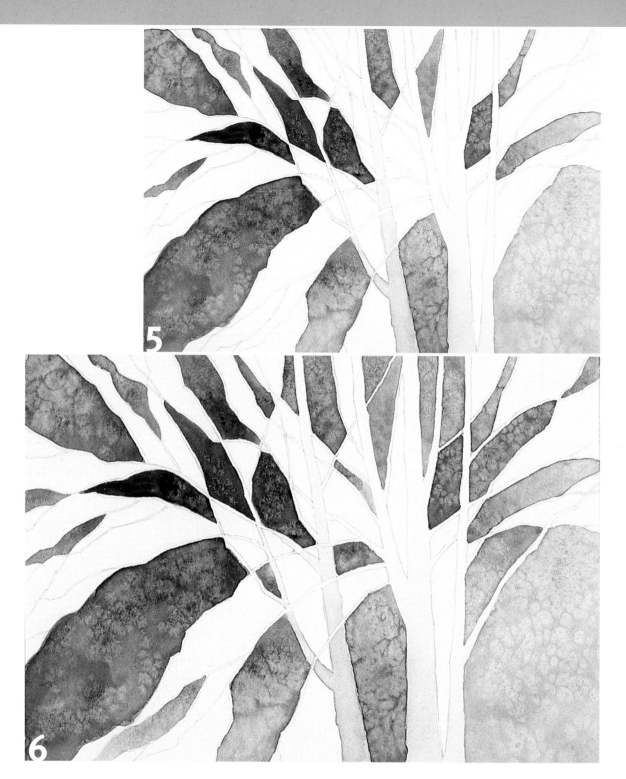

5 | Don't Rush

Continue painting the background just a little at a time so you have control over the paint. Take your time adding salt to get the right effect. Don't rush yourself.

6 | Continue Painting the Background

Paint a few more pieces of the background and add salt.

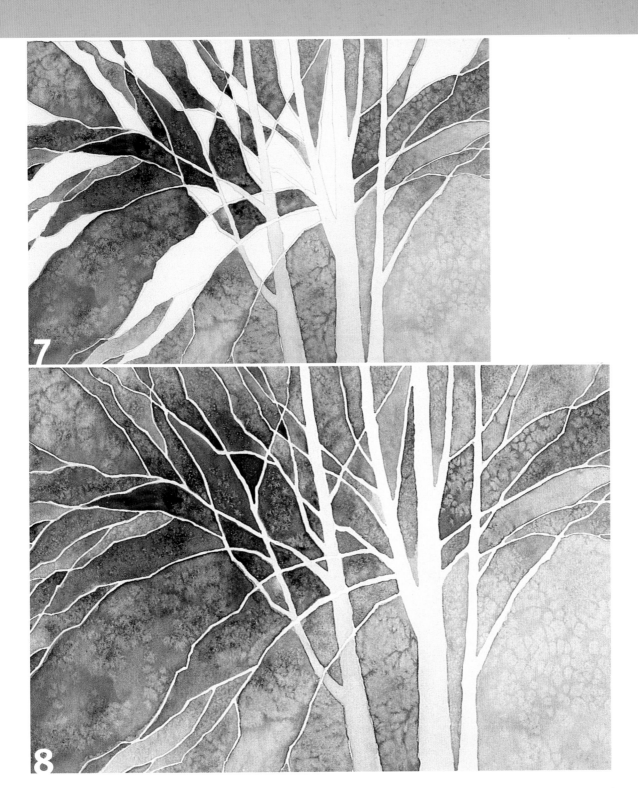

7 | Paint the Details

Once you've painted the bigger parts of the background, concentrate on the smaller, more detailed areas with a no. 2 round. Don't forget to keep adding salt.

8 | Add the Missing Pieces

Finish painting the background with the no. 2 and no. 6 rounds as if you were adding the last few pieces of a jigsaw puzzle.

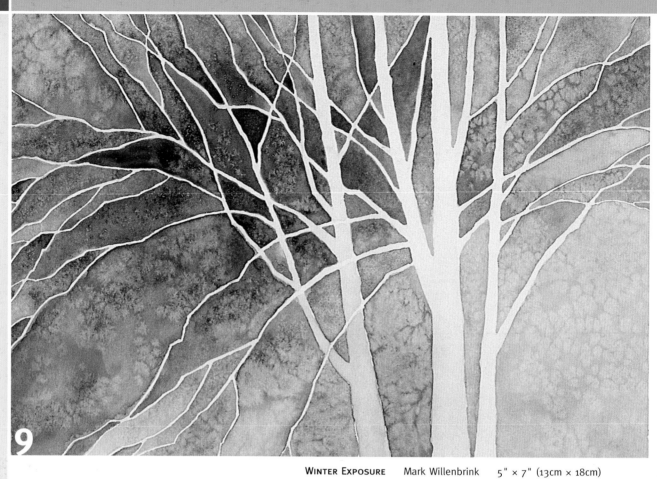

9

WINTER EXPOSURE Mark Willenbrink 5" × 7" (13cm × 18cm)

9 | Finish Your Painting

After I filled in the background and the paint
dried, I stepped back to evaluate the painting. I
decided to darken some of the background areas.
When everything is dry, brush away the remaining
salt and erase your pencil lines carefully. Sign and
date your painting.

3 COLOR ANSWERS

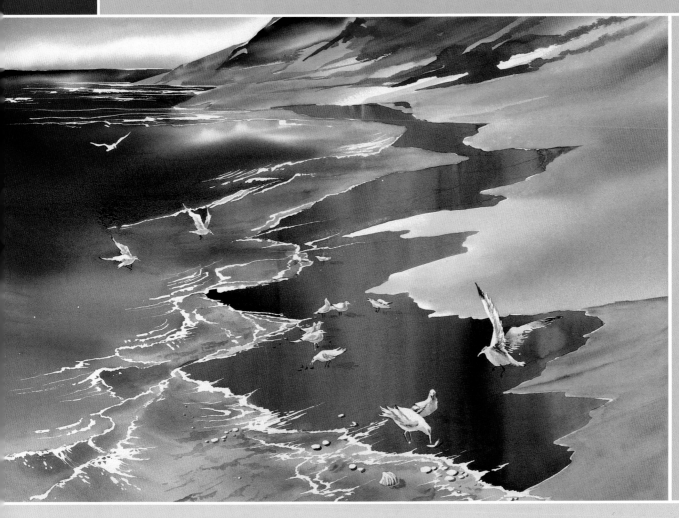

> " *Color has great impact,*
> *and you have the choice to either shout or whisper it.* "
>
> — Penny Soto

BEACHCOMBERS Jan Fabian Wallake 20" × 28" (51cm × 71cm) Collection of the artist

A COLOR **SOLUTION**

by Linda Stevens Moyer

Seeing Color

Sight is the most important possession that an artist has. As we use the gift of sight, our perceptual abilities increase. My vision has changed and become more acute over the years: I now notice light phenomena that I was unaware of even ten years ago.

As a young artist, I listened to other artists discuss the quality of light and how it differed between various locations. It disturbed me that I wasn't able to visually distinguish what others seemed to take for granted. One morning, I awoke and looked through the bedroom into the bathroom where my husband had left the light on. It was an epiphany for me to recognize that the color of the natural light coming in through the window in the bedroom was a very different color from the incandescent light in the bathroom. From that moment on, I was much more aware of the different colors and qualities of light in various situations.

Artist Wayne Thiebaud has always been a hero of mine. I love the way he uses color in his painting. For many years, I thought that he was just being marvelously inventive with color. In a number of his works you will see a thin red-orange line on one side of the painted objects and possibly a blue-green line on the opposite side. The color vibrations that result when these colors interact with the colors of the objects are wonderful.

Eventually, I began to see these colors on the edges of real objects in strong sunlight. With a little research, I discovered that this phenomenon is called *halation*. When an object is placed in a strong, direct light you may see a thin red-orange line on the side nearest the light source. There may be a line of the opposing color (blue-green) on the opposite side. This has been explained in various books as a manifestation of how our eyes work. Because our eyes are binocular and because it is impossible to hold our eyes completely still when we are looking at an object, the edges are fuzzy. This is true, but I also believe that it is due to the refraction of light as it encounters the edges of the object. The light is separated into different wavelengths, much like when light enters a prism and becomes fragmented as it leaves the opposite side. The phenomenon of halation may be seen in photos as well as with the naked eye.

Because halation occurs naturally in light and because representing light is one of my obsessions, I put it into my work whenever I see it. Seeing color works in the same way. The more you use your eyes and the more you look for a particular color in your still life, landscape or any subject, the more of that color you will see. The more you exercise your sense of sight, the more color will become apparent to you. And you will find that as you see more color, you will put more color into your work.

Halation

If you look closely you can see a thin red-orange line on the edges of some of the forms. This halation is one of the phenomena that occurs when an object is in strong light.

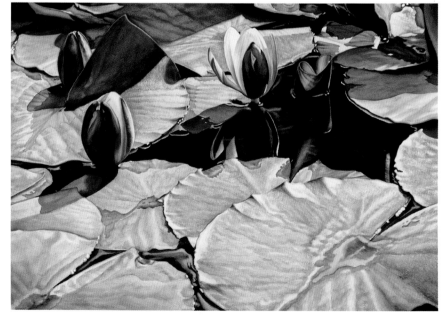

HAIKU NO. 3 Linda Stevens Moyer 29" × 42" (74cm × 107cm) Collection of Martha Bonzi Photograph by Gene Ogami

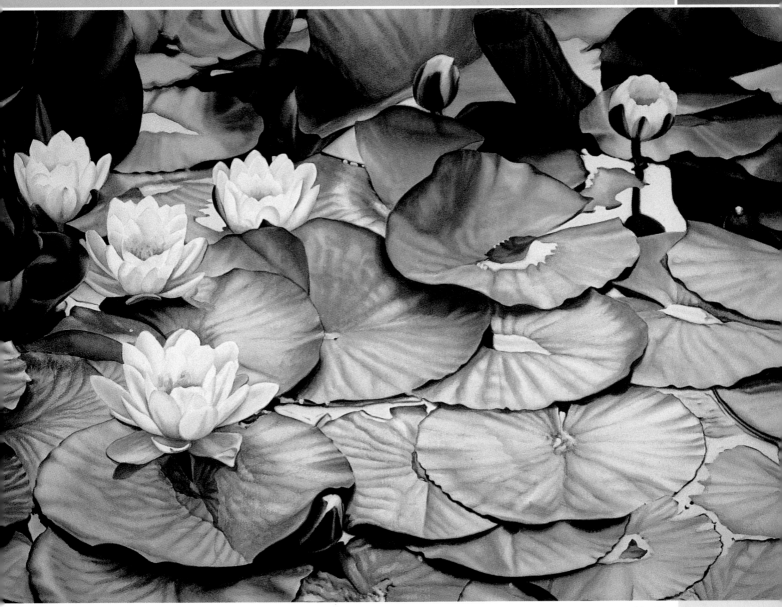

HAIKU NO. 16 Linda Stevens Moyer 29" × 42" (74cm × 107cm) Collection of Mrs. Beverly Leggett

Notice the *halation*, the thin red-orange line on the right side of some of the forms. The light is coming from the right in this painting.

Detail

BASIC COLOR **TIPS**
by Pat Weaver

Color can be simple or it can be very complicated. There are many formulas for mixing and so many terms that it becomes overwhelming. So, let's see if we can simplify things for you and start off rather basic.

170 Know the Primaries

Let's start with the three primary colors of red, yellow and blue. You cannot make any of the primary colors, nor can you make white. All other existing colors are made from the various hues of red, yellow and blue. Without these three colors, it is impossible to create orange, green and violet, commonly referred to as the secondary colors. The three primaries are also needed to make all the grayed or tertiary colors.

171 Experimenting is Essential

Experimenting with the mixing of the primary and secondary colors is essential to training your eye and being able to quickly mix any color required for your painting. When you start creating color charts, you will quickly learn what it takes to make all the other colors.

172 Create Secondary Colors

The primary colors are red, yellow and blue. When you combine any two primary colors you create a secondary color. Mixing yellow and red produces orange, mixing yellow with blue creates green and combining a cool red with blue creates violet.

HELPFUL COLOR TERMS
Familiarize yourself with the following terms.

Complementary Colors: any pair of contrasting colors that, when mixed in the right proportions, create a neutral gray

Earth Colors: permanent, low-priced pigments found in most parts of the world

Hue: the name of a color

Intensity: the strength and purity of a color, usually as compared with gray

Local Color: actual, true surface color of an object

Opacity: the quality of not allowing light to pass through an object or material; the opposite of transparency

Primary Colors: the three colors that cannot be created by mixing other colors; yellow, red and blue

Secondary Colors: any one of the three colors created by mixing two of the primary colors; green, orange and violet

Intermediary Colors: mixed colors that fall between a primary and secondary color on the color wheel

Tertiary Colors: grayed colors obtained by mixing the three primaries together or any two secondaries

Tint: a color lightened by adding water

Tone: most often refers to the value of a color

Shade: a color darkened by introducing a darker color from the same family, the complement or the color black

Value: the relationship of any color to the lightest color, or white (referred to as value no. 1) , and the darkest color, or black (referred to as value no. 9)

Wash: a transparent coat or layer of color mixed with water

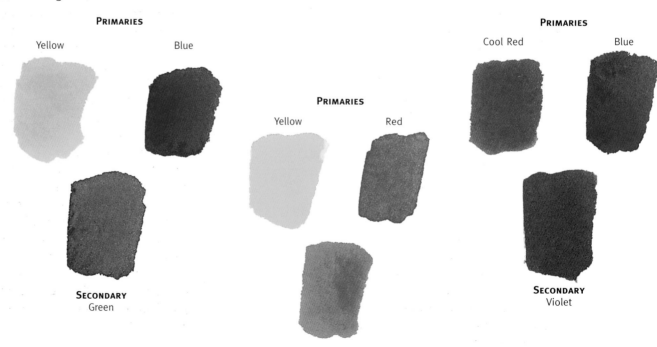

PRIMARIES

Yellow Blue

PRIMARIES

Yellow Red

PRIMARIES

Cool Red Blue

SECONDARY
Green

SECONDARY
Orange

SECONDARY
Violet

COLOR WHEEL **TIPS**

by Pat Weaver

I often ask students who attend my workshop for the first time if they know the color wheel. A few say "yes." Then I ask, "Right side up, upside down and in your sleep?" The answer then becomes a resounding "no." Before painting with color, you should learn the color wheel. It's really very simple.

If you go to the art supply store and stand in front of the racks looking at tubes of paint, you'll soon realize that there are many different hues of red, yellow, blue (the primary colors) and green, violet and orange (the secondary colors).

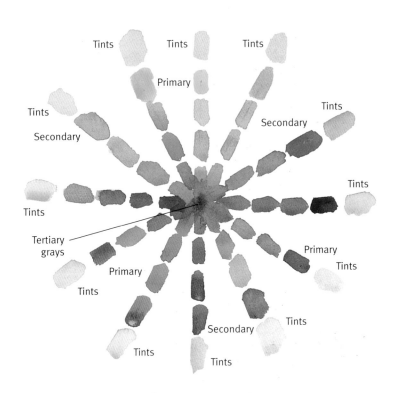

173 Which Are Tertiary Colors?

In addition to the primary and secondary colors, there are the tertiary or earth colors: Burnt Sienna, Burnt Umber, Cobalt Violet, Indigo, Raw Sienna, Raw Umber, Quinacridone Gold, Payne's Gray and Yellow Ochre. That leaves only black and white.

174 What Does *Tertiary* Mean?

There seem to be conflicting ideas as to the meaning of the term *tertiary*. *Webster's Dictionary* defines *tertiary* as third. I am a great admirer of artist Richard Schmid, who says this about tertiary colors in his book *Alla Prima: Everything I Know About Painting* (Stove Prairie Press: Longmont, CO, 1998): "The Tertiary Color Families—all three primary colors mixed together. All the grays, browns and earth colors." Ralph Fabri believes that "any two secondary colors mixed together form a tertiary color. A tertiary color may be reddish brown, which would include the yellows, or bluish brown, which would include the violets." For example, when you mix orange and green, you actually mix yellow and red with yellow and blue. That would be two parts yellow, one part red, and one part blue.

175 Tertiary vs. Intermediary

You will often see books refer to tertiaries as yellow-green, green-yellow, etc. Instead, I consider these to be intermediary colors, because they fall between a primary and secondary color on the color wheel. Tertiaries are the mixture of all three primaries or two secondaries creating the color gray and are located in the center of the color wheel.

176 Figuring Out Tertiaries

This color wheel shows each primary, secondary and intermediary color and their tints, which are produced by adding water. When mixing each color with some of its complement (the opposite color on the wheel), the color becomes grayer, eventually becoming tertiary as it reaches the center of the wheel.

The colors on the outside row are tints of the primaries, intermediary and secondary colors, which are located in the second row from the outside. The third, fourth and fifth rows show what happens to a color when it is gradually mixed with its complement. For example, orange plus a touch of blue grays the orange down. Adding more blue neutralizes the color further, and even more blue takes it to gray at the center of the wheel. Another example is blue plus a touch of orange, which grays the blue. More orange begins to neutralize the blue and even more orange takes the color to gray, located in the middle of the wheel. This shows how any color becomes grayer and grayer once it has all three primaries introduced into it. This is how the tertiaries are made. Yellow plus red equals orange. Adding blue to the mix gives you all three primaries, which produces a tertiary (grayed) color.

COLOR TRIAD **TIPS**
by Pat Weaver

177 Learn to Make Endless Color Combinations

A triad is any equilateral grouping of three colors on the color wheel. When working with a primary triad, you can use different hues of red, blue and yellow to obtain endless possibilities of color combinations. For example, create a triad of Yellow Ochre, Cadmium Red Light and Ultramarine Blue. Yellow Ochre is a tertiary color created from yellow, red and blue. When mixed with Ultramarine Blue, it will create either a grayed yellow-green or a grayed blue-green. When mixed with Cadmium Red Light, Yellow Ochre will create a grayed yellow-orange or a grayed red-orange. Cadmium Red Light has yellow in it; therefore, when mixed with Ultramarine Blue, it creates a brownish gray or a bluish gray depending on which color is dominant. You won't be able to mix any clean violets with this particular palette.

178 Making a Clean Mix

If you want clean secondary violets or purples, choose a cool red such as Permanent Rose, Red Rose Deep or Opera to mix with any blue for satisfying results.

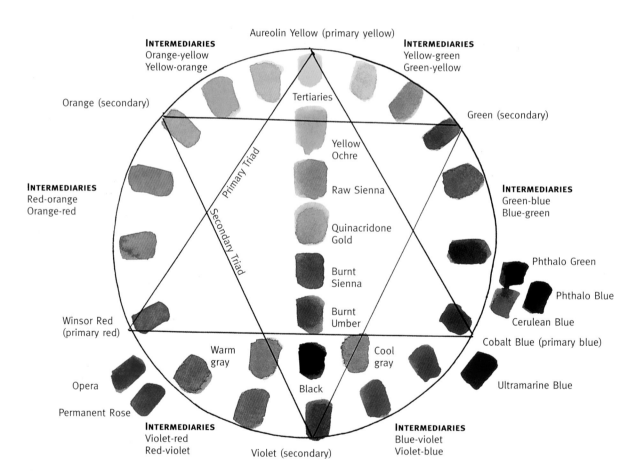

Create a Triad

You can create a triad on the color wheel by drawing an equilateral triangle between any three colors. Aureolin Yellow, Winsor Red and Cobalt Blue form the primary triad shown as the equilateral triangle with the point at the top. Orange, green and violet form a secondary triad shown as an equilateral triangle pointed down. You can rotate the triangle around the wheel and find two more triads: yellow-orange, blue-green and red-violet; and red-orange, yellow-green and blue-violet.

COMPLEMENTARY COLOR **TIPS**

by Pat Weaver

179 Opposites on the Color Wheel

Colors that are opposite one another on the color wheel are called complementary colors. When placed next to one another in a painting, they create tension and interest. Their energy and vibrance attracts the eye.

180 The Most Common Pairs

The most common pairs of complements are yellow and violet, blue and orange, and red and green. Some less obvious complements are yellow-green and red-violet, blue-green and red-orange, and blue-violet and yellow-orange. Use your color wheel to locate complementary colors to use in your paintings.

181 Match Up Your Complements

Any two colors that appear directly opposite each other on the color wheel are complements. When placed side by side they look great or they "complement" one another. Mixed together they cancel each other out and produce the tertiary color gray.

Green Yellow · Red Violet · Warm Gray · Cool Gray

Green · Red · Cool Gray · Warm Gray

Orange · Blue · Warm Gray · Cool Gray

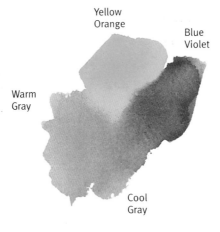

Yellow Orange · Blue Violet · Warm Gray · Cool Gray

Yellow · Violet · Warm Gray · Cool Gray

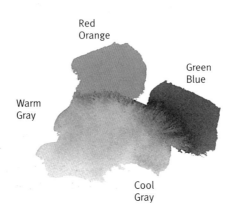

Red Orange · Green Blue · Warm Gray · Cool Gray

ANALOGOUS COLOR **TIPS** AND **SOLUTIONS**
by Pat Weaver

182 Work Analogously

A good way to darken a color and keep it in the same family is to work analogously. Analogous colors are found next to one another on the color wheel. For example, start your palette with Aureolin Yellow, then add Aureolin Yellow plus Yellow Ochre, followed by pure Yellow Ochre, then Yellow Ochre plus Quinacridone Gold, then Quinacridone Gold plus Burnt Sienna, then Burnt Sienna. You'll be surprised what you'll learn about color when you do these color charts and eventually become more confident in your color choices.

183 Excite the Color

The knowledge and use of analogous color expands the painter's ability to spark color by introducing a color above or below it on the color wheel, thereby *exciting the color*, keeping it much cleaner and usually brighter.

184 Paint Simple Objects

Try painting simple objects using a limited analogous palette, such as this apple (warm) and pear (cool) using a palette of Aureolin Yellow, Opera and Phthalo Blue.

The apple is painted starting with an orange-red in the light area, moving to red and then to red-violet on the shadow side. The shadow is painted with blue, then as it moves away from the apple, violet and then red. The shadow directly under the apple is painted with a mixture of blue, red and orange. Always paint with a variation of color, temperature and value. The highlight is white paper.

The green pear goes from orange to yellow, to yellow-green, to green, to green-blue. The shadow is a gray mixture made from green-blue and orange accented with orange. Painting simple subjects is a good place to start and will help you learn to use color.

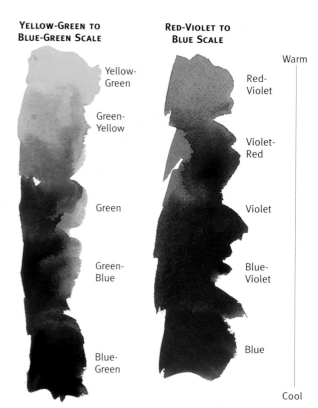

Paint Simple Objects

Analogous Color Scales

Analogous colors scales are four or five colors that are close to each other on the color wheel. Try painting your own analogous scales of color.

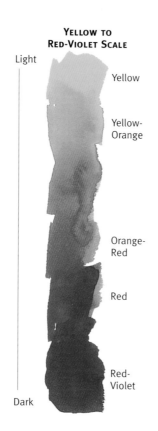

YELLOW TO RED-VIOLET SCALE

Light

- Yellow
- Yellow-Orange
- Orange-Red
- Red
- Red-Violet

Dark

YELLOW-GREEN TO BLUE-GREEN SCALE

- Yellow-Green
- Green-Yellow
- Green
- Green-Blue
- Blue-Green

RED-VIOLET TO BLUE SCALE

Warm

- Red-Violet
- Violet-Red
- Violet
- Blue-Violet
- Blue

Cool

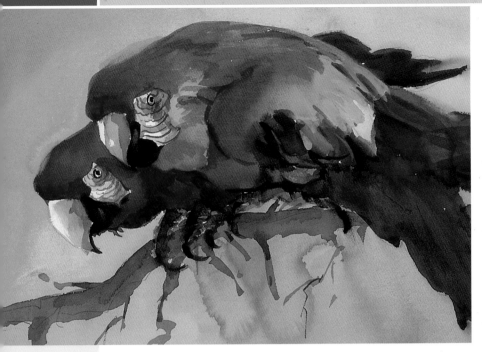

So Curious Pat Weaver 15" × 22"
(38cm × 56cm) Collection of Christine Lesak

Add Unity and Harmony to Your Work
Using analogous colors in your paintings has
many benefits. They provide a sense of unity
and harmony to your work. They also automat-
ically limit your color palette, which will help
you determine color temperature. It is also
easy to establish a mood or feeling for your
painting when using colors that are related to
one another.

185 Create Warmth

The parrots (above) are painted with a palette
of Aureolin Yellow, Opera and Phthalo Blue.
This is the same palette used to paint the
apple and pear on page 86. The more intense
reds were mixed with Aureolin Yellow and
Opera. The darker reds were the same mix
with blue added, and then more red and a
touch of yellow. Greens were made with Aure-
olin Yellow and Phthalo Blue. Blue-violets
were made with Phthalo Blue and Opera. The
painting is warm overall with a cool accent.

186 Capture the Light

Raggedy Ann's hair (at right) has been painted
analogously with yellow-orange, orange,
orange-red, red-orange, red and red-violet.
The analogous color scheme is very effective;
it works to capture the light in the doll's hair.

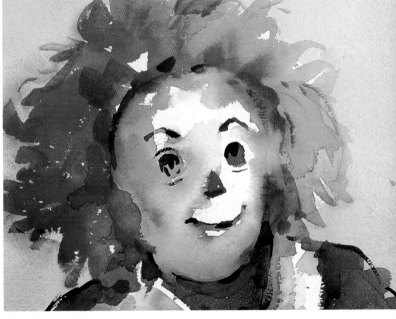

Raggedy Ann Pat Weaver 11" × 15" (28cm × 38cm)
Collection of the artist

TIPS FOR CREATING A COLOR CHART
by Pat Weaver

I hope you'll take some time to create color charts and color value scales. There are many subtle changes in colors, and creating color charts will teach you that each color can be easily altered or changed by the addition of another color or colors.

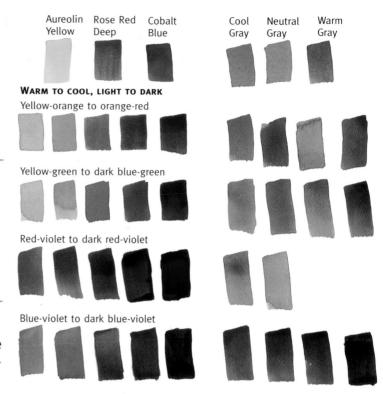

Aureolin Yellow Rose Red Deep Cobalt Blue

Cool Gray Neutral Gray Warm Gray

WARM TO COOL, LIGHT TO DARK

Yellow-orange to orange-red

Yellow-green to dark blue-green

Red-violet to dark red-violet

Blue-violet to dark blue-violet

187 Master Color Mixing
Mastering the art of mixing color will help you match any color you need for painting. Economy of paint means fewer tubes of paint, but you'll get just as much mileage out of fewer tubes because of your ability to see and mix whatever you need.

188 Understanding the Chart
The top row on the left is the palette of Aureolin Yellow, Rose Red Deep and Cobalt Blue. When working up a color chart, I always put the palette on the top row and the name of the color in pencil. How does this chart work? The first color, Aureolin Yellow, is mixed with the second color, Rose Red Deep, to make a secondary orange. Now paint a value scale making the orange darker by adding more red, taking it from light to dark as well as from warm to cool.

189 Family Secret
There is a secret to keeping the color in the same family as it becomes darker and cooler. When the orange color swatch reaches a number five value (see page 109 for making a basic value scale), add a little blue to the mixture, then push the color back to the orange family by adding a touch of red and a touch of yellow back into the puddle of color. Repeat this process for the value scale of orange until it is as dark as you can get it without losing the integrity of the color. This process causes the orange to become grayer as it gets darker. All shadows have a little blue in them, so these colors will become grayer whenever you put all three primaries together. Start the process again for the next row, which is green. Get the idea?

190 Make an Exception
The exception to this process is the violets. When making violets work only with red and blue—don't introduce yellow into these colors—to keep the violets clean. For example, combine Permanent Rose with Cobalt Blue and add a little more Permanent Rose. This will keep the color secondary and in the red-violet family. Another example is Cobalt Blue plus Permanent Rose plus more Cobalt Blue. This will keep the color secondary and in the blue-violet family.

191 A Variety of Grays
The right side of this color chart shows mixtures of yellow, red and blue that produce different combinations of gray. Individual colors are introduced into this gray to produce many beautiful warm and cool grays. The brighter, cleaner colors are usually saved for my center of interest; the biggest portion of the painting will be grayed colors.

The grayed colors are created by mixing blue, red and yellow to create a brown. More blue is added to create the neutral gray. Adding a small amount of blue to the neutral gray creates the cool gray. Add a little red and yellow to the neutral gray to make a warm gray. Mixing each color from your palette with the neutral gray produces a variety of grays.

TIPS FOR A LIMITED COLOR PALETTE

by Pat Weaver

I use the palette of Aureolin Yellow, Permanent Rose and Cobalt Blue for almost everything, including portraiture. It's a very versatile palette and is the one that I recommend for beginning artists.

192 Remember the Basics
Keep in mind that these are the three primary colors—yellow, red and blue—and that green, violet and orange are made from mixing the primaries.

193 Primaries Create Gray
If you mix all three primaries together, you'll produce some form of gray: a cool one, a warm one or a neutral one.

194 Secondaries Create Gray
If you mix any two secondaries together, you're going to come up with another form of gray.

195 Endless Possibilities
Theoretically, if you have a warm and a cool of each primary color, you should be able to mix any color you could possibly want or need.

196 Pat's Favorites
Three primary colors straight from the paint tubes are generally all that I need for a painting, but occasionally I include five or six tube colors. Here are some of my favorite color combinations:

Aureolin Yellow, Permanent Rose and Cobalt Blue

Aureolin Yellow, Opera and Phthalo Blue

Quinacridone Gold, Red Rose Deep and Ultramarine Blue

Aureolin Yellow, Permanent Rose, Phthalo Green and Phthalo Blue

Aureolin Yellow, Cadmium Red Light and Ultramarine Blue

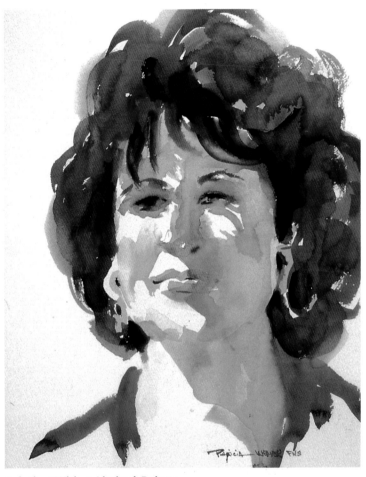

Painting With a Limited Palette

FEMALE STUDY Pat Weaver 22" × 15" (56cm × 38cm)
Collection of the artist

197 Painting With a Limited Palette
A limited palette of Aureolin Yellow, Permanent Rose and Cobalt Blue was used for this painting. The values in the skin tones are very light so they require a good bit of water mixed with the paint. Permanent Rose was floated in first, followed by Aureolin Yellow, then a touch of Cobalt Blue for cool relief. The fluid colors were mixed on dry paper. I used less water for the values in the hair. First I floated in Cobalt Blue; then, while it was still wet, I introduced Permanent Rose, followed by some Aureolin Yellow, which creates a brownish tertiary color. You can find a limited palette demonstration on page 103.

TIPS AND SOLUTIONS FOR MIXING BLACK

by Pat Weaver

198 Start With the Darkest Color

When mixing blacks, always start with the darkest color, add the middle value to it and finally add a touch of the lightest color. A small amount of water will give you a very dark value, more water will push your pigment to a middle value and a lot of water will produce a light value.

199 See and Feel the Mixtures

It's just not possible to tell you exactly how much water to add to a certain amount of paint. This is something you have to practice for yourself. Learn to see and feel the paint mixtures. Dark color can be painted into very wet middle value color without blooms occurring if you understand how much, or how little, water to mix with the paint. I use a small amount of water in my darks and go directly into wet paint on the paper so the darks don't move. Try it. It really works!

200 Solutions for Mixing Black

Some good color combinations that produce black are: Ultramarine Blue, Cadmium Red Light and Aureolin Yellow; Red Rose Deep (or Permanent Rose) and Phthalo Green; Ultramarine Blue and Burnt Sienna; Cadmium Red Light and Ultramarine Blue; Phthalo Blue, Cadmium Red Light and Quinacridone Gold. Use these combinations or create your own to make beautiful, colorful blacks.

FIGURE 1

Cadmium Red Light

Aureolin Yellow

Ultramarine Blue

Black

Tints to Gray

FIGURE 2

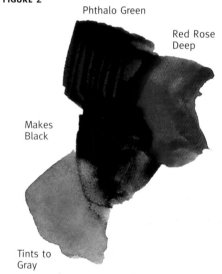

Phthalo Green

Red Rose Deep

Makes Black

Tints to Gray

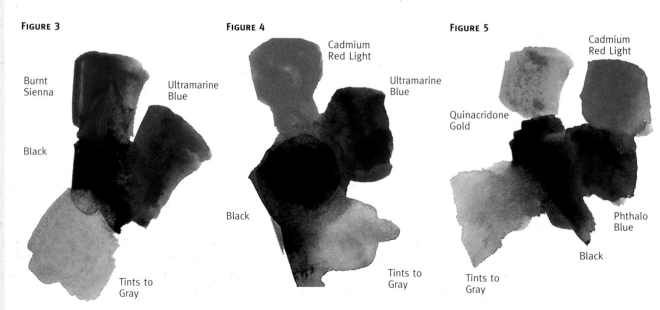

FIGURE 3

Burnt Sienna

Ultramarine Blue

Black

Tints to Gray

FIGURE 4

Cadmium Red Light

Ultramarine Blue

Black

Tints to Gray

FIGURE 5

Cadmium Red Light

Quinacridone Gold

Phthalo Blue

Black

Tints to Gray

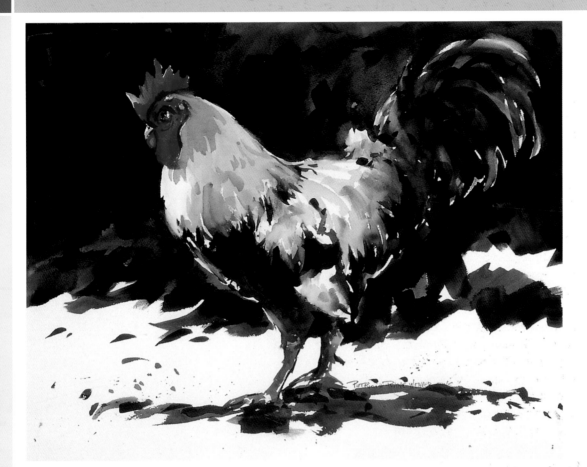

Painting With Black

SO SURE OF HIMSELF Pat Weaver 22" × 22" (56cm × 56cm)
Collection of Barbara Aras

201 Painting With Black

So Sure of Himself was painted with a triad of Ultramarine Blue, Cadmium Red Light and Aureolin Yellow as shown in figure 1 (page 90). I wanted to keep my colors limited and make the rooster really pop against the background. I believe you should paint the same colors into the background that are in the subject. The value of the background had to be very dark, but not solid. I wanted the viewer to see color in what appears to be black.

Some of the warm colors from the rooster's comb and neck feathers were introduced into the background for some warm relief. Notice that I have practiced the theory of placing something light next to something dark. The shadows under the rooster are the same colors and dark enough in value that they anchor the rooster to the ground. Also, note the lost or soft edges.

202 Painting in Black and White

The palette used to paint this little kitty is a limited palette of Cadmium Red Light and Ultramarine Blue (see figure 4, page 90). A two-color palette is about as limited as you can get without painting monochromatically.

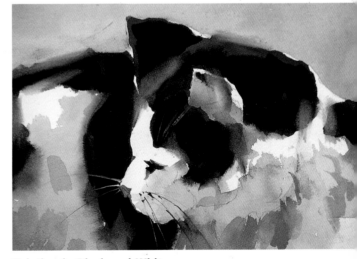

Painting in Black and White

PATIENTLY WAITING Pat Weaver 11" × 15" (28cm × 38cm)
Collection of Christine Hagin

It's a simple painting, but strong in value contrast and very effective. The cat's face is the focal point and is very light against very dark. The beautiful blues are a result of lifting color and softening edges while the paint was still damp. The nice grays are produced from blue with a little red and more water. Note that the largest white piece, which is just white paper, is reserved for the face of the cat.

TIPS AND SOLUTIONS FOR CAST SHADOW COLORS

by Pat Weaver

203 Know Your Shadow

Shadows created by a direct light source that fall on other planes are cast shadows. For example, when you are standing outside in bright sunlight, the shadow you see on the ground is your cast shadow.

204 The Value of a Shadow

If a shadow is cast over a colored surface, most often it will be in the same color family as the surface, but three to four values darker (see page 109 for a basic value chart). If the surface reads as a number 2 or 3 value, then the shadow could read as a 5 or 7. If a tablecloth is painted in hues of yellow, the shadow will be yellow, but three to four values darker. In addition, I would introduce colors from the object casting the shadow, but not so much that it doesn't read as yellow anymore.

205 What Is the Color of the Shadow?

Each local color swatch has the shadow color to the right of it. Shadows are generally three to four values darker than the local color.

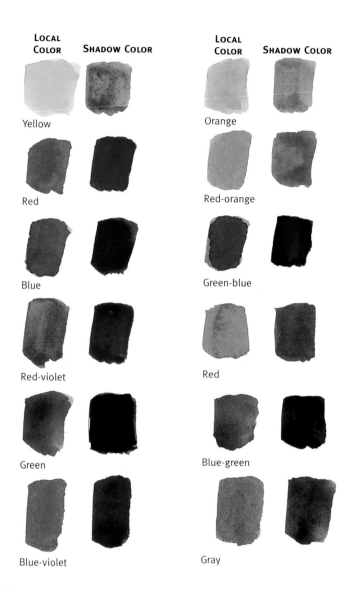

LOCAL COLOR	SHADOW COLOR	LOCAL COLOR	SHADOW COLOR
Yellow		Orange	
Red		Red-orange	
Blue		Green-blue	
Red-violet		Red	
Green		Blue-green	
Blue-violet		Gray	

What Is the Color of the Shadow?

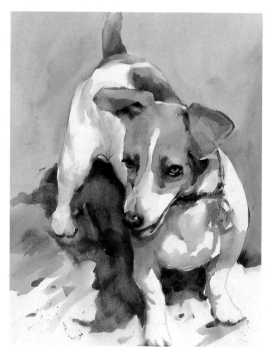

JACK RUSSELL TERRIER Pat Weaver 30" × 22"
(76cm × 56cm) Private collection

206 Cast Shadow Solution

Jack Russell Terrier (at left) is another example of a limited palette with an overall warm temperature—Aureolin Yellow, Quinacridone Gold, Permanent Rose and Ultramarine Blue. The cast shadow is a darker brown than the dog and a darker value than the ground. I usually paint my backgrounds with the same colors as the subject, either lighter or darker in value and in the same color temperature. To stay focused on the animal, I keep my backgrounds and cast shadows simple.

TIPS AND SOLUTIONS FOR USING A GRAYED PALETTE

by Pat Weaver

207 Avoid Mud

The word *mud* is often heard in watercolor painting. Mud can happen by making the wrong color choices or by overworking the paint on the paper. Watercolor is a little temperamental and really doesn't appreciate being stirred on the paper.

208 Use a Light Touch

You want to fully charge the brush with fluid paint and float the paint onto the paper using a light touch. If you press down too hard or too long when applying the paint, the brush will act as a sponge, sucking the color right back off the paper, resulting in a very dry, dull look.

209 Don't Overwork

Overworking the painting—taking paint off, putting paint on, dab, dab, dabbing with a facial tissue or paper towel—destroys the color on the paper. If you have vanilla ice cream and chocolate ice cream side by side, they are still identifiable; but continuously stirring them will soon destroy their individual identities. It is the same with paint; don't stir too long on the palette or the colors will be lost. Do some mixing on the palette, but let most of the color mixing occur naturally on the watercolor paper.

210 A Gray Solution

Quinacridone Gold, Burnt Sienna, Red Rose Deep and Ultramarine Blue are the primary colors used for the tertiary palette above. These earth colors combine beautifully to form the basic palette for *Mouser*, right.

211 A No-Mud Solution

Mouser (right) is a good example of the use of a grayed palette with blue, red and yellow used for the darks in the cat's fur. No muddy color here, just rich gray color.

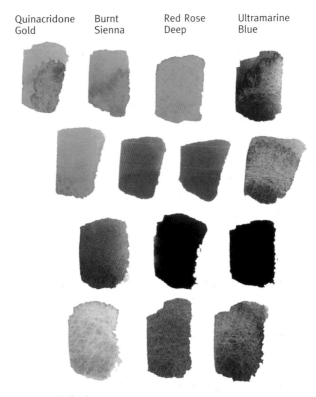

Quinacridone Gold Burnt Sienna Red Rose Deep Ultramarine Blue

A Gray Solution

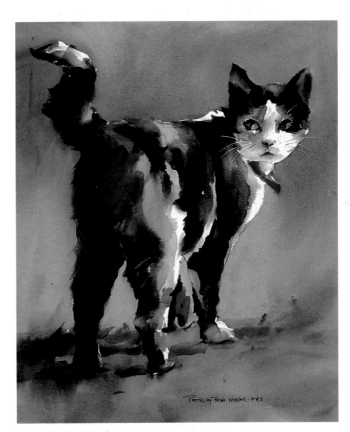

A No-Mud Solution

MOUSER Pat Weaver 30" × 22" (76cm × 56cm) Collection of Dr. Donna Cohen, USF

TIPS FOR CREATING BEAUTIFUL SHADOWS
by Penny Soto

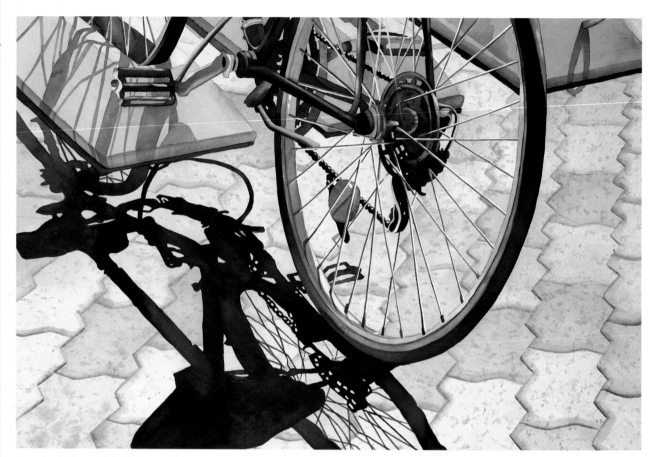

Create A Powerful Statement

BICYCLE SHADOWS Penny Soto
22" × 30" (56cm × 76cm)

212 Seeing Value and Color

If you have a hard time seeing color, try holding up a red piece of mylar to the side of someone's face in strong light. See how the red hue changes the values of the face. You can see them clearly. Go out on a sunny day with a white mat board and place colorful objects on it; study the shadows, and you will be amazed by what you see! Try to associate the colors you see with the colors in your palette, then get a little daring and make them more intense!

213 Direct the Viewer's Eye

Shadows can create another dimension to your work, adding more vibrant color and character. They connect shapes and make your composition more unified. Shadows should enhance your subject matter while directing the viewer's eye gently around the painting.

214 Create A Powerful Statement

It's amazing where you find ideas for paintings. I was walking along the street on a hot summer day when I came across this bicycle above. I was attracted to the orange and blue complementary colors and then noticed the shadows. I came closer for a better look. My imagination started to take over. I began to see all sorts of colors in the shadows and that suddenly became my focal point. I started to take photographs of it from all kinds of angles. I was nearly lying on the ground at one point. The things artists do!

I love the abstract quality this has as a piece of art, and the luminous colors I could create. I got out my pencil and piece of paper and jotted down some notes on color and design. I couldn't wait to develop the film. The next morning I started the drawing. This particular painting was like a puzzle. The negative shapes on the ground were all different shapes and sizes; the colors integrated well and were naturally complementary.

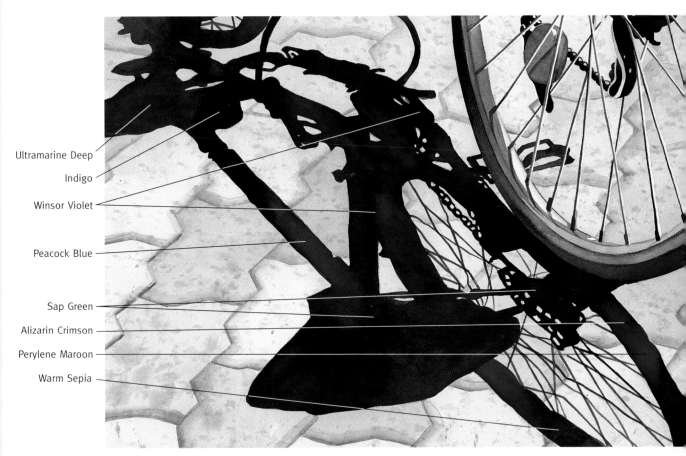

Ultramarine Deep

Indigo

Winsor Violet

Peacock Blue

Sap Green

Alizarin Crimson

Perylene Maroon

Warm Sepia

Exaggerate Shadow Colors

215 Make Your Shadows Work Hard

Shadows have tons of responsibilities: they anchor objects, illuminate the subject, connect passages and integrate colors. Most importantly, they add form to the objects in your paintings.

216 Exaggerate Shadow Colors

Focus on creating gradual changes of wonderful colors. It's nice to have the option of leaving your painting just as you see it in real life or exaggerating the color. Don't be afraid to put colors in your shadows; they are there, you just have to find them. There is color all around us, just look and exaggerate it. I have listed the colors I used to make the shadows in my painting *Bicycle Shadows*, shown above.

COLOR INTENSITY **TIPS**
by Mark Willenbrink

217 Intensity Is Not Value

Think of *intensity* as the richness or potency of a color—how yellow is a yellow, how blue is a blue—and *value* as the lightness or darkness of a particular color.

You can't control intensity like you can control value. Some colors, such as yellow, can vary in intensity but not much in value. Other colors, such as blue, can vary in both intensity and value.

218 Get to Know Your Paints

Certain colors and paints simply have certain intensities. As you paint more often and experiment with different paints, you'll find the brands and grades of paint that suit your style.

219 Using Intense Colors

Both paintings use light values of yellow around the sun, but the less intense colors in the scene at the top (right) lose the penetrating effects of the intense colors in the scene at the bottom (right).

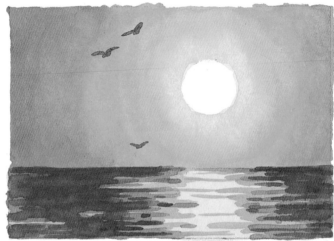

Using Intense Colors

Varying Intensities

This yellow (1) is very intense. This yellow (2) is not intense. Both are light in value. This blue (3) is very intense and has a dark value. This blue (4) is not intense and has a light value.

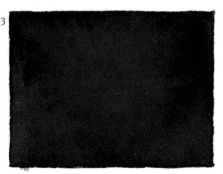

220 Water Affects Intensity

Learn the intensity of each of your colors and how far you can push them. More water makes the intensity of the color lighter and paler. Less water makes the intensity of the color stronger and darker.

221 Organize Your Thinking

You can get to know the intensities of your colors by making a numbered value intensity chart. Take all your high-key (light) colors and place them on a chart. Number the chart 1 through 10. The intensity should become darker as the numbers become higher. For instance, Rose Madder Genuine is a light, delicate, high-key color and will only go up to about 4 or 5

on your chart. On the other hand Indigo, Payne's Gray and Winsor Violet are low-key (dark) colors and will go up toward 9 or 10. If you number them it will organize your thinking a little better, similar to a value chart.

222 Learn to Recognize Color Intensity

A color intensity chart like the one shown below will help you to recognize the value for each of your colors and their natural intensities. That does not mean that Winsor Violet cannot be a light, soft, high-key color. If you mix more water with this pigment it will be a light, soft purple. The intensity of all colors will be lessened if you add water to them.

COLOR INTENSITY LEVELS:

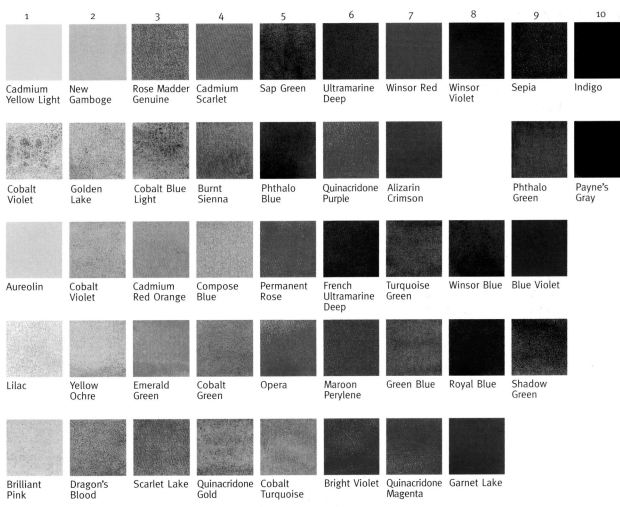

1	2	3	4	5	6	7	8	9	10
Cadmium Yellow Light	New Gamboge	Rose Madder Genuine	Cadmium Scarlet	Sap Green	Ultramarine Deep	Winsor Red	Winsor Violet	Sepia	Indigo
Cobalt Violet	Golden Lake	Cobalt Blue Light	Burnt Sienna	Phthalo Blue	Quinacridone Purple	Alizarin Crimson		Phthalo Green	Payne's Gray
Aureolin	Cobalt Violet	Cadmium Red Orange	Compose Blue	Permanent Rose	French Ultramarine Deep	Turquoise Green	Winsor Blue	Blue Violet	
Lilac	Yellow Ochre	Emerald Green	Cobalt Green	Opera	Maroon Perylene	Green Blue	Royal Blue	Shadow Green	
Brilliant Pink	Dragon's Blood	Scarlet Lake	Quinacridone Gold	Cobalt Turquoise	Bright Violet	Quinacridone Magenta	Garnet Lake		

TIPS FOR USING TRANSPARENT AND SEDIMENTARY COLORS
by Penny Soto

Using Transparent Pigments

RENAISSANCE MAN Penny Soto 22 × 30" (56cm × 76cm)

French Ultramarine
Blue (Sedimentary)

New Gamboge
(Transparent)

223 Find Your Color's Personality

Part of knowing your color's personalities is knowing whether it is transparent or sedimentary. Transparent pigments can be layered or glazed so you see the underlying color or the white of the paper through the dried pigment. This is one of the beautiful features of watercolors. Sedimentary pigments have particles in the pigment that can look like a light dusting of sand or appear very granular.

224 Practice Painting

Take at least a few hours a week to practice painting and learn about your paints. After all, art is 10 percent inspiration, 10 percent perspiration and 80 percent education.

225 Using Sedimentary Pigments

Sedimentary pigments can be very useful, depending on what you are painting. For instance, beach scenes, landscapes and weathered barns all lend themselves to the use of sedimentary colors. However, if you think of

painting a portrait and lay in Cobalt Violet and Lunar Earth—both very sedimentary colors— on the cheek area of a beautiful woman, it may look as though your subject has the chicken pox. This is a good scenario for you to remember what sedimentary colors can do.

226 Using Transparent Pigments

In *Renaissance Man*, above, I've used only transparent colors to glaze the shadows on his face. The underlying colors glow through and still present places on his face in shadow.

TIPS FOR USING OPAQUE VS. TRANSPARENT COLORS

by Penny Soto

227 Water Changes Opacity

I have a different view than most artists when it comes to opaque and transparent colors. You can make an opaque color transparent by adding more water to it and a transparent color more opaque by using less water. A color is opaque if the pigment floats on top of the water and is a little chalky looking. Most transparent colors diffuse into the water.

228 Lifting Color

Nonstaining, opaque colors will lift out easily, while staining colors must be scrubbed out. That's not to say you can't remove staining colors without damaging your paper. Practice gently scrubbing with a bristle brush until you become adept at removing the staining colors without damaging your paper.

229 Opaque vs. Transparent

A good test to see if your pigments are transparent, opaque or staining is to take a permanent (not water-based) black felt-tip marker and draw a 1-inch (25mm) line horizontally across a piece of your favorite watercolor paper. Paint a vertical strip of each of your colors using a number 5 value. Opaque colors will cover or stand up on the black line. The black line will show through the transparent colors. Check the color charts provided by manufacturers to see what the qualities of your pigments are. They will list whether they are staining, nonstaining, transparent or opaque.

After your strip of colors is dry, take a bristle brush and gently try to lift out each color on one side of the chart. You will not be able to lift out the staining colors but will be able to easily lift out the nonstaining colors.

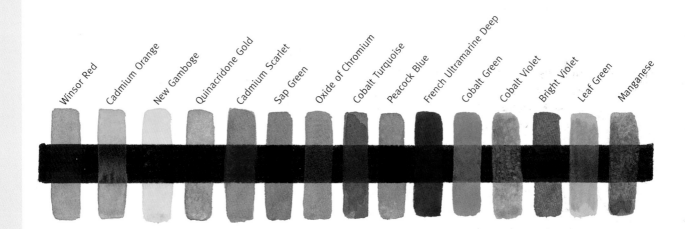

COLOR TEMPERATURE **TIPS**
by Penny Soto

230 Understand Color Temperature

Understanding color temperature is one of the most important parts of painting. You should learn to recognize the temperature of every color. A good way to start is to compare colors against each other. Paint a small strip of French Ultramarine Blue, the coolest color. Look for the blue in the French Ultramarine. Now paint a strip of Cobalt Turquoise next to the French Ultramarine Blue and look for the yellow in the Cobalt Turquoise. You have to look into the color. Now paint a strip of Alizarin Crimson and Winsor Red next to each other. Look into the Alizarin Crimson to see the blue in it. Look into the Winsor Red to see the yellow in it. By comparing the reds to one another you will be able to see their temperatures better. Learning to do this and memorizing what you discover will help you produce paintings with balanced color temperatures.

231 Use Temperature Variations

Often artists paint beautiful paintings that are all cool with no warm relief or all warm with no cool relief. It's good to have temperature variations in your work. You should avoid 100-percent warm paintings or 100-percent cool paintings.

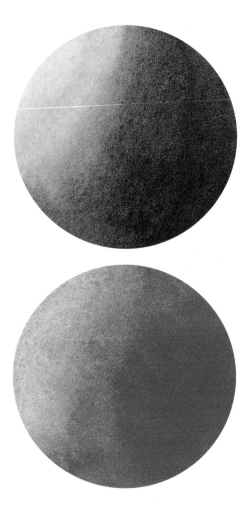

232 Explaining Color

I once saw a movie about a blind girl who didn't understand what color was. To explain color, her teacher took an ice cube and placed it in the girl's hand and told her that some colors looked "cool." Cool colors include blues, violets, blue-purples and blue-greens. Then the teacher placed something hot in the girl's hand for the warm colors, which include yellows, yellow-greens, reds and oranges. This is a good analogy for color temperatures. We are so blessed to be able to see all the rich colors around us. Look at them and relate what you see to the name of the color in your palette. This will help you use color more effectively.

233 Balance Color Temperatures

These circles are good examples of how to distribute your color temperatures. The circle at the top (above) is predominantly a cool, dark painting. The color balance is 25 percent warm lights and 75 percent cool darks. The circle at the bottom (above) has a warm color scheme or a warm dominance. The temperature composition is 25 percent cool lights and 75 percent warm darks.

If you think of this balance while painting, it will help you avoid an all-too-hot or all-too-cool composition.

234 Balanced Temperature

This photograph shows a perfect example of 75 percent cool dark and 25 percent warm light. Notice the yellows in the warm area and the blues in the cool areas. Add 10 percent warm into the cool area and 10 percent cool into the warm area. This perfectly balances out the color temperature.

235 Squint to See Temperature

If you squint your eyes you will see 75 percent warm light and 25 percent cool dark. Notice the blue-pinks in the cool shadows.

Balanced Temperature

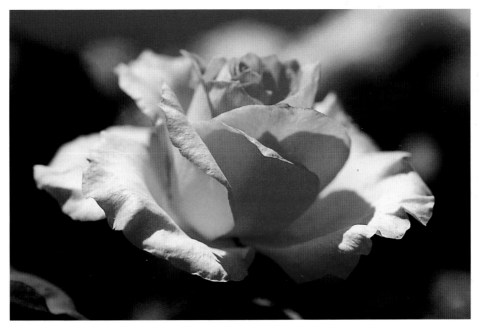

Squint to See Temperature

TIPS FOR CREATING LUMINOSITY THROUGH CONTRAST

by Linda Stevens Moyer

One of the wonderful characteristics of transparent watercolor is its potential for creating luminous paintings. Light becomes an active part of the medium as it passes through the transparent layers of paint, contacts the surface of the paper and bounces back into our eyes. Watercolors naturally communicate light within our works, if we know how to use the color properties involved: hue, *the color itself;* value, *the lightness or darkness of a color; and* intensity, *the brightness or dullness of a color.*

236

Creating Luminosity

You can create luminosity by creating contrasts in the three properties of color (hue, value and intensity). Imagine that you want to paint a picture that features a sunset. You want to make the sky look luminous. How would you do that?

First, make the sky lighter in value than the land (value contrast). Next, choose a warm color for the sky and a cool color for the land (hue contrast). Then, make the sky colors more intense than the land colors (intensity contrast). Dull the colors of the land surfaces by mixing their complements with them.

That's all there is to it! You can make any subject in your paintings look luminous by establishing contrasts in the three properties of color.

Hue Contrast
Both green rectangles are the same color. Which one looks brighter?

The green rectangle on the right. Why? Because the red background sharply contrasts with the green. Complementary colors provide the greatest contrasts in hue.

Value Contrast
Both yellow rectangles are the same color. Which one looks lighter?

The yellow rectangle on the left. Why? Because of the extreme value contrast between the yellow and black. The dark background emphasizes the lightness of the yellow.

Intensity Contrast
Both blue-green rectangles are the same color. Which one looks brighter? The blue-green rectangle on the right. Why? The rectangle on the right has been placed against a gray background with low intensity. We could make the blue-green rectangle appear even brighter if it were placed against its dull complement (dull red-orange). This way we would not only have a contrast in intensity, but also in hue.

237 TECHNIQUE
Using a Limited Color Palette
by Mark Willenbrink

Pumpkins are good subject matter to paint when learning to use watercolors because they have relatively simple shapes. As my students have learned, pumpkins may not hold the beauty of roses, but they sure are a lot easier to paint! Starting simply is a valuable part of the learning process.

MATERIALS

PAPER 12" × 16" (30cm × 41cm) 300-lb. (640gsm) cold-press watercolor paper

PAINTS Alizarin Crimson | Cadmium Orange | Cadmium Yellow | Prussian Blue

BRUSHES Rounds | Nos. 6 and 10 | Large bamboo brush

OTHER Eraser | Pencil

TIPS

238 Limit Your Palette
Limiting your palette to just four colors and using each of these in almost each element will give your painting a feeling of unity. Even if pumpkins are orange, that orange can have a little red, yellow and blue in it.

239 Preserve White Space
Remember to plan and preserve white space and highlights. The light source is shining from the upper right.

240 Get the Color Right
When mixing browns, use your color chart to help get the color right. If your mixture has a bit too much of one color, add a slight amount of its complement. For example, if your brown looks too green, add red.

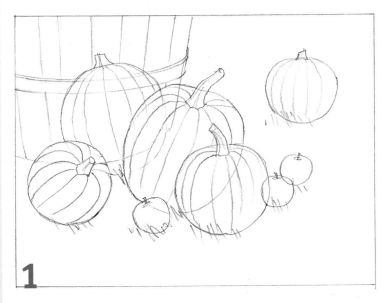

1 | Draw the Structure

Draw the basic shapes of your composition to work out the placement of your pumpkins. Vary the pumpkins' sizes and tilt some of them to create interest. Overlap them and make the pumpkins closest to the viewer appear lower in the scene. Even pumpkins have perspective! After adding the barrel and pumpkin stems, I decided my painting still needed a little something, so I added a few apples and some simple lines to indicate grass.

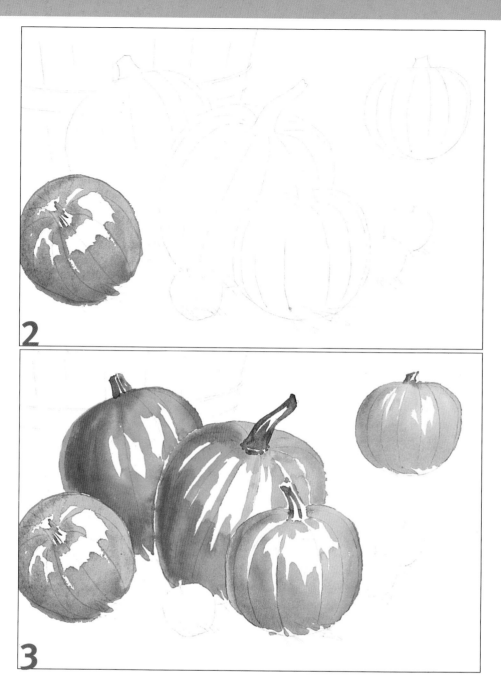

2 | Begin Drawing Your Pumpkins

Draw or transfer the image onto watercolor paper. I changed the tilt of the pumpkin on the bottom left because I felt that it led the viewer's eye out of the painting. This small change will keep the viewer's eye within the frame of the picture. I decided to use orange and its analogous colors plus orange's complement, blue, for the color scheme.

Fill in the pumpkin on the left with a large bamboo brush and very wet, somewhat sloppy applications of Cadmium Orange. Painting wet-into-wet, drop in a mixture of Alizarin Crimson and Cadmium Yellow with a no. 6 round. Paint the stems with a brown mixture of Alizarin Crimson, Cadmium Orange, Cadmium Yellow and Prussian Blue.

3 | Continue Painting Your Pumpkins

Paint the three center pumpkins with Cadmium Orange. Painting wet-into-wet, add some color from a mixture of Alizarin Crimson and Cadmium Yellow. Paint the pumpkin on the right the same way, adding a trace amount of Prussian Blue to the mixture. Remember to preserve the white of the paper for highlights. Paint the pumpkin stems with a brown mixture of Alizarin Crimson, Cadmium Orange, Cadmium Yellow and Prussian Blue.

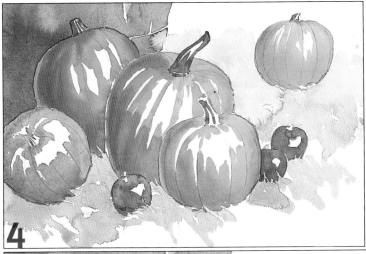

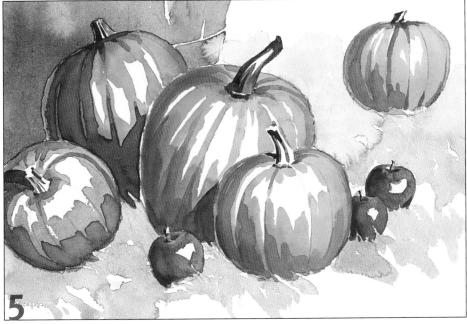

4 | Add Some Browns

Paint the barrel with a mixture of all four colors and a large bamboo brush. Paint the grass area a more neutral orange-green color with a mixture of Cadmium Orange, Cadmium Yellow, Prussian Blue and just a touch of Alizarin Crimson. Just suggest the grass, leaving lots of white space. Paint the apples with a no. 10 round and a mixture of all four colors, using mostly Alizarin Crimson.

5 | Add Proper Shading

Add shading to the pumpkins to imply depth with a mixture of Alizarin Crimson, Cadmium Orange and Prussian Blue and a no. 6 or no. 10 round. Add shading to the apples with a mixture of all four colors, using predominantly Alizarin Crimson and a little more Prussian Blue than you used to paint them in step 4.

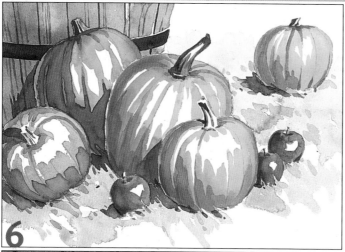

6

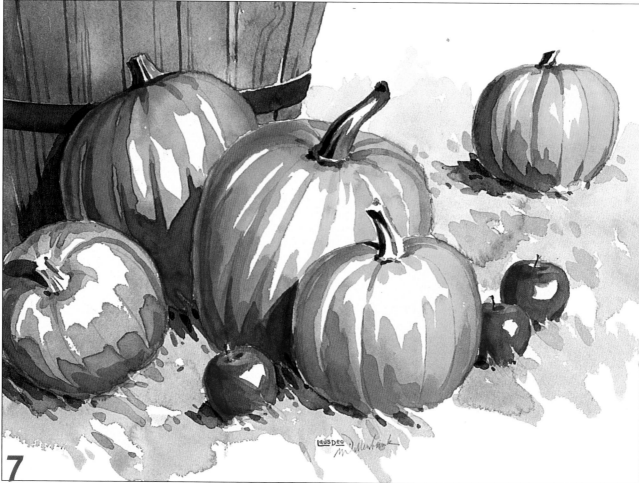

7

FALL PUMPKINS Mark Willenbrink 11" × 14" (28cm × 36cm)

6 | Add Details to the Barrel

Paint the lines on the barrel with a darker brown mixture of all four colors and no. 6 and no. 10 round brushes. Add details and shading to the grass with a dark green mixture of all four colors, using mostly Prussian Blue. The blue will make the green color of the grass a bit deeper, creating cool shadows.

7 | Add Your Finishing Touches

Add a darker wash over the barrel. Make the shadows on the pumpkins and apples darker with mixtures of Alizarin Crimson and Prussian Blue. Define the shadows in the grass with a darker version of the green mixture from step 6. Erase the pencil lines and sign and date your painting.

4 VALUE and LIGHT ANSWERS

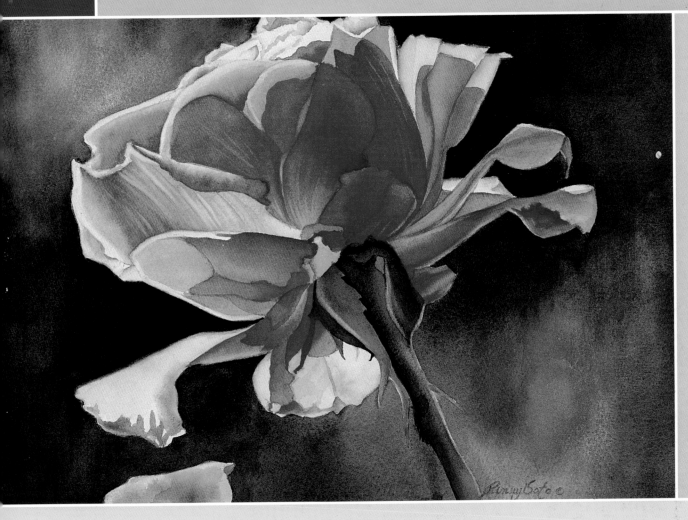

> ❝ In order to bring life to your work,
> you must understand the relationship between light and shadow. ❞
>
> — Donald Clegg

THE ROSE Penny Soto 11" × 15" (28cm × 38cm)

TIPS FOR CREATING FORM AND DEFINITION WITH VALUE
by Mark Willenbrink

Values are the light and dark qualities of color. Use shading, shadows and contrasting values to provide form and definition for objects and the entire painting.

241 Observe Shading and Shadows

To get a better understanding of shading and shadows, observe values on basic shapes. Use white foam shapes from your local craft store as models to examine the characteristics of light. You may need to paint the foam a light color to get an opaque surface that reflects light smoothly and accurately.

Pay attention to the location of the light source—whether it shines from the left or right, above or below, in front of or behind the object. Once you've determined the light's direction, observe the lightest and darkest areas and the effect of the light source on the object's shadow.

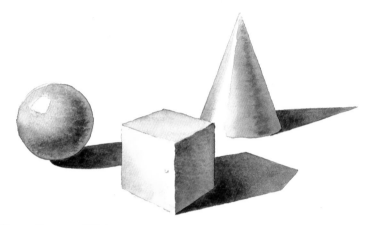

Use a Range of Values

242 Plan Values

Especially when painting with watercolors, keep the light areas as well as the shadows in mind. You can always make areas darker with watercolors, but you have to plan the light areas from the very beginning.

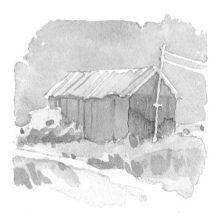

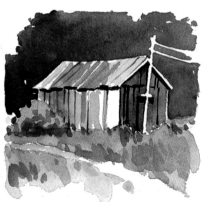

Don't Be Afraid of Contrast

243 Using Contrast

Contrast is the range of dark and light between values. Contrast enhances the depth and clarity of a picture. Objects with values that contrast very little appear to be close together. Objects with highly contrasting values appear farther apart and more defined. Look at the example below, left.

The darker the darks in your painting, the lighter the lights will appear. So if you want a light area to look really bright, make the objects around it dark.

244 Don't Be Afraid of Contrast

A picture with a low contrast of values (at the top, left) may look flat and undefined, as on an overcast day. Beginners tend to be timid with their paints, so they often end up with low-contrast paintings. A picture with a high contrast of values (at the bottom, left) shows depth and definition, as on a sunny day.

245 Use a Range of Values

Values don't just come in white, black and gray. Value also defines the light and dark aspects of color. For instance, the color green may appear as a light value or dark value, each portraying very different moods. (In the example at the top of the page, the light source is located to the left and in front of the three objects.)

246 TECHNIQUE
Making a Value Scale
by Mark Willenbrink

When you've completed this value scale, you'll be able to look through the punched holes to identify the values in a scene and determine the values you'll need for a drawing or painting.

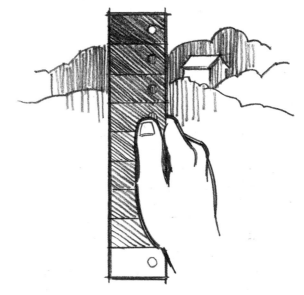

MATERIALS

PAPER 140-lb. (300gsm) cold-press watercolor paper

PAINT Burnt Umber

BRUSH No. 10 round

OTHER Hole punch | Scissors

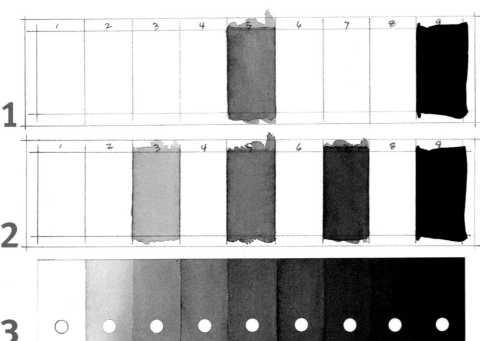

1 | Establish the Darkest and Middle Values

Divide a 10-inch (25cm) rectangular piece of 140-lb. (300gsm) cold-press paper into nine equal rectangles, leaving about a ¼-inch (6mm) border around the edges of the paper. Number the rectangles 1 through 9 from left to right on the top border. Paint the ninth rectangle as dark as possible. Then paint the fifth rectangle a value midway between the ninth value and white.

2 | Paint the Intermediate Values

Paint the third rectangle a value between the fifth value and white. Then paint the seventh rectangle a value between the fifth and ninth values.

3 | Fill In the Remainder of the Values

Paint the even-numbered rectangles to make a continuous range of values that gradate from light to dark. Leave the first rectangle white. Trim all four sides and punch holes in each of the rectangles.

TECHNIQUE
Learn to Simplify Value

by Linda Stevens Moyer

Imagine that you are taking a black-and-white photograph of something. The different grays you see in the finished photographic print correspond to the values of the colors in the actual scene.

Learn to simplify the values you see without losing the essence of the subject. Practice the following value exercise several times by using progressively more difficult plant forms (for example, several leaves on a branch, or flowers). As you gain more experience, your brushwork will become better and you will also be able to better recognize and simplify the values in your work.

In transparent watercolor, various values are achieved by adding water rather than by adding white. Mix three different values of Payne's Gray by diluting it with different amounts of water. You will need a light, a medium and a dark value that are evenly spaced from each other.

Work from a plant form such as a leaf. Place the leaf in a strong light so that changes in value will be very apparent. Examine the many different values that reveal the three-dimensional form of a leaf. Visualize how you can best express these values with the three values you have mixed, and then paint.

MATERIALS

PAPER 140-lb. (300gsm) cold-press watercolor paper

PAINT Payne's Gray

BRUSH Medium round

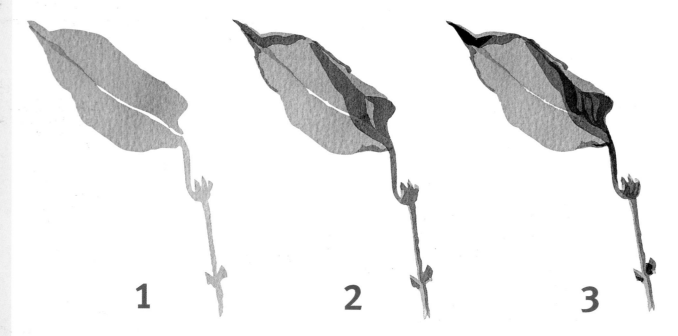

1 | Start With the Lightest Value

Beginning with the lightest value, paint the entire shape of the leaf; leave the paper white only where there are highlights. Use as few brushstrokes as possible for each shape you paint. Allow the paint to dry thoroughly before going on to the next step. You may use a hand-held hair dryer to dry your paint.

2 | Add the Medium Value

Now look at your leaf carefully. Where are the middle and dark values? Paint those shapes with the medium value of paint you have mixed, using economical brushstrokes. Those shapes will overlap parts of the lightest value you applied in the previous step. Dry the paper thoroughly.

3 | Finish With the Darkest Value

Last, look for the darkest values. Paint these shapes carefully using your brush economically. Applying the darkest value completes the painting. The result should be a leaf that has convincing light and form.

OBSERVATION **TIPS**
by Linda Stevens Moyer

We perceive our world, in part, as a result of the various amounts of light that enter our eyes from reflecting surfaces around us. Some surfaces are highly reflective; others return very little light to us.

248 Learn How Light and Shadow Reveal Form

As artists, we must train our eyes to be highly discriminating in a number of ways. Changes of value across the surface of an object reveal the form of that object to us. To represent light accurately, we must first accurately observe the lights and darks that describe form.

Many of the objects that you paint will have a combination of curved and flat surfaces. Understanding how light interacts with each of these surfaces will help you to see the value changes and record them in your paintings. The result will be a convincing illusion of three-dimensional form.

249 Observe the Subtle Changes

An object with a curved surface will have a system of darks and lights that changes constantly and smoothly. Whenever a curved object is to be depicted, the artist should look for a core shadow (the darkest part of the shadow), reflected light on the dark side and a slight shadow on the light side, as well as the gradual change from light to dark values across the surface of the object. Where these different shadows and lights occur will depend on the direction from which the light encounters the object. Noticing these subtle changes of light and dark will help you paint a convincing curved form.

250 Strong Value Contrast

We are able to perceive the dimensionality of an object with flat surfaces, such as a cube, because of the contrast of value between each of the surfaces. No lines are needed to establish form. Each side of a cube is perpendicular to the others and receives a different proportion of light. The value does not stay constant across each surface; it changes slightly as each side recedes into space.

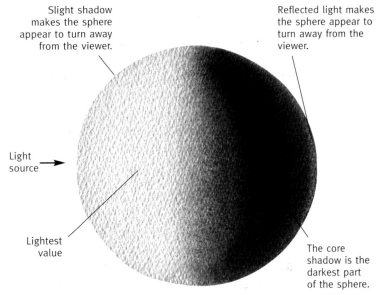

Slight shadow makes the sphere appear to turn away from the viewer.

Reflected light makes the sphere appear to turn away from the viewer.

Light source →

Lightest value

The core shadow is the darkest part of the sphere.

Curved Surface: A Sphere
The sphere above is illuminated with a strong directional light coming from the left. Notice how the light gradually changes across its surface.

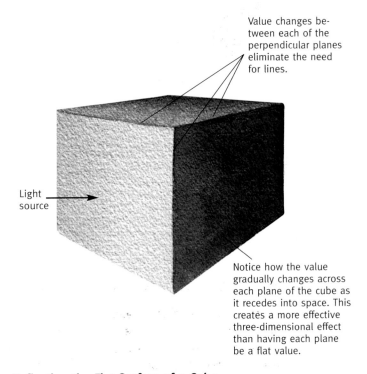

Value changes between each of the perpendicular planes eliminate the need for lines.

Light source →

Notice how the value gradually changes across each plane of the cube as it recedes into space. This creates a more effective three-dimensional effect than having each plane be a flat value.

Reflecting the Flat Surface of a Cube
One of the first steps toward abstraction or flattening an object is to draw lines around it or within its boundaries. If our objective is to make an object look realistically three-dimensional, we must eliminate those lines by using contrasting values within the object to make those lines unnecessary.

TIPS FOR CREATING FORM WITH COLOR

by Betty Carr

251 Use Complementary Glazes

This statement by artist Charles Hawthorne from *Hawthorne on Painting* tells it all: "Let color make form; do not make form and color it. Work with your color as if you were creating mass—like a sculptor with his clay."

In the illustrations on this page we see what happens when we glaze with opposites to create form. The red sphere and blue cube appear as flat shapes until their complements, green and orange, are used to create form. As you can see, various amounts of the opposite color were used to darken the value and lower the intensity, creating gradation while modeling with color.

The use of color temperature, value and even softening edges gives these basic forms their dimensional appearance. Create dimension in your work by glazing complements over colors, mixing complementary colors and placing complements next to one another.

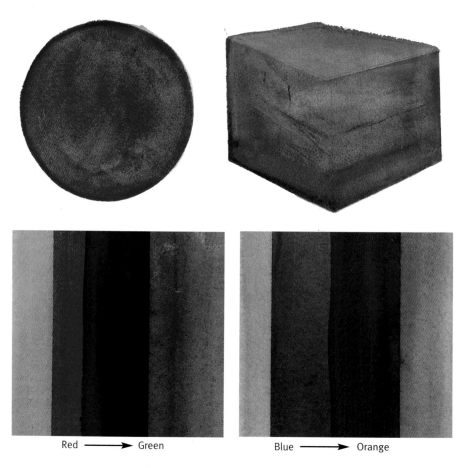

Red ⟶ Green Blue ⟶ Orange

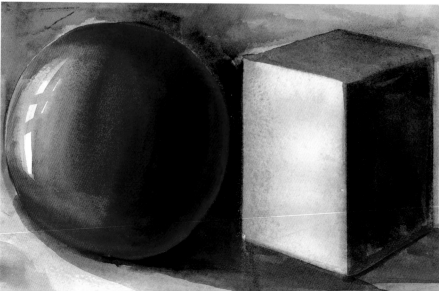

VALUE **TIPS**

by Betty Carr

252 Value Creates the Effects of Light

Color is powerful, vivid, moody and romantic. Most beginning artists are attracted to color's beauty and often forget to utilize its best feature when painting light: value. It is crucial to understand value to create the effects of light in your painting. Every color has a value: a degree of lightness or darkness.

253 Determine Values Through Observation

Value is color's most important characteristic. Placing a gray value scale ranging from 1 to 10 (white to black) next to a specific color's value scale (ranging from lightest to darkest) can help you determine the color's values through observation. By examining colors in terms of relative lightness or darkness, your skill as an artist will grow.

254 Use Variety in Darks

If the value is correct, it doesn't matter what color you use. Often I'll tell a student when he is doing a painting, "Let's punch up the darks with vivid color." For example, the shadow side of a tree trunk could be more alive and exciting if dark purple were used rather than the typical brown. Remember that color is not as important as value in painting, so have fun and play with variety in your darks.

Try this: Look around and pick a color. Squint at it and ask yourself what value you are looking at—not what color. Get into the habit of analyzing color like this and in no time you'll be judging value relationships.

255 Create a Dominant Value Scheme

Understanding a form's color value is crucial because the contrast of dark against light is what creates the drama in any painting. The viewer's eye will be attracted to the areas of highest contrast: lightest light against darkest dark. In developing a design, keep in mind the importance of a dominant value scheme. When a painting has no value plan—and is basically just a potpourri of values—it generally lacks punch and is just another pretty picture rather than a great painting. While developing a painting, simplify the forms to three values with a minimum of details.

No Value Dominant
This design lacks spunk and drama. There is no dominant value theme. The light, medium and dark shapes all want attention.

Dark Value Dominant
This dramatic design is dark-value dominant and has punch and excitement. The diagonals make it more dynamic. There's a definite center of interest. The overall design is basically better, but the unified values connect the forms.

Light Value Dominant
Here I've developed more intrigue in the center of interest and enabled the light value to dominate. When you begin to develop a composition from a variety of decisions, keep in mind what value dominance you will have. It's the organization, balance and unity of values that create dramatic light.

256 High Key vs. Low Key

In a high-key painting, the light values are dominant: on a scale from 1 to 9, values ranging from 1 to 4 are the focus. In a low-key painting the darker values dominate (values 5 to 9). The middle values range from about 4 to 5 and are important for unifying the lights and darks in a scene. Imagine a painting without its middle values. The dark and light values get the most attention, but the middle values do the transitional work and hold the overall value scheme together.

257 Work With Value

Using your own initials as the subject, create an interesting design with a light- or dark-dominant value scheme.

TIPS FOR CAPTURING THE EFFECTS OF LIGHT

by Betty Carr

258 Consider Direction and Angle

No matter what subject you attempt to paint, to accurately capture the effects of light on that subject you must consider which direction and at what angle the light is falling on the scene, and the quality of that light.

259 Consider How Light Affects Mood

Everyone has looked out a window and experienced a changing view depending on the time of year, day, hour and even minute. When the quality of light changes, this affects the shapes, colors, textures and general mood of the scene.

260 Consider Your Position

Where you are in relation to the scene before you—at eye level, below eye level looking up, or above eye level looking down—is crucial because this affects how you see the forms within it and how you perceive the light falling on and around those forms.

261 Choose an Angle to Reflect the Mood of Your Painting

Look at this display of fruit (above, right) and then guess the eye level of the viewer and the light's angle and direction. Squint if you must to help you concentrate on the basic forms and light only.

Because of the extreme shadow area at a sharp diagonal angle on the right of each fruit, it's apparent that the light is coming from the left and at a low angle. The viewer's eyes are looking down on the pears. Always be aware of the light direction and angle, and your position relative to the scene. Be aware of what you're after and choose the quality of light most appropriate to reflect the mood of your painting.

262 Save the Whites

This value sketch (middle, right) and the resulting watercolor still life demonstrate an awareness of eye level and light direction. The viewer is looking down just a bit, and the light is coming from the front right. The quality of light is low and dramatic. A value sketch was drawn first to guarantee success in saving the precious whites—the light.

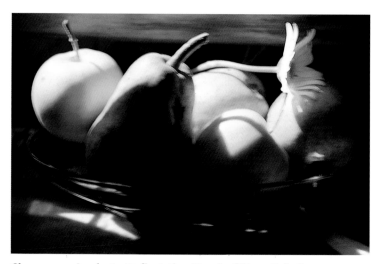

Choose an Angle to Reflect the Mood of Your Painting

Save the Whites

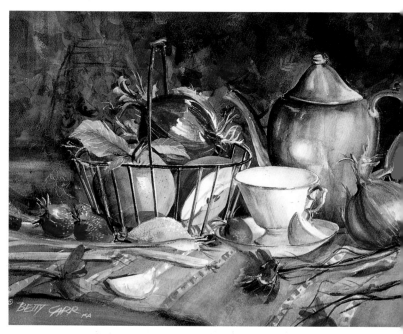

GOOD BLEND Betty Carr 12" × 16" (30cm × 41cm)

VALUE **SOLUTIONS**
by Betty Carr

263 Remember the Big Picture
Placing too much emphasis on the color and texture of a scene can distract you from two very important elements of design: value and shape. As soon as you start to think in literal terms—for example, defining each leaf on a tree or making sure the fence posts are equally spaced—you are forgetting about the big picture: light enveloping form. Avoid this pitfall by simplifying a scene down to its basic values (darks and lights) to see forms.

264 Squint to See Basic Values
Squint your eyes at a scene to see the basic value range and to eliminate unimportant details. Think almost abstractly. Place values and shapes in the right spots, and realism appears! Note your observations with value sketches. Start with darks and leave whatever is in light as the white of the paper.

265 Emphasize Value Rather Than Color
In this painting (above, right), the texture and color are emphasized too much, while the elements of value contrast and shape are lost. The shapes of the trees are uninteresting; the colors are too bright; the values are all the same because there is no established light source. Obviously, literal thinking occurred during the painting of this boat surrounded by lollipop-perfect trees. If the values and shapes in a painting are wrong, even beautiful texture and color will not make it successful.

266 Make an Escape Route
Using light and dark values correctly helps emphasize the center of interest and creates an escape route for the viewer's eye. Simply follow the lights.

267 Use Contrasting Values to Create Interest
In this example (right), the colors and textures do not dominate. The asymmetrical shapes are much more interesting and the values clearly show the direction of light.

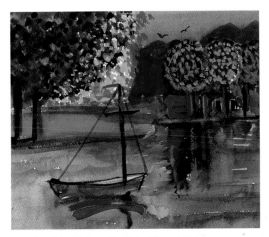

Emphasize Value Rather Than Color

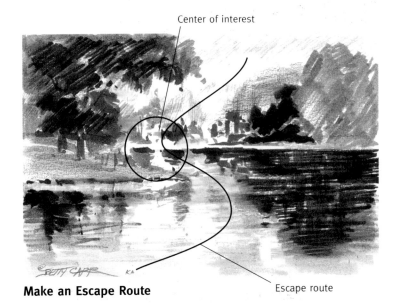

Center of interest

Make an Escape Route

Escape route

Use Contrasting Values to Create Interest

GOLDEN HOUR Betty Carr 7" × 9" (18cm × 23cm)

COLOR **TIPS** FOR LIGHT AND SHADOW
by Betty Carr

268 Consider the Time and Season

The changing position of the sun throughout the day and in different seasons will affect the colors of light and shadow. You can usually sense autumn in the air, winter approaching, and the fresh, fun feeling of spring and summer getting close. At summer's hottest time, the energy of yellow and yellow-orange light is more apparent, while blue and violet light surrounds you in the fall and winter. Generally, the sunnier the scene, the warmer the colors.

269 Consider Atmospheric Conditions

Atmospheric conditions will affect light and shadow as well. Mist, fog and rain are examples of moisture filling the air and consequently dimming the light. Imagine an intensely red tugboat approaching shore, slowly finding its way through heavy fog. The bright red will soon stand out on shore against the gray conditions. Subtle contrast is used often in painting for emphasis, but keep in mind that a cool or warm plan should dominate.

270 Observe Subtleties

Generally, the subtleties rather than the obvious features are more important and valuable to observe in creating great paintings. When painting a scene, take into consideration the lighting situation, temperature, moisture level, time of day, surrounding color value and intensity. The temperature of the light source, the color of adjacent shadows and the character of a shadow's edge (soft vs. hard) are all important details.

271 Analyzing Shadows

Observe the subtleties of shadow by asking the following questions:

What is the color of your subject, and what are the surrounding colors?

What kind of light source exists (natural or artificial)?

Is the light warm or cool?

What temperature is the shadow?

Are the shadows long with fuzzy edges or short with sharp edges?

What time of day is it?

Shadows have a few common characteristics; take notice of them.

Shadows are generally transparent, not just plain black or gray. Shadows tend to have a violet base when cast onto a white surface.

The complement of the object's color will be slightly apparent in the cast shadow.

Warm light will cast cool shadows, while cool light will cast warm shadows.

The transparency or opaqueness of the form in light will directly affect the color of its cast shadow.

Shadows get cooler and lighter as they recede.

The color of a cast shadow is determined by the local color on which it is cast. As the shadow approaches the form that is doing the casting, it often gets slightly warmer and darker, and the edges become sharper. Be careful not to paint cast shadows too dark.

Autumn Morning Shadows
The cool blue shadows of an early autumn morning stretch across the contour of the land. The long shadows create fantastic patterns to paint.

Warm Evening Glow
The warm evening atmosphere surrounds the palm trees and creates glowing silhouettes.

Early Morning Mist
The atmospheric qualities and cool morning glow create a soft and gentle feeling. The mist filters the view.

272 Surrounding Color Affects Shadows

Have some color fun with shadow shapes in natural light. As you can see, the color of the fabric surrounding these objects (above) really affects the colors of their shadows. The light source for these photos was daylight, at about 10:30 A.M. in late January. Cool light bounces into the colored fabric and is absorbed by some nearby objects, but transmitted by others. By closely observing shadows, you'll become more sensitive to their colors and the temperatures they emit.

TIPS FOR PAINTING REALISTIC SHADOWS
by Betty Carr

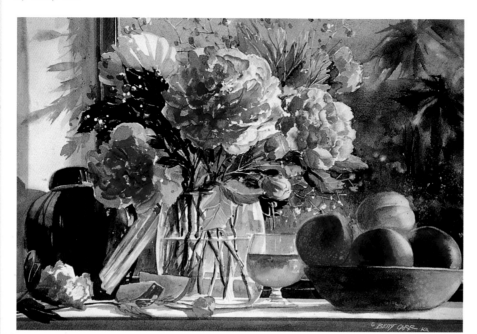

Create a Path for the Eye

DESERT BOUQUET Betty Carr
12" × 18" (30cm × 46cm)

273 Use Shadows to Define Light

Shadows are crucial to painting light. Essentially it's the shadow shapes that define the light, whether subdued or highly contrasting. They create mood, movement and direction, along with unifying the painting's various elements.

274 Use Escape Routes

Escape routes are breaks or areas of rest that allow the eye to move through the foreground, middle ground and background of your painting. Pablo Picasso used this device often in his drawings by breaking his lines. These small breaks allow the viewer's gaze to flow in and around the piece. By not closing all the forms with a line or hard edge, your work will have a more atmospheric quality.

275 Avoid Thinking Too Literally

Oftentimes I'll discuss a painting with a student who says, "I can't put a shadow there—it's not in the scene," or "How should I shape the shadow if I can't see the whole thing?" These are the pitfalls of literal thinking. Create shadows to facilitate eye movement. They will be believable if the light direction is consistent.

276 Points to Remember When Painting Shadows

Shadows follow the contour of the objects on which they lie.

Shadows are transparent and create drama, direction and movement.

Temperatures are warmer closer to the object and cooler as the shadow disappears.

The edge of the shadow is sharper closer to the object and blurs as the shadow recedes.

The more contrasting the light, the deeper the shadow.

Shadows are the key element in my work. At times, I'll paint almost the complete network of shadows before I touch the positive objects. If the shadow shapes and the play of light are correct, I'm confident that the painting will be a success.

277 Create a Path for the Eye

The overall design in *Desert Bouquet*, above, is based on the *L* composition, with the eye level straight on and light filtering in from the lower right. Eye movement follows the light, along the whites of the paper in the foreground, moving up through the flowers. The eye continues through the broken soft edge of the distant mountain in the background. Wall shadows bring us back and circle us up through the old jar's diagonal shape.

BASIC LIGHT PHENOMENA **TIPS**
by Betty Carr

To paint light, we need to understand some basic lighting phenomena. Light is the incredible, invisible energy that makes it possible for us to see. It can come from a variety of sources and can result in a number of visual effects. To paint light realistically, it is crucial to understand what it is doing. Let's look at a few common occurrences related to light: diffraction, refraction and gradation.

278 Diffraction

Diffraction is the breaking up of a ray of light into dark and light bands—or into the colors of the spectrum—caused by the interference of one part of a beam with another when the ray is deflected at the edge of an opaque object, or when it passes through a narrow slit.

Hang in there. This characteristic is crucial to great landscape painting. Imagine holding a long, white, tapered cone against the deep blue sky. The narrow tip of the cone will appear cooler and bluer due to the diffraction of light rays surrounding the narrower part of the cone. This same principle of diffraction causes the narrow branches of a bare tree to seem cooler than the thicker branches.

At times it's difficult to see, but using the principle of diffraction will help you create more convincing, realistic paintings. Remember that the rays of light will sneak around the forms, and that the narrower the form, the more illumination you will see.

279 Refraction

Refraction describes the bending of a ray of light as it passes through a transparent surface. Refraction causes a stem in water to appear distorted—bent, off-line or even thicker—as it crosses below the water line (see page 121 for a few examples). We know that the stem itself has not changed, but it appears different to our eyes. Being aware of this lighting phenomenon will help you make your paintings more lifelike.

Gradation and Diffraction in Action

The glowing shadows in this painting make a gradual transition from warm to cool, light to dark. Light is diffracted, reflecting throughout this scene from the radiant sky. Warm light gradually wraps the cylindrical staircase, while abrupt value changes occur on the cubical building.

REFRESHING RETREAT Betty Carr 24" × 30" (61cm × 76cm)

280 Gradation

Gradation is the gradual transition from light to dark. This phenomenon is most noticeable on rounded or curved forms. Imagine holding a white ball in your hand, with a light source at your right. The light will gradually envelop the ball, creating a gradation of value from lightest (on the side of the ball in direct light) to darkest (on the side farthest away from the light). Now imagine holding a cube in the same light. Because of the sharp angles created by the sides of the cube, the light will not gradually envelop the form as it does the ball, but will change more abruptly.

When painting light it's essential to know how gradation affects different forms. Gradation is one of the characteristics which most effectively portrays depth. Exaggerating gradation in a painting can produce dramatic lighting effects. Getting the different gradations of light correct is a major step toward making objects appear dimensional and the illumination in your paintings realistic and vibrant.

LIGHTING DIRECTION **TIPS**

by Betty Carr

281 Effective Side Lighting

This type of lighting is the most effective for painting dimensional forms. You can see the subtle shifts in value quite well. Long, dramatic shadows can result and fulfill the purpose of connecting forms in your composition.

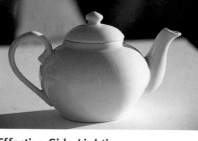

Effective Side Lighting

282 Top Lighting Makes Short Shadows

Gradation of value is easily seen in top lighting as well, but shadows are generally short. The core shadow of the shape and areas of reflected light are readily found on this shiny teapot.

Top Lighting Makes Short Shadows

283 Backlighting for Drama

Little gradation results from backlighting, but this kind of lighting can create very dramatic paintings. A luminous glow often radiates around the silhouetted form, and the excitement of the shadow shape reaching out to you is fantastic.

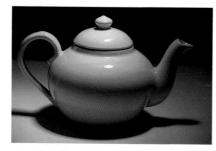

Backlighting for Drama

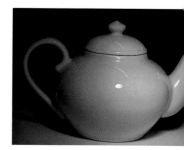

Unpleasant Front Lighting

284 Unpleasant Front Lighting

As you can see, front lighting is the least pleasing. Gradation of value is minimal, and there isn't much shadow to play with.

285 Experiment With Natural and Artificial Lighting

Most of my photographic references are shot outside in natural daylight. Studio light can be balanced using proper cool and warm lighting, but I prefer the energy of outdoor light, even for traditionally indoor scenes such as still lifes. Experiment with various types of lighting to see what you prefer.

286 Side Lighting Solution

The natural morning light coming from the right side allows the gradual transition from light to dark on the silver teapot's form, in *Morning Reflections*, right.

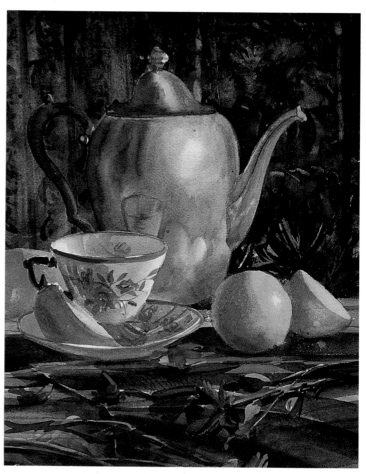

MORNING REFLECTIONS Betty Carr 16" × 12" (41cm × 30cm)

Refraction Solution

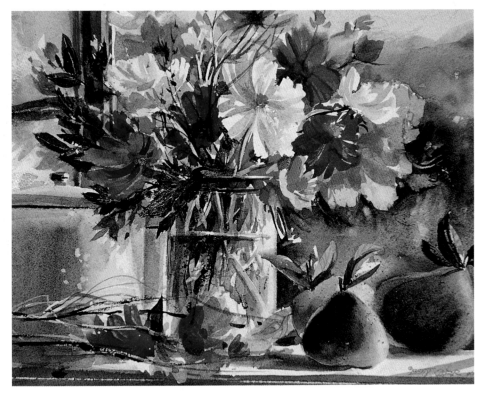

Overlap Various Lines

Fresh Pick (Pears) Betty Carr
16" × 22" (41cm × 56cm)

287 **Refraction Solution**

If you are having difficulty understanding the phenomenon of refraction, try this: Fill a glass half full of water, place a few stems in it, and take a close look. As you can see from these different eye levels (above, top), the line of each stem shifts.

288 **Overlap Various Lines**

Notice how the stems change as they pass through the water. The greater the angle of a particular stem, the more broken the line of the stem appears. Overlapping these various lines at the water's edge also helps to create the illusion of leaves and stems in the water.

REFLECTED LIGHT **TIPS**
by Betty Carr

My earliest memory of learning about reflected light is when my dad said, "Let's see if you really like the taste of butter." He picked a nearby buttercup and placed it under my chin in morning's light. We looked in a mirror. Wow! My neck and chin glowed with vibrant yellow.

289 Capture Reflected Light
Understanding how to capture reflected light will help you create more realistic, vibrant paintings. The luminosity you can incorporate through using the colorful energy of reflection is very effective. Generally the more intense the color that is bouncing into nearby forms, the brighter the reflections will be.

290 Surface Influences on Reflections
The surface of a form greatly influences the amount of light that will be reflected. Imagine an apple and a tennis ball placed next to a bright yellow light. The shiny surface of the apple is more reflective than the fuzzy tennis ball, which reflects much less light.

291 Know the Light Direction
Knowing the direction of the light and its quality, angle and color (artificial or natural) will direct you when painting reflected light. Discovering the color and color relationships of reflected light in shadow shapes is also helpful. The bouncing of light into nearby shadow shapes renders the shadows' value more transparent, lighter and generally warmer. It's this quality that can give a painting great luminosity and a bit of mystery.

292 Play With Light Transparency
The beautiful array of color dancing in and around this teapot (below, right) illustrates the property of light called *transparency*: rays of light transmitted through colorful transparent glass hit the reflective white glass surface. Playing with the transparency of light in painting is a great way to portray the dimensional effects of light.

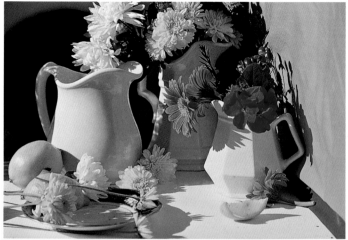

Observe Reflections
These white pitchers were photographed in natural daylight. Notice that the cubelike vase reflects light and shadow differently than the rounded vase, which has a gradual, smooth reflective transition. Again, we see that light envelops basic forms differently.

Play With Light Transparency

BACKLIGHTING **TIPS**

by Betty Carr

Backlighting occurs when the light source is behind the subject. Backlighting produces exciting connecting shadow shapes, great value contrasts and little color. Backlight is at times challenging to paint due to its high-key, contrasting characteristics. Because forms are often silhouetted and details limited in a backlit situation, dramatic, even abstract, compositions can result.

Reference Photo

293 Create Silhouetted Forms

The backlit trees and pattern of shadows form a peaceful winter scene (below, right). I masked the trees before painting the warm and cool shadows with one-stroke action. The background was painted with numerous glazes for grand contrast. I did the trees last, concentrating on the dance between warm and cool, light and dark.

294 Backlighting Limits Details

The gentle flow of morning light as it bounces and sneaks around forms is a delight to capture in watercolor. This pastoral scene (below) was filled with warm lights and cool shadows. I painted a small sketch on location and photographed the scene. This larger version was done back in the studio. Notice how little detail there is on the backlit tree and fenceposts.

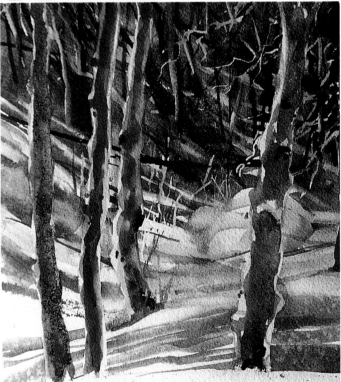

Backlighting Limits Details

MORNING GLOW Betty Carr 22" × 28" (56cm × 71cm)

Create Silhouetted Forms

WINTER SHADOW DANCE Betty Carr 12" × 12" (30cm × 30cm)

TECHNIQUE
Long Shadows and Glowing Light
by Betty Carr

While strolling along the tops of the desert dunes near Lake Havasu, Arizona, my husband and I mounted a grassy hill that overlooked a valley. The sandy, narrow road grabbed our attention as it wound through the desert toward the gorgeous blue lake.

The memory of long, incredible violet and blue shadows, and the sense of warmth and distance I felt while there inspired these paintings. Peering down into a landscape creates a viewpoint that is exciting to paint.

We'll approach this demonstration beginning with the foreground, then proceed through the middle ground to the background. The glowing feeling of light is accomplished through its contrast with the gorgeous stretched shadows. We'll paint in a loose style, leading the viewer's eye down the sandy road.

MATERIALS

PAPER 16" × 21" (41cm × 53cm), 140-lb. (300gsm) cold-press Arches

PAINTS Alizarin Crimson | Antwerp Blue | Burnt Sienna | Cadmium Orange | Cadmium Red Light | Cadmium Yellow Pale | Cobalt Blue | Cobalt Violet | Indian Yellow | Manganese Blue | Permanent Rose | Raw Sienna | Sap Green | Ultramarine Blue | Viridian | Opaque White

BRUSHES Flats | ½-inch (12mm) or 1-inch (25mm) Rounds | *Nos. 8, 10, 12 and 14* | *A few smaller brushes (for details)* | *Fritch scrubber*

OTHER Palette knife | Pencil | Masking fluid

Reference Photo

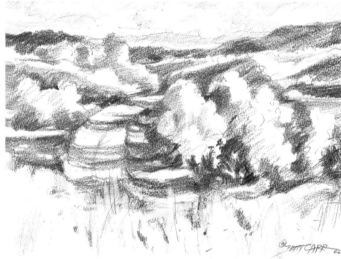

Value Sketch

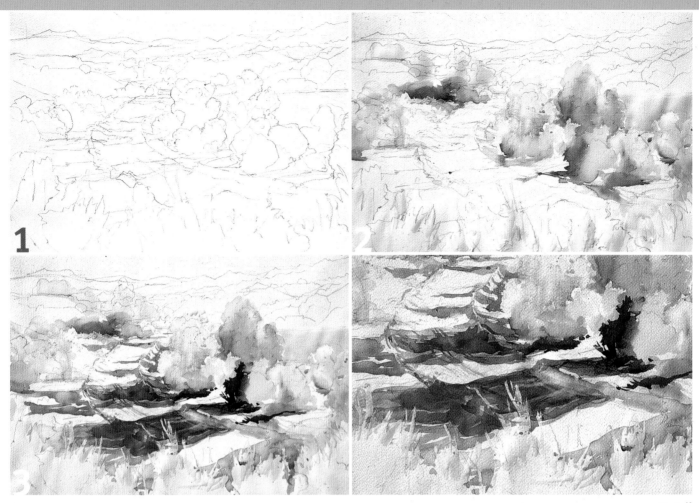

Detail

1 | Make a Line Drawing

In preparing your light drawing on watercolor paper, you decide what level of detail you are comfortable with. More detail does not necessarily mean that you will tighten up the painting. In the impressionistic manner of painting, you aren't bound by the little details—they're just used as guides to confidently approach your painting.

Apply masking to a few edges of the foreground grasses; otherwise it will be tough to save these delicate whites while painting the dark shadows on the road in the middle ground.

2 | Block In the Foliage

Most of the painting at this stage is done wet-into-wet. Start by painting the bushes and trees with various light washes of Raw Sienna, Cadmium Yellow Pale, Manganese Blue, Permanent Rose and a touch of Sap Green. Begin the foreground grasses with a light wash of Cadmium Yellow Pale, making the overall shape interesting. Because the shadows will enhance the dramatic light against these bushes, the building of these light-value shapes is a critical stage for the future shadow play.

3 | Start the Road Shadows

Using Viridian, Burnt Sienna and Cobalt Blue, darken the shaded side of the trees and shrubbery, pulling the directional shadows toward the road. Confidently paint the violet and warm-gray shadows following the contour of the ruts in the sandy road. Use Permanent Rose, Cadmium Orange and Manganese Blue with touches of Raw Sienna. Use a little more Cadmium Orange in the gray mixture when you want to warm it up.

Keep the shadows loose and soft-edged. Remember to vary the elongated shapes and keep the light coming from the right.

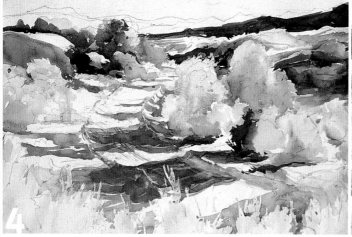

4 | Begin Painting the Dark Mountain Region

It's time now to create horizontal drama against the vertical shapes of the bushes and trees. Use Alizarin Crimson, Ultramarine Blue and Raw Sienna to paint the muted dark mountains in the background that will eventually contrast with the middle ground. Make sure the mountain lines are soft and that the shape does not appear to be man-made. Work more violets, greens and oranges into the background. Deepen the values of the distant trees in the upper left. Add touches of blues to begin the illusion of distant shapes.

5 | Add Distant Mountains

Continue developing the darker mountain area with various colors. Create the distant gray mountains using Cobalt Blue, Raw Sienna, Cadmium Red Light and lots of water to create a very light tint. Keep the edges soft and subtle. Add a few water droplets into the wet mixture to add an atmospheric aura.

6 | Add Darks to the Foliage and Paint the Lake Area

Glaze with Viridian, Antwerp Blue, Burnt Sienna, Alizarin Crimson and Cobalt Violet to strengthen the value and contrast of the foliage, especially on the dark side of the forms. Subdue the lake with combinations of Manganese Blue, Cobalt Blue and Ultramarine Blue with touches of Cadmium Red Light. Wet the lake area and, when slightly dry, drop in the blues and touches of yellow, greens and oranges for the water's edge and reflection. Make sure the edges in the reflection are soft.

Apply Indian Yellow, Ultramarine Blue and Sap Green along the shoreline and additional parts offshore. Suggest grasses, twigs and other

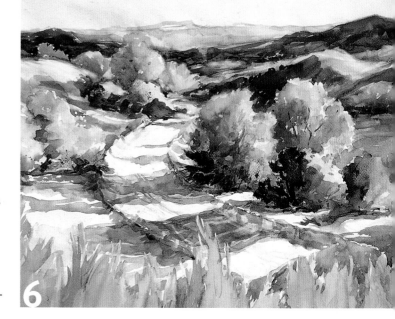

textures with a few palette knife strokes while the paper is wet, but not too wet. Add a few small branches to the large middle-ground trees using Burnt Sienna, Ultramarine Blue and Alizarin Crimson. After removing the masking on the foreground grasses, begin darkening this area using Viridian and Burnt Sienna.

7 | Add the Finishing Touches

Generally the sky is painted last unless it is the focus of the painting. A busy sky would distract the viewer from the center of interest, the shadow-laden desert road with beautiful adjacent trees. Paint the sky with Cobalt Blue, Alizarin Crimson, Cadmium Yellow Pale and a touch of Manganese Blue, using lots of water.

Apply a glaze of Cobalt Blue and Raw Sienna to the foreground grasses, along with a slight glaze of Cobalt Blue on the cool lake. Soften the edges of the middle-ground tree near the road by lifting with

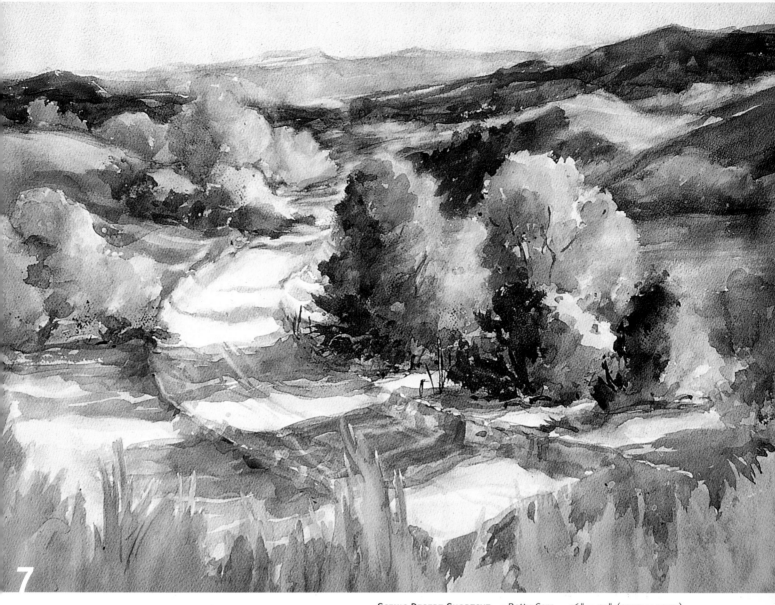

7

SCENIC DESERT SHORTCUT　Betty Carr　16" × 21" (41cm × 53cm)

a Fritch scrubber, allowing air to envelop the form. Apply a light, warm glaze of Raw Sienna on a few of the remaining whites. Sparingly add Opaque White for touches of light hitting the trees and on the road ruts.

It's often difficult to know when to stop, but it's more difficult to fix an overworked painting. It's best to stop a half hour before you think you're finished in order to keep your painting fresh. There's always something you can add, but it is important to leave something for the imagination of viewers.

296 Know Your Painting Strategy

In watercolor you generally start with the lights, gradually building up to the darks. In oil painting you begin with the darks and build up to the lights.

TECHNIQUE
Bright Light and Deep Shadows
by Betty Carr

I always look forward to early spring, when the numerous sunflowers that have been planted earlier in the year pop up. A favorite flower of mine to paint, its seeds are scattered all around from sunflower heads saved from last year. It's amazing how many actually pop up from this random scattering. The lively personality and posture of the sunflower lends itself to an action-packed approach in painting the flower's shape.

Different approaches to the painting process are like dances: sometimes it's a tango, other times a mambo or the waltz. Or you can think of painting styles in terms of athletics: sometimes a slow, thought-out approach works best, as in golf, while at other times the energetic pace of tennis is more appropriate.

In the following demonstration for *Dancing Sunflowers*, you will paint largely with an aggressive approach, moving your brush quickly, slowing down only once in a while. The wild, fresh-picked sunflowers will be painted loosely and impressionistically.

MATERIALS

PAPER 14" × 20" (36cm × 57cm)140-lb. (300gsm) cold-press Arches

PAINTS Alizarin Crimson | Antwerp Blue | Burnt Sienna | Cadmium Orange | Cadmium Red Light | Cadmium Yellow Pale | Cobalt Blue | Cobalt Violet | Indian Yellow | Manganese Blue | Permanent Rose | Raw Sienna | Sap Green | Ultramarine Blue | Viridian | Opaque White

BRUSHES Flats | ½-inch (12mm) or 1-inch (25mm) Rounds | Nos. 8, 10, 12 and 14 | A few smaller brushes | Fritch scrubber

OTHER Palette knife | Pencil | Salt

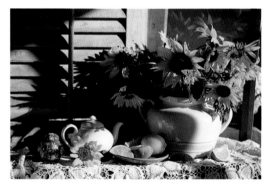

Reference Photo

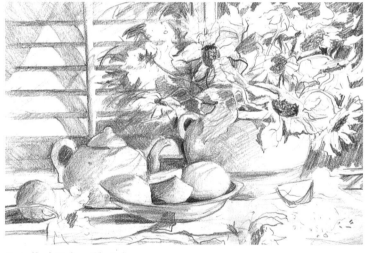

Detailed Value Sketch

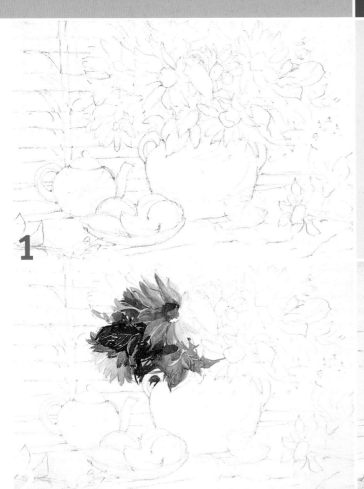

1

Shadows Affect Details, Too

Usually, it is better to paint details before adding the shadow shapes over them. If you try to paint the detail on top of the shadow form, the shadow form may lift and make a mess. Also, placing unshadowed detail on top of a shadowed form will look unnatural.

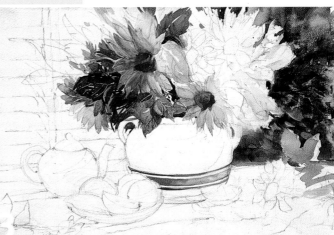

1 | Make a Drawing

Lightly pencil your drawing onto watercolor paper. Keep your drawing loose, hold your pencil as you would a brush and move with confidence—don't hold it as though you're writing a letter.

2 | Begin Painting the Darks

Begin with the darks and zero in on the center of interest. Paint confident dark greens with Antwerp Blue, Viridian, Indian Yellow, Burnt Sienna, Sap Green and Raw Sienna. Using a no. 12 round, pick up dark mixtures of Indian Yellow, Cobalt Violet, Raw Sienna and Sap Green for variety in the greens. Keep your brushwork loose and just have fun creating an almost abstract shape.

Yellow is the toughest color to darken because its value is so light. It's best to lean either to the green side or the orange side of yellow to push the value darker. The colors closer to the light source should be watered down to become tints. For the lighter greens of the sunflowers, use Manganese Blue, Cadmium Yellow Pale, Sap Green and Raw Sienna. Apply Cadmium Yellow Pale and Indian Yellow for the yellow-orange flowers, and establish their centers with a not-too-dark mixture of Burnt Sienna, Alizarin Crimson, Indian Yellow

and a touch of Viridian. Use large rounds or flats, and keep your strokes confident.

3 | Start Painting the Background

Put individual puddles of dark colors—blues, browns and violets—as well as Indian Yellow, on your palette, but don't mix them together. Wet the area around your light-value sunflowers with water and drop in these colors, letting them blend naturally on the paper. Tilt the board to move the flowing paint. Do not overmix or you will have a muddy background for your flowers. Let the area dry. If it's not dark enough, you can always re-wet and glaze the area to deepen the value.

Too often students forget that details on forms are affected by changing light. The bands of color on the vase are a good example of gradation. As you move from the light side of the vase to the dark side, subtly change the value of the detail. Use a watery tint of Permanent Rose and Cadmium Orange to begin and exchange it for Alizarin Crimson, Ultramarine Blue and Permanent Rose as it continues to surround the pot. Manganese Blue changes to Cobalt Blue for the outer two bands, finishing the detail. Continue developing the sunflowers and their greens.

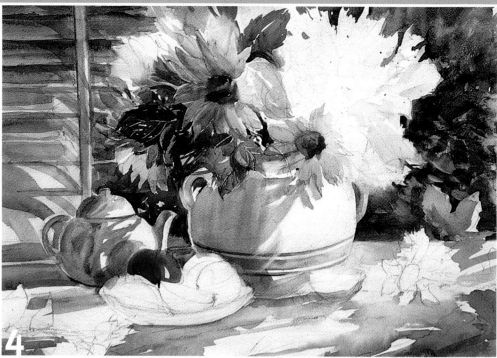

4 | Paint the Network of Shadows

Paint the vase with various grays, changing the proportions of warm and cool. Use more blue in the core shadow of the vase. Add more warm color to the gray as the shadow finds the light on the vase.

To paint the shadows on the vase and windowsill, use Manganese Blue, Cadmium Orange and Permanent Rose, following the light direction and eye level. Keep in mind the warmth in the gray-violet mixture. The gray mixture is warmer where the sunlight first approaches and cooler as it disappears off to the left and the outer edges.

Move on to the shutters with the same colors used for the shadows. Add more blue to the mixture for the area at the upper left; make Cadmium Orange and Permanent Rose more dominant in the mixture for the center of interest near the flowers. As you work on the shadows of the shutter, remember the light direction is coming from the right; as you close in from the left corner to the lower portion of the shutter, save some light areas.

Detail

5 | Add More Shadows and Paint the Fruit

Move on to the teapot using the same technique but with more blue in the form and the cast shadow, cooling the pot even more. Paint with warm and cool grays as well as with Alizarin Crimson, Cadmium Red Light and Cadmium Orange—the reflected colors resulting from the red apple.

Begin painting the fruit next. The light side of the apple is a mixture of Cadmium Orange and Alizarin Crimson; leave a little white highlight. Paint the dark side of the apple with Alizarin Crimson, a touch of Viridian and Ultramarine Blue.

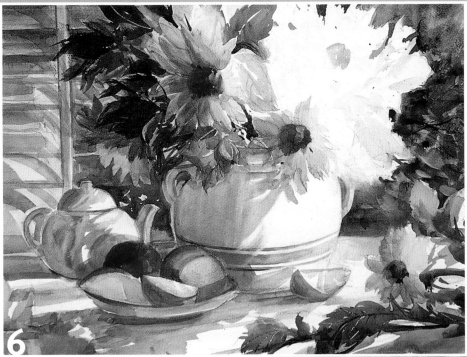

6 | Finish Some of the Dark Flowers

Finish the dark sunflowers using Alizarin Crimson and Cadmium Orange with a touch of Viridian; use Antwerp Blue, Burnt Sienna and a touch of Sap Green to finish the dark green leaves. Add a foreground flower and foliage along with a shadow to the lower-right corner. Use Antwerp Blue and Burnt Sienna for the greens, Cadmium Yellow Pale and Cobalt Violet for the yellow and Alizarin Crimson with Burnt Sienna and Viridian for the inside of the flower center.

Continue with the fruit using various warms to create the simple shapes. Use Raw Sienna, Alizarin Crimson and Viridian for the orange slices, Alizarin Crimson, Cadmium Red and Viridian for the apples; and a mixture of Cobalt Violet and Raw Sienna with a tad of Sap Green for the peach. Sprinkle some salt onto the peach to liven up the texture. Paint the fruit bowl with Manganese Blue, Cobalt Blue and Viridian, applying touches of yellow for the reflection.

Use a Fritch scrubber for continued softening of the hard edges in the background. Save the hard edges for the focal point.

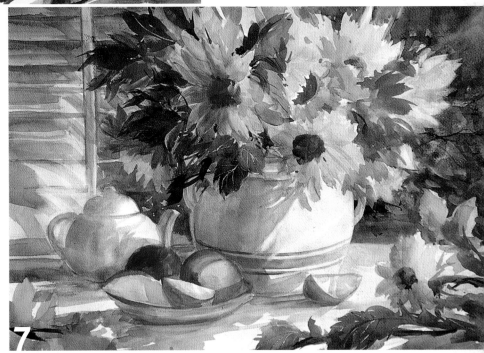

7 | Finesse the Lights and Model the Teapot

Using watery versions of Cadmium Yellow Pale and Cadmium Orange and, with a soft touch, paint the sunshine on the flowers in the light. Be careful to save the white of the paper for areas of light that we will perfect later. Use Raw Sienna and Manganese Blue to create a light tint of green for the sunshine hitting the leaves in light. Deepen the value of the teapot's shadow with strokes of Manganese Blue, Permanent Rose and Cadmium Orange. With Alizarin Crimson, add a few reflections to the sunny side of the teapot.

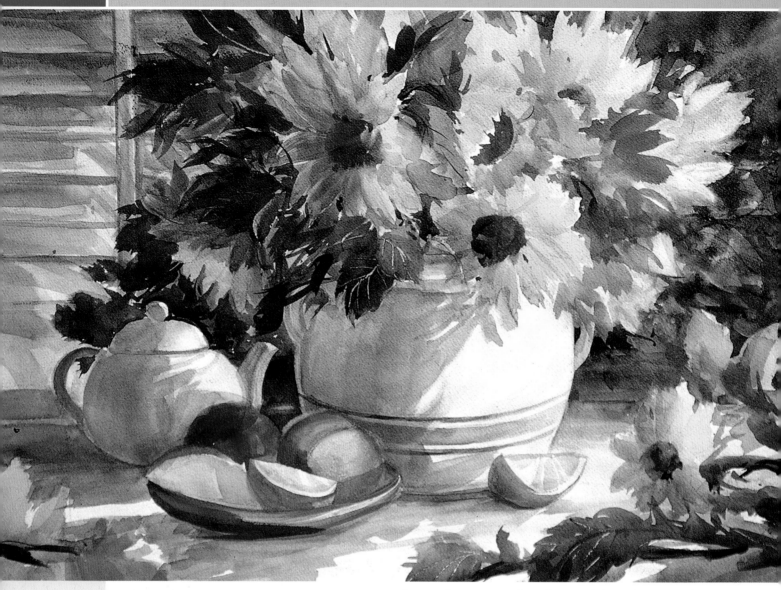

8 | Add Your Finishing Touches

Darken the fruit bowl using Ultramarine Blue and
a little Viridian on the shadow side, with a touch
of Opaque White for the side getting a glimpse of
light. Darken the cast shadow underneath the
bowl with Permanent Rose, Manganese Blue and
a touch of Cadmium Orange to accentuate the
light. Use small touches of Opaque White for the
tips of the flowers in light.

As you stand back from the painting and view
the subtle warm and cool colors that envelop the
forms, check for balance or awkward details that
pop out and seem out of place. Put the painting
aside, enjoy it and re-evaluate it in the morning.
It seems to have captured the light of the scene
effectively, and it looks like there won't be a need
for any final touch-ups. Remember to leave a little
bit to the imagination of the viewer.

5 COMPOSITION and DESIGN ANSWERS

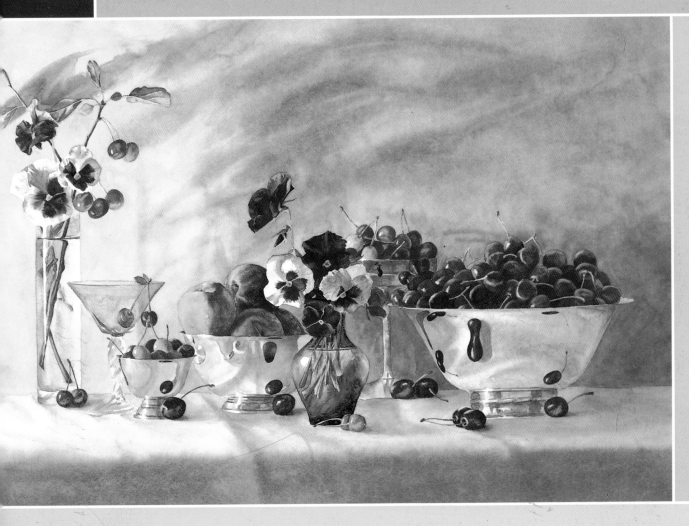

"Good designs are built upon the unbalanced repetition
of well-placed shapes."

— Donald Clegg

GARDEN MEDLEY NO. 6 Donald Clegg 22" × 30" (56cm × 76cm) Private collection

TIPS AND SOLUTIONS FOR CREATING A DYNAMIC COMPOSITION

by Betty Carr

Once you know how to see something properly, it's time to figure out how to portray it on paper in a compelling, attractive composition. This is when you take the time to really think it through. The planning stage is a part of the artistic process that many would just as soon overlook. Some artists make the mistake of jumping head first into a painting without a plan. They aim to convey prettiness, sentimentality or a concept without regard to its overall design.

This is similar to a home builder beginning construction with the light switch covers and wallpaper rather than a solid foundation. One of the most important reasons for having a plan for a sound design is that you will have more confidence that the work will be the best it can be. This confident attitude will show in your brushwork and painting style, making your compositions come alive.

Following are tips to ensure a great composition every time.

299 Decide What Excites You
Your goal should be to convey your excitement of the subject to the viewer.

300 Do a Number of Quick Sketches
How can you position the colors, shapes and values to best show the scene? Vary the point of view (eye level) from sketch to sketch to find one you are most satisfied with.

Also remember that an asymmetrical design is almost always more interesting than a symmetrical one.

301 Create a More Powerful Scene by Editing
Just because you see a silo in the field before you doesn't mean it has to make it into the finished painting. When you design a painting, you are taking a little section out of nature and selecting, arranging and balancing—basically, composing.

302 Establish a Direction of Movement
For example, horizontal forms move the eye across, and vertical ones move the eye up and down.

303 Incorporate Good Design Principles
Great art withstands the test of time primarily because of its good design. The principles of rhythm, movement, balance, direction, unity and proportion are all considered in establishing a successful design. Preliminary drawings, value sketches and compositional thinking will help you gain momentum in becoming a great artist.

304 Start With Big, Simple Shapes
Let's take a look at some of the most common formats used to design a painting. Observe the organization of big, simple shapes. Remember that detail is not considered at this point; just design—think of the big picture!

305 The *S* Format
The *S* format leads the eye through your painting and toward the center of interest. It usually takes the form of a road, path or river.

The *S* Format

306 The Asymmetrical Balance Scale Format

The largest mass is close to the center, balanced by a subordinate, smaller mass. The movement between the two is eye-pleasing. The value sketch is especially handy for constructing this type of composition—small darks balance light and medium values.

307 The *L* Format

In the *L* format, the center of interest is generally placed at the point where a strong vertical and an important horizontal connect.

308 The Three-Spot Format

An odd number is more artistically interesting than an even number. Counterbalance occurs here when a third mass is placed among two; the design will be more pleasing.

309 The Tunnel or *O* Format

Use the tunnel or *O* format when lines or masses are grouped together and form a tunnel or bull's-eye effect. In this format there is no mistaking where the center of interest is.

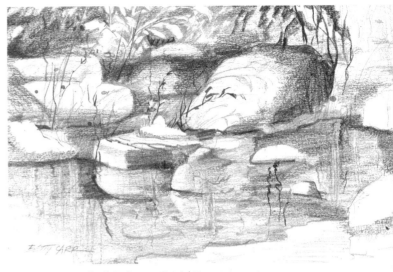

The Asymmetrical Balance Scale Format

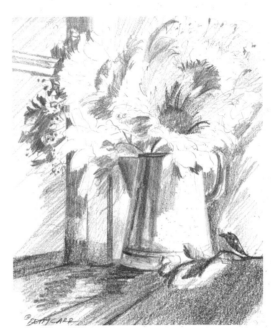

The *L* Format

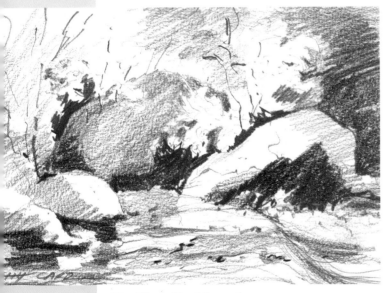

The Three-Spot Format

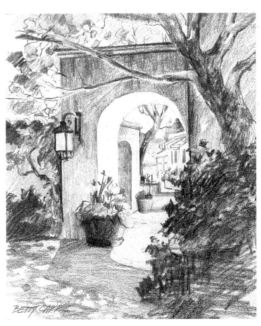

The Tunnel or *O* Format

310 The Triangle Format

A triangular composition suggests sound structure. A triangle is created by the placement of the main objects in your painting.

311 The Off-Center Placement Format

This format follows the golden mean. Think of a tic-tac-toe grid: Any of the four off-center intersections is a pleasing visual spot for your center of interest.

312 The Pattern Format

This is the most abstract format, with no formal center of interest. Its emphasis is placed upon similar masses or a pattern of harmonious shapes.

313 The Radiating Lines Format

Think of radiating lines as similar to sun rays or spider legs. Where the lines (or masses) seem to or do converge, they meet at the center of interest. Designs with one-point perspective are good examples of this format.

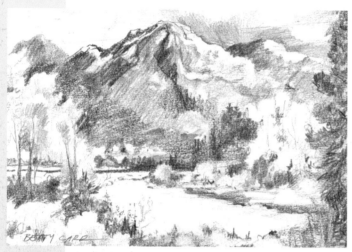

The Triangle Format

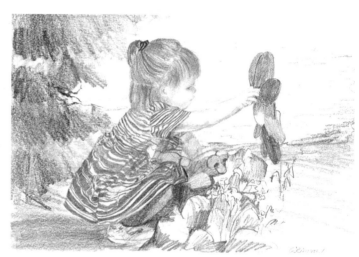

The Off-Center Placement Format

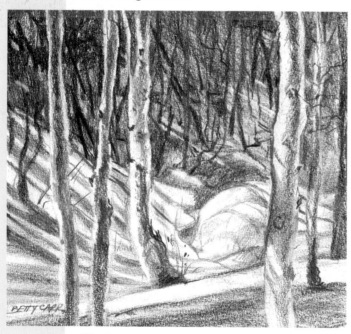

The Pattern Format

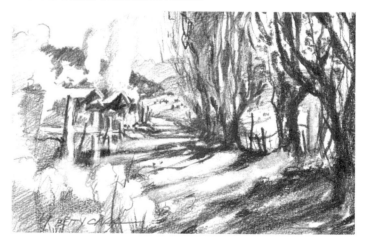

The Radiating Lines Format

DESIGN **SOLUTIONS**
by Jan Fabian Wallake

314 Communicate Your Vision

Subject matter is portrayed using design elements: color, line, value, shape and texture. After choosing the dominant theme (center of interest) for a painting, you must next decide on the best way to go about telling your story. The critical work of developing a painting involves decisions on design. What format best emphasizes the center of interest or focus of the painting? What direction and movement will lead viewers on the most exciting journey? What can be exaggerated? What can be eliminated? What is the most effective design to promote the desired impact? When you begin to relate to potential subject matter with these questions in mind, you emerge from painter to artist. Being an artist is not about replicating nature; it is about communicating a personal vision. Don't worry about whether your art is pretty; worry about whether it is effective.

315 The Bar Solution

If you divide your composition into three equal horizontal parts, a top (background), middle and bottom (foreground), it will be boring. If you alter the proportions of those bars, they become a design tool you can use for dramatic effect. This painting (below) has a small background, a medium-sized middle ground and a large foreground. I often use the exaggerated foreground for its dramatic quality.

316 The Butterfly Solution

Imagine a butterfly with outstretched wings. That pattern makes a good guide for remembering to open up your composition. Viewers enter a painting from the bottom. Opening a path from the bottom invites the eye to enter and explore your composition.

The butterfly should head toward the center of interest.

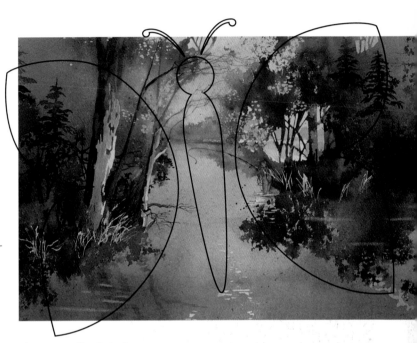

The Butterfly Solution

CASTING THE FLY Jan Fabian Wallake 14" × 21" (36cm × 53cm)
Private collection

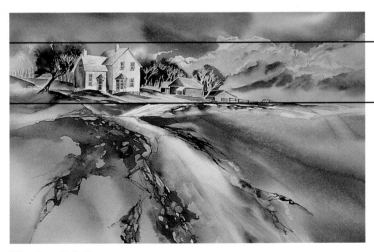

Background

Middle ground

Foreground

The Bar Solution

ROUTE ONE FARM Jan Fabian Wallake 20" × 28" (51cm × 71cm)
Collection of the artist

THE GOLDEN MEAN **SOLUTION**
by Pat Weaver

From my earliest studies I was taught the importance of a center of interest. While taking a workshop taught by Betty Lou Schlemm many years ago, I was introduced to the principles of the golden mean. I became aware of the fact that inside every rectangle there is a square, and inside every square there is a rectangle. That was one of those "Aha!" moments.

Not all artists use the principles of the golden mean. Some feel that it is not necessary for the success of their painting. I, however, think this is a very valuable theory and it has continued to intrigue me.

Studying further, I found several approaches to using the golden mean.

The approach I most often use breaks the picture space into seven unequal shapes with the focal point near the center, but not in the center. This creates visual tension and adds interest to the painting.

317 Determine Where to Place the Center of Interest

In each of the paintings on this page I have used the principles of the golden mean to determine the center of interest. This foolproof method has been used for centuries. Visually, the picture planes have been broken up into seven unequal parts.

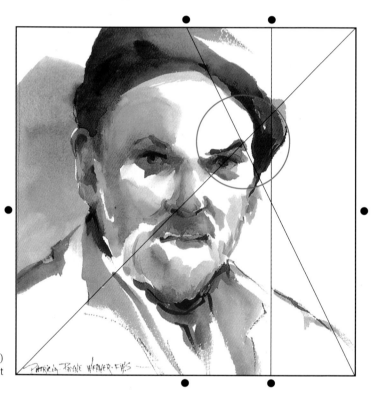

FRANÇOIS 11" × 11" (28cm × 28cm)
Collection of the artist

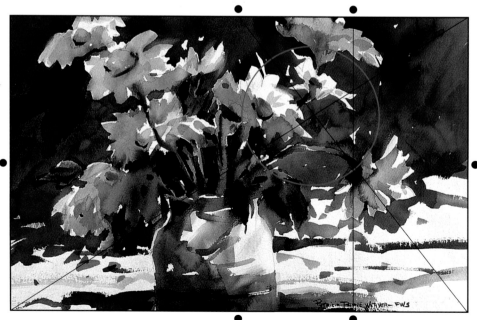

WHITE DAISIES AND LAVENDER
15" × 22" (38cm × 56cm)
Collection of the artist

TIPS FOR PLACING THE CENTER OF INTEREST
by Pat Weaver

318 The Standard Approach
The focal points are marked with *X*s. This shows that there are four possibilities for a center of interest; only one should be selected. This looks similar to the Rule of Thirds but has not been measured out.

319 The Rule of Thirds Approach
The rule of thirds is another compositional convention. If you divide the horizontal and vertical sides of the paper into three equal parts, the intersection points give you the placement for your center of interest.

320 The Four Rectangles Approach
In this approach, the rectangular paper is divided into four unequal rectangles. The center of interest is where the two lines intersect.

321 The Seven Unequal Spaces Approach
This rectangle is divided into seven unequal spaces. The center of interest is where the two lines drawn from the corners cross each other and form an *X*.

322 Don't Do This!
If you place your center of interest in the dead center of your paper, visually it divides the painting into four equal parts, making a very boring and static composition.

Another mistake is placing the center of interest too close to the edge or too near the corners, which leads the eye out of the painting rather than allowing the eye to travel through the painting. If your painting is busy all over, there will be no focal point and the eye will become confused and quickly tire of looking at it.

The Standard Approach

The Rule of Thirds Approach

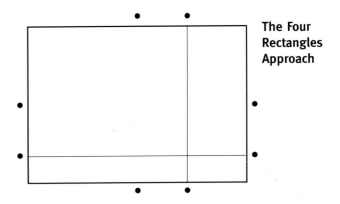

The Four Rectangles Approach

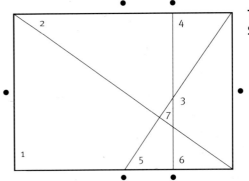

The Seven Unequal Spaces Approach

Don't Do This!

323 TECHNIQUE
The Golden Mean and the Center of Interest

by Pat Weaver

How do you find the right spot for the center of interest? We usually have some idea of what we want the center of interest to be. It could be a person, an animal, a building, a certain flower in an arrangement or even one eye in a portrait. Whatever you choose for your center of interest, it should show the lightest light, the darkest dark, the richest, most intense color and the most detail.

Let's explore how to find the center of interest using the golden mean by following this easy step-by-step demonstration. In this example we will place the center of interest in the upper-right corner.

MATERIALS

Paper | Pencil | Ruler

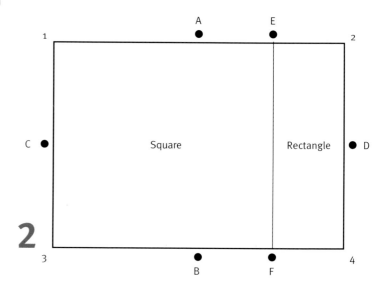

1 | Mark the Center of Each Side

Place a dot at the center of the top (A) and bottom (B) edges of the paper. Then place a dot at the center of the left (C) and right (D) edges.

Decide which side of the paper you want your focal point to be, then you will be able to locate the square inside the rectangle. In this example, we will be placing the focal point on the upper-right side.

2 | Find the Square and the Rectangle

Place a dot halfway between the horizontal center dots (A) and (B) and the right edge of the paper on both the top (E) and bottom (F) of your paper. Draw a vertical line between these two dots (E and F). The large rectangle is now divided into two unequal spaces that you can easily see. There is a square on the left and a rectangle on the right. The center of interest always lies on the inside edge of the square, never on the outside of the square.

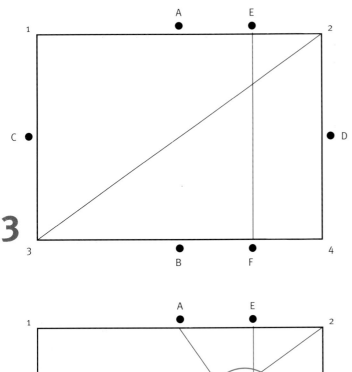

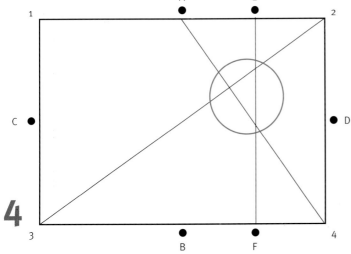

324

Keep It Simple

I often tell my students that in a play, a movie or an opera, there is room for only one star. If you attend a play and everyone on the stage is fighting for attention, out-singing or out-shouting one another, it will more than likely be very nerve-racking. The same is true of a painting. Keep it simple with one center of interest placed in just the right spot.

3 | Draw a Diagonal

Remember which corner you want your center of interest to be in. In this example, the center of interest will be in the upper-right portion of the picture. You will always begin in the corner nearest to where your center of interest will be. Draw a diagonal line from the upper-right corner (2) diagonally to the bottom-left corner (3). Now the picture space is divided into four unequal spaces.

4 | Define the Space for the Center of Interest

Start on the same side as your center of interest, but at the opposite (bottom) corner. Draw a diagonal line from the lower-right corner (4) to the top-center dot (A). Now count the spaces. There are seven unequal spaces. This formula visually breaks the large rectangular space into seven unequal smaller spaces, which is interesting and pleasing—never boring.

The golden section is where the two lines drawn from the corners cross each other to form an X. Draw a circle around this X as shown to create the golden section. The center of interest can take up all of that circle or just some of it. The bigger the paper, the bigger the area for the focal point becomes.

141

FUNDAMENTAL **TIPS** FOR GOOD COMPOSITION
by Donald Clegg

If you study the topic of composition you can find all kinds of rules for designing a painting. Applied slavishly, they seem to me to be the equivalent of giving you a fish rather than teaching you how to fish yourself, so I'm going to avoid them as much as possible. However, if I had to state just one rule, it might go something like this.

Take a look around you, and you'll see that salad forks are smaller than dinner forks and dinner plates are larger than salad plates. They illustrate the principle of unbalanced repetition, and you'll see it in good designs everywhere! A word of warning, though: Once you start to recognize good design you'll also be more sensitive to bad design. Unfortunately, that's also all around.

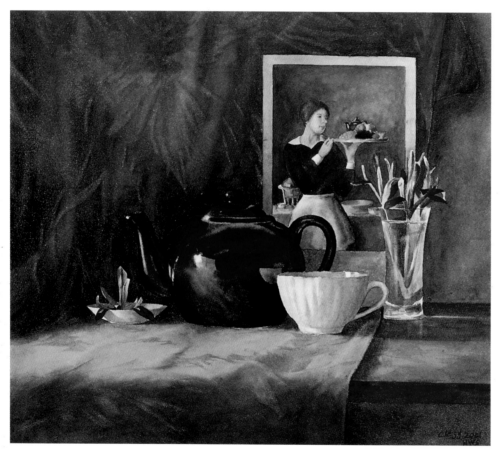

THE WAITRESS Donald Clegg 17" × 18" (43cm × 46cm) Collection of the artist

325 Think Abstractly

I occasionally like to pay tribute to artists whose work I admire, and here the challenge was to fit the white card (William Paxton's *The Waitress*) into the composition and keep it from sticking out like a sore thumb. I chose other elements to complement the shapes, values and edges of the card. Even though I'm a realist, while I'm painting, my concerns are almost entirely abstract. It didn't occur to me until halfway through the painting that the teacup related to the teapot in any other way than shape!

326 Good Designs

Good designs are built upon the unbalanced repetition of well-placed shapes.

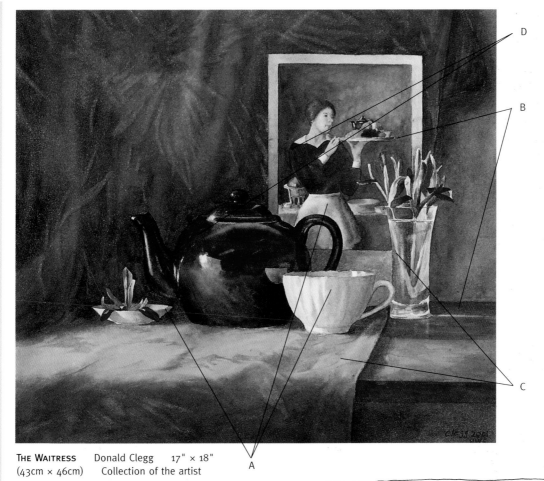

THE WAITRESS Donald Clegg 17" × 18"
(43cm × 46cm) Collection of the artist

327 Complement the Dominant Shapes

Always be on the lookout for ways to complement the dominant shapes in your painting. Your eye is delighted by the repetitions, even if you don't consciously recognize all of them.

A The white apron and cup have similar folds and relate to the small, accenting butter dish.

B The shelf is a rectangular shape that repeats the brown background behind the figure.

C The green stems echo the design of the green cloth, as do the irises.

D Though different colors, the values of the teapot and the waitress's uniform are similar.

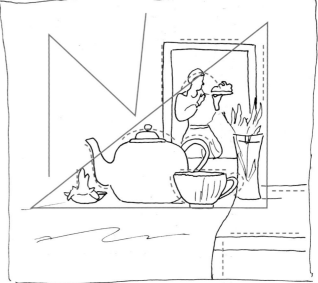

328 Provide Supporting Elements

The basic structure of this painting is a large right triangle. The negative space of the patterned cloth provides a restful complement to the main mass, but the folds also create echoing triangular shapes. You can see that a large variety of straight lines and curves balance one another. I think the eye enters at the card, but you can also make an argument for the left edge of the cup, where the hardest edges and most contrasting values meet. From there, my eye makes a clockwise trip, venturing occasionally into the cloth and out along the shelf. The hard edge of the lower-right side of the cloth is an important arrow, repeating the card's edge and providing a reason to move into the lower horizontal rectangle of the cloth. More significant, though, is the relatively small shape of the butter dish and iris. They provide an important balance to their counterparts on the right.

COMPOSITION: BEFORE AND AFTER **TIPS**

by Donald Clegg

Something I frequently hear is, "Oh, watercolor is so tough, and you can't make changes." I can't deny the difficulty of the medium (it's worth the trouble to learn though!), but you absolutely can make changes. Many of the approaches I now use regularly originated with desperation—trying to fix a bad painting.

At various times I've taken sandpaper, a razor blade or the sharp edge of my brush to paintings. I've put them on the ground and kicked and scuffed 'em with my shoes. I've rubbed the surface with a sponge or paper towel or the palm of my hand. I've even taken paintings outside and turned a garden hose on them!

From all this I know that you can make changes. When a good painting goes bad, don't hesitate to do whatever it takes to try to save it. If it's already bad you have nothing to lose, and as time goes by you'll learn the most effective ways to modify it. You may not even need your garden hose!

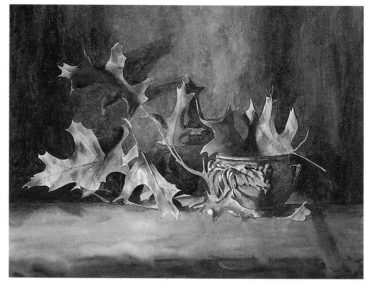

Oak Leaves (Before)

329 Crop to Fix a Flawed Composition

All artists have experienced that sinking feeling when a good design starts looking suspiciously like a stinker. I started this vase (above, right) as a visual complement to the oak leaves. However, as the painting went along, problems arose in the the most important area of the painting, the seat. These were among the most noticeable: The vertical bands of dark and light were boring—too much the same size and shape; none of the leaves was dominant, as each fought for attention; the leaves on the vase didn't read right.

I kept looking at a smaller section of the painting, which had some good qualities. Giving up the larger idea made me focus on the real area of interest—the leaves themselves—and crop the irrelevant space. Of course, it's best to avoid this situation altogether, but no one's perfect!

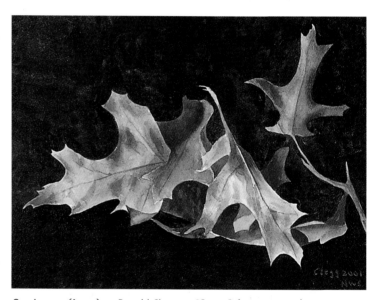

Oak Leaves (After) Donald Clegg 8" × 10" (20cm × 25cm)
Private collection

330 Simple Power

You can see in this final version (lower right) that I not only cropped the image, but I dramatically altered the background. Dominant and secondary areas of interest are clearly stated. Lost and found edges add an element of mystery and help to integrate the leaves with the background (when you squint your eyes, the background leaf almost disappears). If the leaf wasn't integrated with the background, it would appear to be somewhat awkwardly placed. As it is, I like the challenging element it adds to the design. I decided the light on the leaves, along with their crisp edges, were the qualities I wanted to emphasize.

TIPS TO CREATE INTEREST AND MOVEMENT

by Donald Clegg

331 Design Details

You might initially think this design doesn't work because it's too centered, but take a closer look and I think you'll find that it does work.

A This design is almost literally hanging by a thread. Cover this with your thumb and you'll see what an important directional pointer it is.

B Even though the negative space on either side of the bowl is essentially the same, these shadows break up the right side, creating smaller negative shapes that provide interest.

C Close values and lost edges provide movement from the oranges through the plums, keeping your eye from being stuck inside the bowl.

332 Use Silver to Your Advantage

One of the most appealing things to me about polished silver vessels is the chameleonlike way they take on their surroundings. As you can see, the reflection of the cloth's edge carries the eye through the bowl. Without that element, the breakup of space above and below the bowl would be insufficient; you'd stay trapped in the bowl.

333 Provide Relief From Static Shapes

It's clear here just how important the background cloth is. Without it, the shapes form an equilateral triangle, with the orange at the top being smack in the middle. There's virtually no reason to look to either side of the painting, since the negative shapes are identical, and the horizontal rectangle is equally boring—one long, unbroken passage.

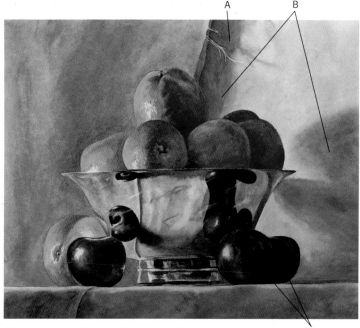

ARRANGEMENT IN PURPLE, ORANGE AND OCHRE
Donald Clegg 14" × 16" (36cm × 41cm) Private collection

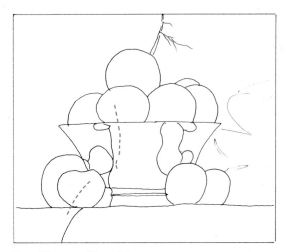

Use Silver to Your Advantage

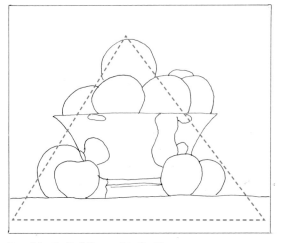

Provide Relief From Static Shapes

TIPS FOR DIRECTING VISUAL MOVEMENT
by Donald Clegg

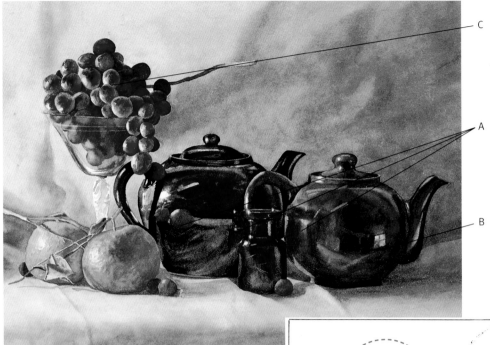

ARRANGEMENT IN BLUE AND GREEN Donald Clegg
14" × 20" (36cm × 51cm) Private collection

334 Look Beyond the Edges

Though many of the objects in my painting have clearly defined edges, I try to break up the internal shapes, expanding the possibilities for creating mood and movement.

A Although the outer edges of the teapots are well defined, I think the interiors provide some mysterious sweet spots with a lot to explore. The blue ink bottle heightens the appeal, with its own shape almost lost against the adjacent close values. Its reflections, though subtle, enhance the illusion of depth and move the blue across into the green.

B This reflection is interesting not only because it's a window, but because I needed a light value there to move the eye into that region of the painting. Cover it up and see what happens to the movement.

C Squint your eyes and you'll see that the grapes read more as a large mass than as individual grapes. Defining them any more would have been a mistake, making that area too busy.

335 Repetition Promotes Movement

This painting really shows how the repetition of one or more shapes—using a variety of sizes—can anchor a design. The grapes are a dark value and the only shape placed in the upper negative space; my eye enters there. The stem is a directional arrow further breaking up the negative space and leading the eye across that relief area. Then the eye begins to encounter the pleasing repeated curves of the teapots, eventually moving to additional curves provided by the tangerines. Even the folds are important, moving the viewer from the cloth back into the focal area. The stem in the lower left is perhaps placed at a somewhat risky angle, but I didn't want to be too obvious with another pointer.

TIPS FOR ENHANCING A CLASSIC ARRANGEMENT
by Donald Clegg

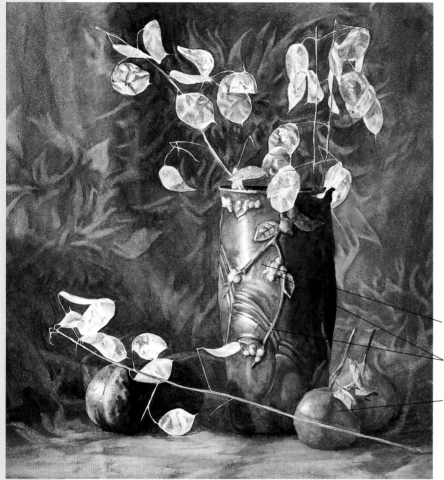

A

B

C

ROSEVILLE WITH SILVER DOLLARS Donald Clegg 18" × 16" (46cm × 41cm)
Collection of the artist

336 Making the Perfect Pattern

Occasionally, the elements of your subject matter may so naturally complement each other that the painting practically falls into your lap. This offsets all the times you have to struggle.

A Complementary reddish and green glazes make the vase an exciting focal point.

B The snowberries and twigs nicely echo the leaves and stems of the silver dollars.

C You'd spend too much time on the warm glaze of the vase without the tangerines to balance it. The leaves also repeat the green of the vase, and the stems provide an important entry into the negative space above.

337 Use Simple Structure

While the silver dollars, vase and patterned cloth certainly make for a lot of activity, the simple structure of this painting provides stability. The vase forms a solid vertical rectangle and the various stems of the silver dollars and raised twigs of the pottery move your eye along that vertical path. Complementing that area are the three main flower clusters of the background cloth, effectively breaking up the negative space and echoing the foreground shapes as well. The long, diagonal stem of the lower silver dollars is a bit risky, but I like the edge it gives to an otherwise classic arrangement.

TIPS FOR BALANCING MOVEMENT WITH REST AREAS

by Donald Clegg

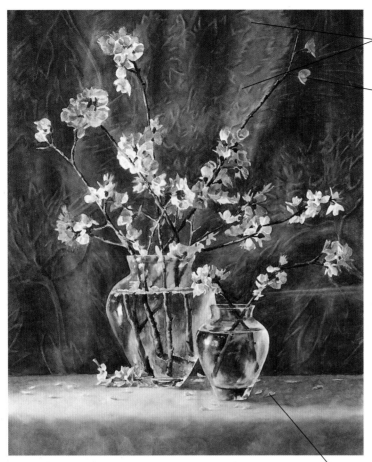

A

B

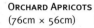

ORCHARD APRICOTS Donald Clegg 30" × 22"
(76cm × 56cm) Private Collection

C

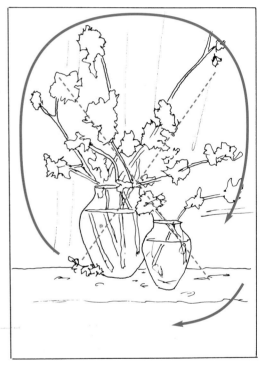

338 Tie It Together

The structure and edge quality of your foreground shapes often suggest the type of treatment you might give to the background and smaller details, such as the fallen blossoms here.

A Even though the fabric's printed pattern does not exactly match the design of the blossoms, they share many of the same edge qualities.

B The upper-right corner of the painting would be too empty without this interjecting branch and its blossoms.

C I think the fallen blossoms add an interesting circular movement to the tabletop, as well as an air of casualness.

339 Create a Circular Movement

Though there's quite a lot going on in this piece, the design is a simple one. The X of the branches and blossoms creates the dominant movement.

The pattern provides a supporting circular movement that moves the eye through negative space. All this activity needs a quiet relief area, so the background and foreground were left understated.

TIPS FOR INCORPORATING SHADOWS INTO THE COMPOSITION

by Donald Clegg

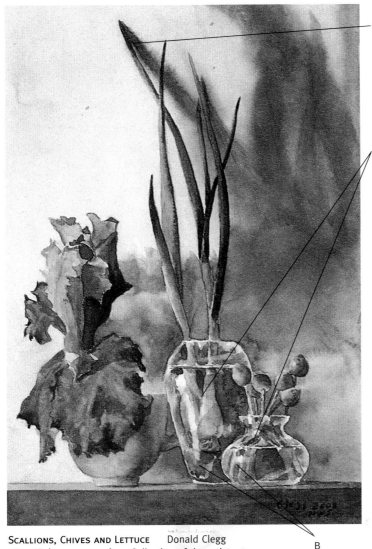

SCALLIONS, CHIVES AND LETTUCE Donald Clegg
9" × 6" (23cm × 15cm) Collection of the artist

340 Create Depth on a Flat Plane

Artists sometimes fall into the trap of allowing shapes on a flat plane to remain static and separated. Try to use interesting shadows and overlapping shapes to prevent this.

A This shadow anchors the scallion to the wall, providing more depth than if it were missing.

B Overlap shapes of objects at eye-level to show what's in front and what's behind.

C To make objects in clear vases look right, pay attention to how glass and water distort their forms.

341 Use Shadows as Compositional Elements

The vertical shapes of the lettuce and scallions, connected to the shelf, make a dominant triangle that is then echoed by the smaller cluster of the cup and vases. You can see that the upper thrust of the scallions would stick the eye right in the middle of the painting without the directional movement provided by the cast shadows. Notice, too, that the shadows from the lettuce, as well as the top edges of the vases, provide horizontals that help to break up the overall vertical thrust of the design.

TIPS FOR CREATING MOVEMENT
by Donald Clegg

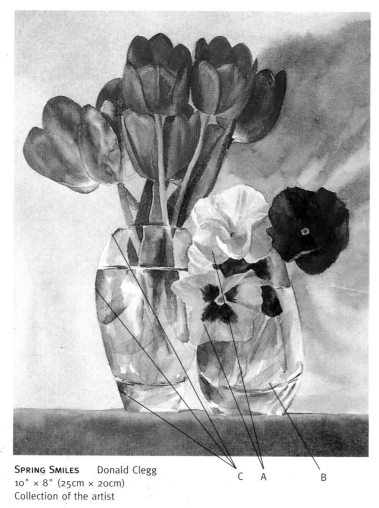

SPRING SMILES Donald Clegg
10" × 8" (25cm × 20cm)
Collection of the artist

C A B

342 Create a Lively Look

Some subjects—like these flowers—are so naturally dynamic you don't need to search for ways to "punch it up." Just paint what you see!

A A variety of pansies is more fun to look at than one single type since each has its own appeal—some solid, some with faces.

B A number of small, wet-on-dry strokes enhance the surface of the vases, as well as creating an interesting abstract rhythm and movement.

C Accenting a few key edges pops the vase out; otherwise, it's nearly invisible against the background.

343 Create Movement With Multiple Entry Points

This composition has a playful movement that's hard to nail down exactly. The eye can enter the painting at the tulips or the pansies, either the yellow or dark purple pansy. Basically, the entire mass of flowers makes up a large rectangle, and the eye moves back and forth within it, rotating in a circle or a figure eight. Then, occasionally, it zips out of there, exploring the vases before going back in. The movement actually reminds me of a bee in flight!

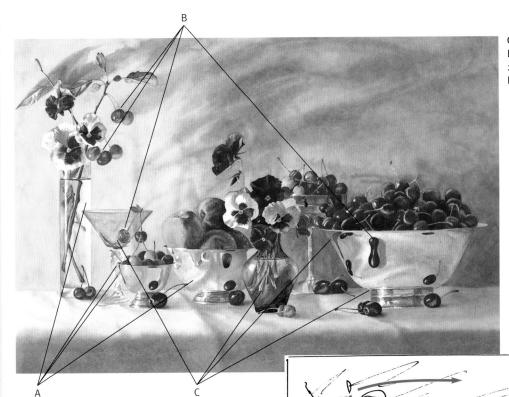

GARDEN MEDLEY NO. 6
Donald Clegg
22" × 30" (48cm × 51cm)
Private Collection

344 Make Abstracts Punch

Even though I'm a representational painter, I readily make use of abstraction in my work. If you arrange shapes to be reflected, like this, be careful not to make an accidental smiley face!

A A variety of lost and found edges provides movement through adjacent areas and helps to create a feeling of light and airiness.

B Cherries dangling and reflecting in unusual places give a playful feeling to the painting, as well as providing extra movement into areas that otherwise might be too empty.

C Though the reds dominate, enough green occurs for complementary impact; even small areas of reflected green have an impact when its overall use is so small.

345 Make the Eye Travel Horizontally and Vertically

Even with all its activity, this design is simply structured. The eye enters at either the upper left or the pansy near the center—the only intrusions into the negative space that composes the upper half of the painting.

If you enter at the center pansy, you rotate back left to the pansies, cherries and leaves,

then sweep back through into the busy area with the massed fruit and flowers.

With all the overlapping shapes, it's fun to explore this busy area before reaching the edge of the silver bowl at the far right. Then, you encounter the secondary horizontal movement back along the base of the bowls, occasionally venturing upward into the vertical diversions provided by reflections and stems.

The eye takes a break, traveling through the negative expanse of light and shadow above the main area of activity, then entering that area again. With the sweeping dive from the upper left into little hills and drops across the way, this painting's design gives the eye a roller coaster ride!

151

TIPS FOR CREATING A DYNAMIC BACKGROUND
by Donald Clegg

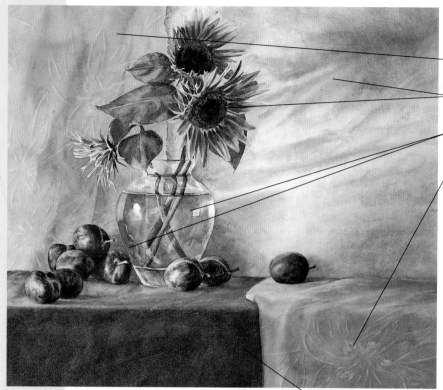

GARDEN MEDLEY NO. 2 Donald Clegg
19" × 20" (48cm × 51cm) Private Collection

346 Tie It Together

This is a good example of using the background to make a centered design work well. Without the breakup of negative space it provides, this would be a relatively boring composition.

A The pattern in the cloth repeats the shape of the sunflower petals. The gold harmonizes with the flowers, while providing a complement to the plums.

B Attention to small details in the vase—for instance, the plums' and window's reflections onto it—contributes to creating the illusion of glass.

C The shadow repeats the shape of the flowers and balances the blaze of light just below.

D This large, dark expanse helps to anchor the painting, and relates to both the dark values of the plums and the green leaves.

347 Build a Solid Foundation

If you were to take away the sunflowers, vase and plums, this would still be a good composition. Notice not only how each rectangle formed by the cloths' edges is a different size, but that each boundary roughly follows the rule of thirds. Look also at how the two gold cloths play against each other, balanced by the other diagonal opposition of light and dark. With this as a foundation, the painting is bound to succeed.

As in many of my designs, the mass of the foreground objects is framed by a large triangle, just about guaranteeing that the eye will pay attention to the shapes within. The arrows point out just a few of the directional indicators that help move you to other areas. Ideally, you should provide something of interest—and a path to get there—in every square inch of your paintings. Granted, that's tough to do!

TIPS FOR INCORPORATING INTERESTING NEGATIVE SHAPES

by Donald Clegg

INDIAN CORN WITH DEB'S PUMPKINS Donald Clegg
16" × 18" (41cm × 46cm) Collection of the artist

348 Negative Shapes Are Key

If you are not continually aware of the impact negative shapes can have on your work, you might miss ready opportunities to increase the visual impact of your image. I think this is a particularly good example of negative shapes at work.

A The movement from a warm red-orange to a darker green-gray keeps the large rest area interesting. The vertical stem divides the large, negative shape at the top into a dominant area (right) and a subordinate area (left).

B All these interlocking negative shapes repeat each other in both shape and value and help to provide rhythm to the design.

C Without this stem intersecting the expanse at the left, the eye would be forced to circle within the shucks and pumpkins with no clear avenue into the negative space around it. Though the lost left edge of the smaller pumpkin helps, that in itself is not enough.

349 Simplify the Design With Overall Movement

This is a busy painting, with the interwoven shucks and all, but the design is relatively simple. As the solid lines indicate, the overall movement within the image is provided by a large reverse *S* curve, balanced by a long diagonal that extends from the upper-right shuck passing across the corn and ending just below the left pumpkin.

The dotted lines show just a few of the echoing curves and diagonals (sometimes both), but they really occur all over the painting. I don't think you can find a single shape that isn't repeated somewhere else. For instance, the tall pumpkin stem is repeated by the small, vertical shuck occupying a similar space opposite it. Looking at the arrows, you can see that some of these shapes also serve as traffic police, telling you to move into and out of negative space, depending on which direction the eye is traveling.

TIPS FOR HARMONIOUS DESIGN
by Donald Clegg

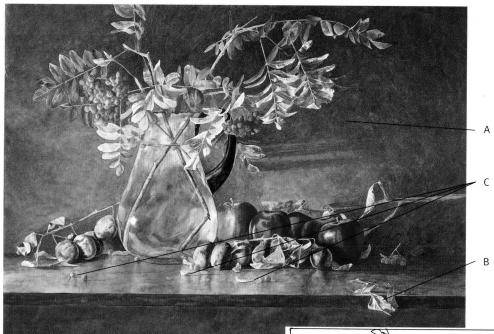

MOUNTAIN ASH WITH GREENBLUFF PLUMS Donald Clegg
22" × 30" (56cm × 76cm) Private Collection

350 Quiet Complements

This is one of my favorite paintings, one that I think sings rather than shouts. As usual, composition was a main concern, but, after that, I just enjoyed painting these wonderful colors.

A The muted green-gray of the background is just enough to pop out the warm golds, oranges and reds in the foreground. Too much green and it would compete; too little and the painting would be bland.

B This small shape not only echoes the strong diagonal created by the branch and right side of the pitcher, it is very important for breaking the long horizontal edge of the shelf. Cover it up with your thumb and you'll see that the design isn't nearly as effective.

C These small accents are all but invisible when you squint, yet they play a vital role in moving the eye as well as echoing the golds and oranges from above.

351 Harmony and Rhythm

Just as musical harmony is built on tones, so is a good painting. Here, the bass note is the long horizontal of the shelf.

I deliberately left a long expanse in order to set up the more intricate notes above it. Other supporting horizontal tones are required to provide rhythm as well as harmony.

Supporting that rhythm is the strong skeleton of the well-placed pitcher and the *X* design that provides dynamic diagonals to offset the stability of all the horizontals. Finally, each branch of the mountain ash acts as a directional arrow, moving the eye through the composition.

6 CREATIVE TECHNIQUES and HELPFUL HINTS

"Greatness is based on what we feel is worth saving, what we want to pass on to future generations. The spirit of the artist must, in some way, touch the soul of the viewer. Technique is certainly part of greatness, but the individual spirit of the artist or his or her mode of expression is what painting is all about."

— Betty Carr

WATER FLESH NO. 24 Linda Stevens Moyer 29" × 42" (74cm × 107cm)

NEW MATERIALS AND **TECHNIQUES** TO EXPLORE

by Jan Fabian Wallake

This chapter will help you explore new ideas and experiment with painting. It is exciting to see how the pigments and water are altered when various products are applied to them. Ordinary, everyday products can yield exciting new effects.

One day, I raided the kitchen looking for items that might cause some reaction with my paints. I tried coffee crystals; they stained the paper light brown. I can get the same effect by glaz-ing with varying mixtures of Daniel Smith Quinacridone Gold and Burnt Umber. Flour made a paste that is similar to an impasto medium, but it is not permanent and I realized that it would eventually attract bugs. Egg whites gave no particular effect. Dish soap works well as a base for monoprint (see page 163); it keeps the paint from beading up on the Plexiglas. I also experimented with cornstarch. Like soap, it works well for the monoprint technique. I even put a wet wash of color into the microwave to see what would happen to it (not much of anything, by the way).

Another time, I went to the garage to explore items that could change the texture or performance of my paints. I added acetone, turpentine and mineral spirits. Of these, I got the most striking results with the acetone. It created beautiful halos in the paint wash. A similar effect can be created by dropping rubbing alcohol onto a wash.

I also went outdoors to paint with nature, literally. I wanted to explore the technical possibilities of how auxiliary materials like leaves, twigs and sand would alter the expressive qualities of my paints. I found that I can impart an image of leaves and foliage by using a real leaf as a stamp. I can use the sharpened end of a twig dipped in paint to drag fine lines of paint or masking fluid across my paper. Small pebbles, shells or even flowers laid on a damp wash will leave interesting imprints and have viewers wondering how the painting was developed. These auxiliary techniques offer a contrast to painting done with a brush.

If you are looking for a fresh approach with your watercolors, try some of these unconventional techniques and materials.

352 Try Household Items

Experiment with everyday household items to create interesting effects with watercolors.

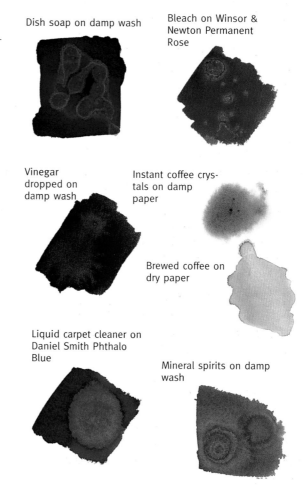

Dish soap on damp wash

Bleach on Winsor & Newton Permanent Rose

Vinegar dropped on damp wash

Instant coffee crystals on damp paper

Brewed coffee on dry paper

Liquid carpet cleaner on Daniel Smith Phthalo Blue

Mineral spirits on damp wash

353 Create Texture With Salt

Salt crystals repel pigment. They create an interesting texture when sprinkled on an even wash of watercolor. There are, however, a few tricks to getting the effect you want. Take a look at these different approaches to spicing up a window.

Approach 1: A Frosty Window Lay down an even wash of color. Watch the wash settle into the paper. Just as the wash begins to lose its shine, sprinkle on a few grains of ordinary table salt. You will not see a pattern immediately. Wait until the wash dries, then brush off the salt grains and take a look at the pattern. If you want to bring the pattern out even more, scrub over the area with a clean, dry paper towel.

Approach 2: A Rainy Window Lay down an even wash of color. A dark, nonstaining pigment will yield a striking effect for this technique because the paint lifts away to reveal white paper. Staining pigments bite into the paper and, like dyes, are difficult to lift out. Just as the wash settles into the paper and begins to lose its shine, sprinkle on a few grains of table salt. Now hold the paper up at an angle so that gravity will pull the moisture down. Give the area a quick spray of water from a pump spray bottle; use one that has a forefinger pumping mechanism on the top of the bottle. It will broadcast a field of individual droplets.

Individual droplets of water from the pump sprayer must hit individual grains of salt for this technique to work. As the salt reacts to the water, it repels the paint, and the result is a fluid drizzle running down through the color wash.

Continue to hold or prop the paper up at an angle until it dries. Scrub the area with a clean, dry paper towel to brighten the effect.

354 Apply Salt Granules Sparingly

You will get a better effect if you drop the granules on sparingly. Each grain must have room to repel the color around it.

355 Use the Right Type of Sprayer

Avoid fine-mist sprayers such as hair spray bottles; the droplets are too small and too close together. Also avoid a trigger-type sprayer; it shoots a stream of water that is too powerful for this effect.

Salt on a Wash

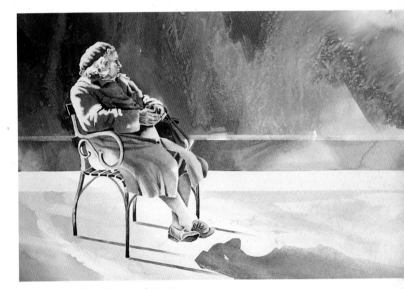

An Interesting Textural Pattern

I wanted the design and mood of this subject to dominate, so I eliminated all background matter. The textural pattern behind the figure is nondescript yet interesting in its movement. I used the salt technique with clear water spray.

WAITING Jan Fabian Wallake 12" × 17" (30cm × 43cm) Collection of the artist

356 Salt Solutions

If you are having trouble, check the consistency of your paint. Is it too thin? Is it too heavy? Are you using a staining color? Are you sprinkling the salt on too soon or letting the wash dry too much? Are you dropping on too much salt? Remember, less salt is better for this technique.

357 Create Texture With a Pump Sprayer

I use a spray bottle for almost every painting I do. As a method of wetting my paper, I spray to wet the surface instead of using a brush or sponge, which would depress the surface fibers of my paper and reduce transparency. That is especially important when glazing, because I want light to refract off each fiber of the paper's surface. Use a pump sprayer for this technique.

Hold the bottle approximately 10 inches (25cm) from the paper, spray once, spray again and continue until the individual droplets just begin to merge. Then load a brush with paint of a creamy consistency. Saturate the brush until paint drops freely from the tip. Touch the tip onto the top of one of the droplets of water on your paper. The paint will swim from one drop to the next, invading the entire spray pattern. Tip your paper to help the paint run if needed.

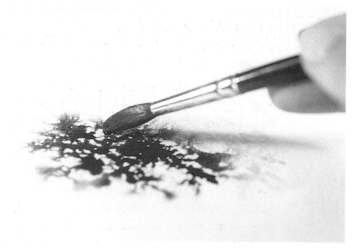

Touch the tip of a loaded brush to a droplet of water. To see this technique in a finished painting, look at the foliage in *The Gardener* on page 168.

358 Paint Through Cheesecloth

Cut a piece of cheesecloth, and lay it out in a single thickness. Stretch and pull the threads into long strands, creating holes and tangled fibrous clumps.

To confine the texture to a given area, tape or mask off any spaces that are not to receive patterning. Lay the fabric down on dampened (not wet) watercolor paper, arranging a design of the connective pattern of strings. Mist the entire sheet and the fibers with clear water to hold everything in place. Now add color. Use a large, soft mop brush to move the color over the threads. Be careful not to move the fibers as you add the paint.

When everything is completely dry, remove the fabric.

Stretch and pull a piece of cheesecloth into an interesting pattern.

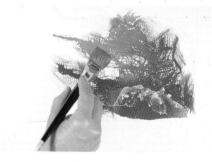

Add color. Here, I masked out a leaf pattern before applying the cheesecloth technique.

359 Determine the Distance

Practice with your pump sprayer to determine at what distance from the paper you get the best pattern of separate droplets. Try a spray pattern on a counter or a piece of Plexiglas so you can see the droplet design. If you hold the sprayer too close to the surface, the droplets will merge into one pool. Hold the sprayer about 10 inches (25cm) from the surface and deliver a confident pump. Repeat this spraying until each droplet is heavy with water.

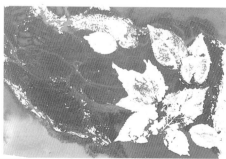

Let dry. Remove the fabric and see your exciting pattern.

360 Imprint With Plastic Wrap

Ordinary kitchen plastic wrap creates interesting effects when it is laid on a color wash.

Application 1: Gather and Stretch Cover any areas of your painting that you do not want textured by the plastic wrap technique. Use masking fluid to save those spaces. You can also save them by simply covering them with a paper towel.

Cut a piece of plastic wrap that is larger than the area you want textured. Gather it first along one side, then along the opposite side. Stretch it tightly apart, then lay it down on a wet wash of color. Tape the gathered edges down to prevent the pattern from moving. Allow the wash to dry.

When the paint is dry, remove the plastic wrap and discover a unique and natural pattern that can be used for waves, wood textures, stratified cloud layers and furrows in ledge rock.

Application 2: Crumple the Wrap If you crumple plastic wrap and press it into a wet wash, you will get a pattern of fractured shapes.

First, lay down a nonstaining wash of color. While it is still wet, lay the scrunched plastic on it. Press and hold it down with a weight until the paint is dry.

This makes a nice effect for floral backgrounds, rock texture and distant mountains.

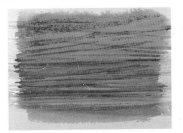 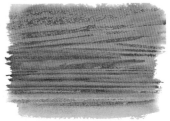

Tightly stretch the plastic wrap across the area you want to texture.

This unique pattern can be used for waves, wood, rock or stratified cloud layers.

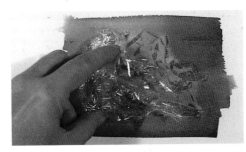

Press the crumpled plastic wrap into a wet wash.

Use this effect for floral backgrounds, rocks and distant mountains.

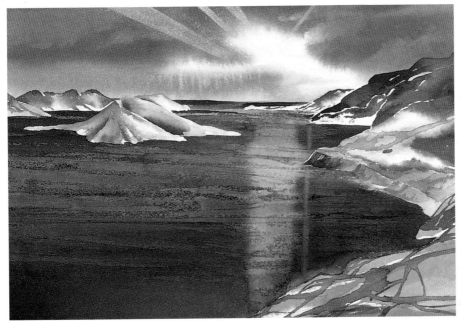

SANTORINI SUNSET Jan Fabian Wallake 10" × 14" (25cm × 36cm)

The Wave Effect

When I was on location in Santorini, I began a painting of the islands amidst the blue Aegean Sea. I wanted a dramatic effect for the water. First, I covered the islands with masking fluid. Then I chose an intense mixture of French Ultramarine for the sea and used the stretched plastic wrap technique. When the paint was dry, I removed the plastic and had an image of distant waves on the sea.

361 Use Natural Objects to Make a Stamp

I like to paint my own greeting cards, and whenever I can, I bring nature into my work. Stamping with leaves works well and is an easy way to create natural looking impressions without having to paint every tiny vein.

First, find a leaf with a prominent veining pattern on the back. Add color to the vein side of the leaf, then turn the leaf over and place the painted vein side down on your paper. Press it down with a clean, folded paper towel.

Lift the towel and leaf from the paper. I usually paint in some areas of the imprint with clear water so that the lacey texture is not overwhelming. Touch up any points on the leaf design that need refining, and add a stem.

362 Use Natural Objects to Make a Stencil

This technique makes a glazed, layered quality.

First, place a real leaf on dry watercolor paper. With a clean brush, dampen the paper ½ inch (1cm) away from the edge of the leaf. Do not dampen the paper right next to the leaf, or the color you paint on will bleed under it.

Next, hold the leaf down. With your brush (a large flat works well) loaded with color, paint over and out from the center of the leaf into the dampened area. Use a heavier consistency of paint so that it does not run back under the leaf's edge. The paint that touches the dampened area will feather out to a soft edge, while the paint that runs over the leaf's edge will form a hard edge.

Pick up the leaf and let the entire area dry. Once dry, you can repeat the process with the same or another leaf and the same or another (analogous) color of paint. Build up a foliage pattern in this way. I use this technique for backgrounds and like to combine it with the stamping technique.

363 Soap Solution

If the leaf has a waxy surface, paint a thin layer of dish soap on the underside. It will help the paint adhere and not bead on the leaf. Paint over the soap on the underside of the leaf with one or more colors. Analogous colors work best because they will not merge into muddy tones, but will blend naturally into each other. A creamy consistency will produce a good imprint.

Use Natural Objects to Make a Stamp

Paint color on the vein side of the leaf.

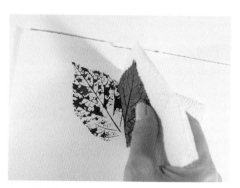

Gently lift the leaf from the paper.

Use Natural Objects to Make a Stencil

Paint over and out from the center of the leaf into the dampened area. Remove the leaf and let dry.

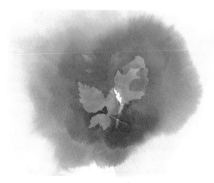

Use this technique to build a foliage pattern.

Blow Through a Straw

I live in Minnesota and see beautiful trees in every season. In the summer, the deciduous trees are full of green leafy foliage. In the winter, the bare branches of birch, poplar and oak provide a linear contrast to the towering evergreen pines. To paint bare tree branches that have a natural look, I often use a straw to blow the paint into angular branch formations. Most trees have twigs and branches that grow at an angle to each other. Twigs grow smaller in size and are more plentiful at the top of the tree.

To mimic this appearance, paint the tree trunk and a few of the main branches up the middle of the tree. Working on dry paper, drop a large amount of paint onto those branch lines. You actually want to see a bead of paint sit on the paper.

Next, place one end of a straw very close to the branch lines and give a mighty blow. (I like the straws that have a bendable section, because they are easier to manipulate.) You can drive the spurts of color in various directions by changing the straw's position for each blow. It is surprising how many offshoots you can get from one original branch line. Short, powerful bursts of air work best and produce an intricate pattern of tiny twigs.

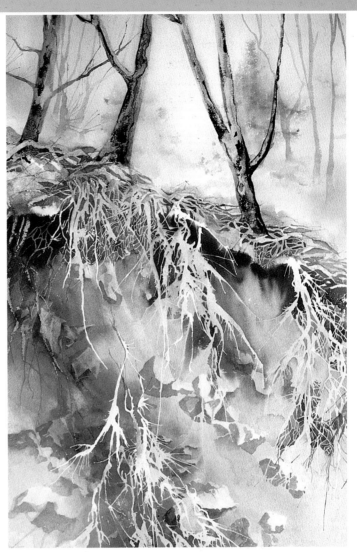

Paint a few main branch lines. Use an excessive amount of very wet paint for these lines.

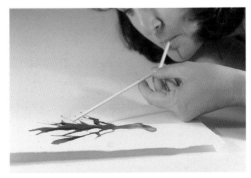

Place your straw close to a branch line and blow.

Create a Web of Roots

After laying down the initial wash of colors for this painting, I used masking fluid to indicate a few of the tangled roots that cascade down the crest of the hill. Then, with a straw, I quickly blew the masking fluid at angles down the hillside to form a web of root growth. The natural-looking roots form a design centerpiece for this painting.

CRESTLINE CASCADE Jan Fabian Wallake 28" × 21" (71cm × 53cm)
Collection of Kay Boyd

365 Spatter With a Paintbrush

To spatter with a paintbrush, first load a brush with paint of a creamy consistency. (A no. 9 round Kolinsky sable works especially well, but any natural-hair brush will work.) Hold a pencil or a small stick parallel to and approximately 2 inches (5cm) from your watercolor paper.

Now strike the loaded brush against the stick using one firm downward stroke. Lift and strike down again. By spattering the droplets on the downward stroke only, you can control the field of spatter. Reload your brush when the spattered droplets become thin and tiny. Try using an analogous color for the reload.

Enhance the spatter pattern by giving it a quick spray of clear water from a pump spray bottle. You can make the effect more pronounced with more water sprays. I use this texture for foliage, floral images, backgrounds and foregrounds.

366 Spatter With a Toothbrush

When spattering with a toothbrush, first prepare a paint mixture of a creamy consistency. Dip an old toothbrush into the paint.

Next, holding a pencil or other small stick approximately 2 inches (5cm) from and parallel to your paper, push the bristles of the toothbrush across the top of the stick and away from you. A fine spatter will fall on your paper. Repeat the process, always pushing the toothbrush away from you.

Try this same process with masking fluid instead of paint. Once the masking fluid spatter is dry, paint a dark sky color over it. When the paint is dry, remove the spattered mask with a rubber cement eraser. This will give you tiny white specks against a dark background. It works well for falling snow or starry nighttime skies. Using both the positive spatter of color along with the negative (masked) spatter in the same painting creates a unique contrast. Try this technique in floral paintings or perhaps to add interest to hillsides of grass or sand.

367 Take Care!

Take care not to pull up from the strike or spatter too quickly. If you do, you will find the lovely spatter pattern continued on the wall or floor in front of your work area!

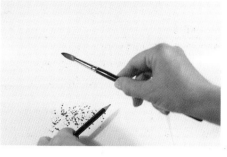

Spatter With a Paintbrush
Strike a loaded brush onto a stick to spatter.

A quick spray of clear water will enhance the spatter pattern.

Spatter With a Toothbrush
Spatter paint using a toothbrush.

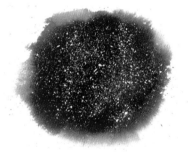

Spatter with masking fluid. Apply paint over the area. Use this technique at random locations around floral paintings and for rock texture, rain droplets, stars in the sky and falling snow.

368 Don't Overload

Be careful to not overload your brush with paint, or you may find large drops falling onto the paper during the spattering process. If your paint mixture is too thin, you risk the same consequence. A heavier consistency will stay on the toothbrush and release a fine misty pattern.

369 Pull a Monoprint

To pull a monoprint, first mix your paint to a creamy consistency. You may want to mix two or more analogous colors to enhance the effect of this textural technique.

Next, on a smooth surface (I use a sheet of Plexiglas), apply a thin coat of dish soap. Use a synthetic brush to spread it around on the surface.

Pour or paint the colors onto the prepared surface in a random pattern, then lay dry watercolor paper right side down on the paint. Press it flat, then peel it off. If you do not get a good pattern, try reapplying the watercolor paper.

Try this same technique with dampened paper for a softer effect. Bristol board or hot-press paper encourages an especially distinct pattern of fluid-looking bubbles.

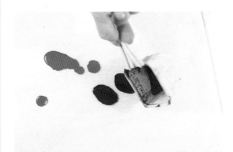

Pour colors onto the prepared surface.

Peel off the watercolor paper and see the pattern you created. If you are dissatisfied, reapply the paper.

370 Blot With a Tissue

I usually advise against dabbing into a wash with a paper towel or facial tissue. This may pick up unwanted color, but it also grinds some of the pigment into the paper, which reduces the overall transparency. However, I make an exception with this technique for forming natural-looking clouds.

First, paint an even or graded wash (one that starts out dark in tone at the top of the paper then becomes paler as it progresses down the wash area). You will get the best results with this technique if you use a darker wash.

While the wash is still wet, crumple a facial tissue and blot it into the wash. A hard blotting will give a very white cloud. Blot more lightly for paler clouds.

Change the tissue formation with each blot, and change the size of each cloud for variety.

371 Add More Pigment

If your paint mixture is thinner than a creamy consistency, you may experience a softer, less definitive monoprint pattern. Add more pigment to the mixture. You might also try adding a cornstarch paste to your paints. It will promote a suction between the paper and the painted surface which is what creates this fascinating texture.

372 All Clouds Are Different

Do not press the same tissue formation more than one time. All clouds are different in size and shape. This is the key to producing the most natural effect with this technique.

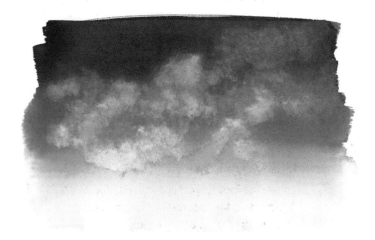

Blot a facial tissue into the wash. Remember to change the tissue formation to add variety.

373 Paint From a Shadow

To paint a form from a shadow, hold a flower, leaf or any object that has a distinctive shape in bright sunlight or under a very bright light. Flowers with a mass of leaf shapes work best.

Next, place your watercolor paper below the flower and move the flower closer to the paper until you see a sharp cast shadow on the paper. Turn the flower; tilt it. You will see interesting shapes forming from the shadows.

When you find a shadow shape you like, hold the flower carefully in that position while you paint in the shadow shape with clear water. Use a lot of water.

Then drop analogous colors into the water. Color will run only where the water is. Allow the shapes to dry without interference.

Paint the shadow with clear water.

Drop color into the water.

374 Texture With Newsprint

Newsprint is quite absorbent. I have discovered that it leaves a vivid fractured imprint when pressed into a wash. It looks amazingly like the surface of jagged rock. This technique provides a natural-looking pattern of light and shadow for sharp, split rock features.

First, lay down a wash of nonstaining colors. Who said that rocks have to be gray or brown? Use beautiful colors for your rocks. More than one color will give more exciting results, but remember to use analogous colors.

Next, crumple a quarter sheet of newsprint. While the wash is still wet, press the newsprint into the color. Hold it down for about sixty seconds to allow the best absorption to take place.

Lift off the newsprint. If you want more rocks, crumple the paper into a new shape and press it into the wash again. Once the wash has dried, add shadows to the areas behind and under each rock. To do this, use a darker shade of the original rock color.

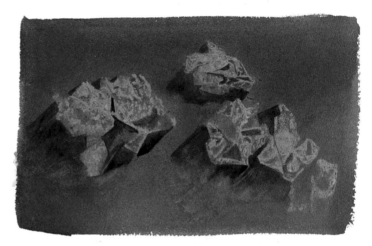

While the wash is wet, hold down the crumpled newsprint for about sixty seconds, then lift it off.

375 Allow Natural Mixing

The best results come from allowing the paint and water to mix naturally and dry on their own. Do not tilt or try to mix the colors. Let the colors swim on their own.

376 Create Texture With a Sponge

Approach 1: Stucco texture First, lay down a soft wash of color. When the wash is dry, lightly soap up a natural sponge, dip it in a pool of masking fluid and tap it onto the dried wash. While this is drying, rinse your sponge clean so that the masking fluid does not dry on it.

When the masking fluid is dry, dip the sponge into a pool of paint, and tap onto the masked and washed area. Allow everything to dry completely.

Next, remove the masking fluid. The area may need additional applications of sponged color. Sponge until you get the effect you want, but do not overdo the texture.

Approach 2: Brick texture Begin this technique by soaping up a natural sponge. Dip it into a pool of masking fluid, and lightly tap it onto your dry watercolor paper. When the mask is dry, lay a wash of color over the area. When that dries, load a large round brush (I use a no. 24) with a pigment mixture for the bricks. Lay the brush very lightly across the palm of your hand and allow the tip to roll over each brick to be formed upon the prepared wash. The brush will skip, paint and skip again over each brick. Avoid a heavy controlling hand. Allow the brush to hit and miss.

When this application is dry, remove the masking fluid. Mix a paler version of the brick color now and repeat the brush-rolling process over each brick. You will hit some of the areas you have already painted as well as some of the previously masked areas.

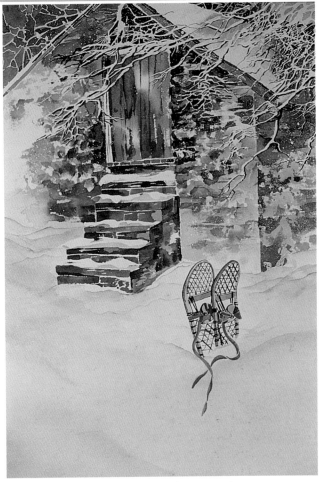

Combining Approaches

I dipped my palette knife into masking fluid and dragged in the bare branches and twigs of the trees. Then I painted on the first layer of wash colors. Using the stucco and brick approaches, I developed the rock walls. Notice that some areas are more detailed and finished than others. I like the contrast of active areas and resting (or static) areas.

WINTER RETREAT Jan Fabian Wallake 21" × 13" (53cm × 33cm)

Stucco Texture

Brick Texture

377 Create Patterns With Cornstarch

To create patterns with cornstarch, first mix a thin paste of water and cornstarch. Use an old synthetic brush to paint the mixture on your watercolor paper, then hold up the paper vertically and give it a quick spray of water.

Next, pour a mixture of paint on or near the top edge of the paper and allow the paint to run down. When interesting patterns begin to form, lay the paper flat to dry.

This pattern was created with watercolor and cornstarch.

378 Drip Alcohol on a Wash

Like salt, ordinary rubbing alcohol repels paint. Apply it in the form of droplets falling on the paper. This action forces a unique pattern of rings to form. I use this technique for rock textures and lichen on rocks, as well as florals and abstract background and foreground textures.

First, prepare a pool of a creamy consistency of a dark, nonstaining color. Brush in an even wash, and while it is still wet, but just beginning to lose its shine, sprinkle a few droplets of rubbing alcohol on it. Drop them from a distance of about 10 inches (25cm) onto the wash. The characteristic ring each drop creates makes a natural soft-edged pattern for bubbles.

This unique pattern of rings can be used for rock textures and florals.

379 Check Paint Consistency

If tiny rivulets do not form, check the consistency of your paint mix (it should be creamy). Also check the consistency of the cornstarch paste. If it is too thin, the paint will slide right over it. If it is too thick, the paint will not make inroads to form the tiny, hairline cracks that are characteristic of this technique. You do not want clumps of cornstarch stuck to your finished painting.

380 Splash With a Trigger Sprayer

I use a trigger sprayer to lay down a river of water into which I drop color for a dramatic flow across my composition.

First, working on dry paper, hold the sprayer close to the surface and aggressively sweep down a predetermined path. It may take three or four sprayings to create the effect you want. Some of the water runs in single streams down the paper. Notice the design the water makes, and adjust the sprayings accordingly. If you do not like the path it is taking, let the paper dry, and then retry.

When you get an interesting flow pattern, pour a heavy concentration of color onto the water areas and allow them to run wherever they want. The paint will not travel outside the water areas.

381 Dramatic Sweeps of Color

A trigger sprayer leaves a river of water that cascades down the paper. I often use this tool to create dramatic sweeps of color in my compositions.

382 Use Strong Pigments

Because a lot of water is used with this spray technique, it is best to use a strong pigment. Remember, the color will fade as it dries.

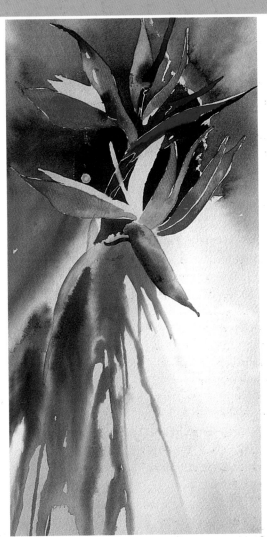

BIRD OF PARADISE Jan Fabian Wallake
12" × 7" (30cm × 18cm)

Sweep a path of water onto your dry watercolor paper using a trigger sprayer.

When you are satisfied with the flow pattern, pour on a color.

383 Create a Lace Pattern

Instead of painstakingly painting in the tiny negative shapes within a piece of lace or a doily, I like to offer an illusion of lace. To do this, first lay a paper doily down on dry watercolor paper, then, with a large flat brush (a 1-inch [25mm] sable works great) dipped in clear water, dampen around the doily. Be careful not to come closer than ½ inch (1cm) from the doily's edge. If your paper is wet nearer than that, the paint may seep back under the doily, and the sharp pattern will be compromised.

Using paint of a creamy consistency, pull the loaded brush across the doily, over its edge and out into the dampened area. The doily is made of very thin paper that disintegrates easily. Paint that is too wet will saturate the doily and flood underneath it. Some seepage can actually enhance an otherwise precise pattern, but too much will cause an unpleasant and confusing blotch.

Remove the doily as soon as you are done painting across it. This technique leaves a charming illusion of lacy curtains. I also use it with floral still-life paintings.

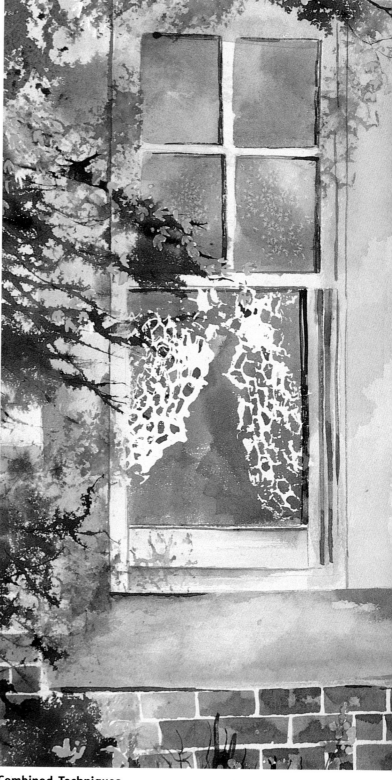

Combined Techniques

The impression of lace curtains was made with the paper doily technique. I balanced this intricate pattern with the salt effect on the windows and the spray technique for the foliage.

THE GARDENER (DETAIL) Jan Fabian Wallake 28" × 21" (71cm × 53cm)

Texture With Sand

Sand and water create fascinating patterns in nature. We can re-create these same patterns on watercolor paper.

A smooth paper produces the best results, but I have gotten very interesting patterns with cold-press surfaces too. I stretch my paper unless I am working very small (a quarter sheet of paper). You may want to try this technique outdoors since it can get messy. If I do use it indoors, I place the paper in a tray to contain the water and sand as they slide off the paper.

First, sprinkle ⅛" inch (3mm) of clean, natural (quartz) sand onto dry paper. Using a pump sprayer, lightly spray the sand with clean water.

Hold the tray up on an angle to encourage gravity to pull the water and sand downward. Continue to spray until the sand is saturated and it begins to run in tiny streams down and off the paper. When you are satisfied with the pattern, lay the paper flat. You can now decide whether you prefer a soft image or one that has a more definite pattern. If you want a softer texture, pour paint onto the sand while it is still quite damp. For a pattern with stronger color and harder edges, wait until the sand dries. You may decide to apply a soft texture first, resand the paper, let it dry and pour paint onto the paper again for a hard-edged imprint over the soft one. When you get the effect you want, you can develop it further by creating an image out of the pattern.

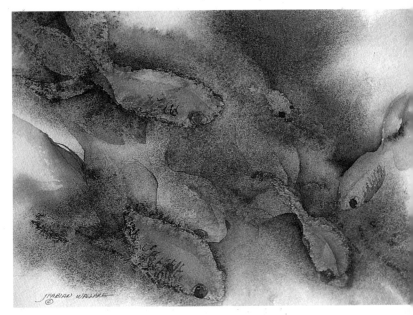

Soft Texture

This painting began with the sand technique. In this case, I did not encourage the run of tiny streams of sand down the page. I wanted a softer texture, so just as the sand and water began to slip down the paper, I poured on two analogous colors of paint. Later, I developed the fish images. I asked myself if I would have created this interesting pattern of light and dark shapes or the unique texture if I had planned a painting of swimming fish. I imagine a preplanned painting would look quite different. I like the fresh, natural quality of this simple painting.

SCHOOL'S OUT Jan Fabian Wallake 7" × 11" (18cm × 29cm)
Collection of Mr. and Mrs. Jamie Wagner

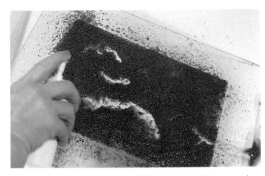

Use a pump sprayer to lightly spray the sand with clear water.

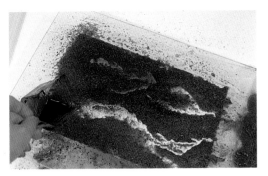

Pour paint onto the damp sand for a soft image. For a stronger color, wait until the sand dries.

385 Pattern With Charcoal

Powdered charcoal slides off of a pool of water, but it adheres to dry paper. The result is a very organic texture. I have used it to texture rocks, to bring interest when painting a forest floor and to add a weathered grain to wood. I have added it to foregrounds, backgrounds and brick walls.

To try this texture, first sift a light coat of pure powdered artist's charcoal onto dry watercolor paper. (I use a small kitchen sifter.)

Next spray the area lightly with your pump sprayer. This will help set the texture.

Now, rinse off the entire paper with clear water from a gentle sprayer or in a sink. Let the paper dry, and assess the pattern. You can repeat the technique for more texture. You can prevent smudging by lightly spraying the area with a clear acrylic fixative.

Sift a light coat of artist's charcoal onto dry watercolor paper.

Then spray the area with a pump sprayer to set the texture. Rinse the entire paper with clear water and let it dry.

386 Freeze Watercolors

When snow or sleet freezes on your windows, frosty, feathered patterns form. You can capture the same effect with water and paint on your watercolor paper if you allow the liquids to freeze.

First, dip your paper into a tub of water, then lay it in a tray. If you are working very large, simply saturate the surface of the paper with water.

Next, pour paint onto the very wet paper and leave it outdoors to work its magic. An outside temperature around 20°F (-7°C) is often needed for a frost pattern to form.

Bring in the paper and thaw it out. When it dries completely, you can enhance the pattern by exaggerating the fractures with detailed brushwork.

Achieve frosty patterns by freezing your watercolors.

387 Sign With a Lasting Impression

The final stroke an artist adds to his work is the signature. It is an important part of the creative process and should not be a casual afterthought. Your signature will live with your work for its duration. It gives value to your art.

Evaluate the placement of your signature within your painting. Also, consider the style with which you make your mark. Size is a factor; a signature that is too large will distract from the art.

Approach 1: Dip Pen This method works best if the signature area is white or light in color.

Choose a color that coordinates with the signature area of the painting, and load a dip pen with watercolor paint. Sign your name with the dip pen.

Approach 2: Imbedded Imprint Choose this method for a signature in a white or light area of your painting.

Wet your paper with clean water in the area you choose for your signature. Then, onto the dampened area, brush a stroke of nonstaining color (preferably one that continues the color scheme of the painting).

Using an ordinary ballpoint pen that is empty of ink, quickly sign your name.

Rinse or spray off the stroke of color, and you will find your signature is permanently imbedded into the paper in a color that complements the painting.

Approach 3: Graphite Many artists choose to sign their names in graphite. It is unassuming and does not distract from the painting.

Use a regular soft-lead pencil. Remember that this is not a permanent method, as the signature could be erased.

Approach 4: Waxed Paper If I am doing a painting that has a lot of dark color in the area of the signature, I plan ahead and employ a method that will allow my name to show through the deep tones.

Before beginning to paint, lay a piece of waxed paper onto the watercolor paper in the signature area. With a ballpoint pen or other sharp point, write your signature, pressing down through the waxed paper. A heavy pressure assures that the wax will transfer onto the watercolor paper.

Later, when you paint over the area, the wax imprint will show through.

388 Use a Staining Color

Signing your name with a staining color ensures a permanent image.

389 Sign With a Heavy Hand for Permanence

When I use graphite, I sign with a heavy hand so that the mark is pressed into the paper.

Sign your art using a dip pen.

Permanently imbed your signature into the paper.

You could also sign with graphite.

Use waxed paper to sign your work.

TECHNIQUES ON ILLUSTRATION BOARD

by Joe Garcia

390 Create Texture on Illustration Board

Illustration board is a good, versatile surface to work on. I make sure it is acid-free and then paint on it as I would watercolor paper. Because it is a board, it will stay flat and not buckle when wet. It may be purchased with a hot-press or cold-press surface. Illustration board is white, and because it is less absorbent than watercolor paper, the pigment lifts easily from the surface. It is not as textured as watercolor paper and also works well with pencil or pen and ink.

391 Make a Reference Notebook

Keep a file or notebook of samples. Start with the basic washes and colors. As you experiment with textures add these to the file. Include the different papers you use. Such a file will make it easier for you to use your samples as references.

Wet-Into-Wet
Wet-into-wet watercolor wash on no. 1 cold-press Crescent illustration board

Gesso
Watercolor on no. 1 cold-press gesso-treated Crescent illustration board

Transparent and Opaque Watercolor
Transparent and opaque watercolor on no. 1 cold-press Crescent illustration board

Masking Fluid
Masking fluid and watercolor applied to no. 1 cold-press Crescent illustration board

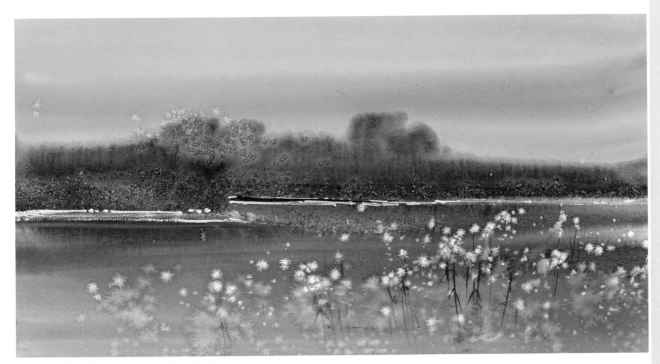

Experiment With Wet-Into-Wet Washes

This experiment was not painted to look like anything in particular, I wanted to experiment with textures. I started with a wet-into-wet wash on illustration board. I used salt, spattered water and opaque paint. I had to quit before I had a painting on my hands!

VARIETY OF TEXTURES Joe Garcia 5" × 9" (13cm × 23cm)

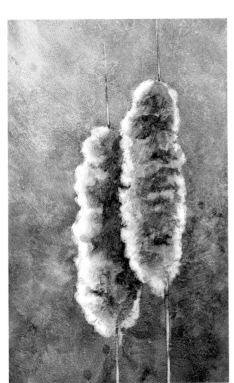

Texture Created From Gesso

Cattails, left, was painted on gesso-treated illustration board. I brushed the gesso on with a bristle brush so the brushstrokes would leave a texture. After the gesso dried thoroughly I painted the cattails. I used a wet-into-wet technique, leaving the outside edge white. The background is a wet-into wet gradated wash. This change in value and color saturation is a good way to let the texture of the gesso show through. After all was dry, I took a small bristle brush and scrubbed the white edge of the cattails to soften the boundary between the background and subject. Gesso-treated illustration board is an enjoyable surface to paint on and everyone should try this trick at least once.

CATTAILS Joe Garcia 5" × 9" (13cm × 23cm)

TECHNIQUES USING SYNTHETIC PAPER

by Joe Garcia

392 Creating Texture on Synthetic Paper

Yupo is interesting to work with. It's a white, nonabsorbent synthetic paper. The pigments stay on the surface and are intense. Yupo creates a lot of textures on its own and can be tricky to use. I thought it might work well with gesso, but when the gesso dried and I painted over the surface, the gesso began to lift. I forgot that it could not adhere or soak into the surface. Experiment—you never know what you will learn.

393 Experiment for Success

I read an article on watercolor that said "tricks" such as using salt and alcohol were to be avoided. The author said that a watercolor should be a transparent painting using traditional methods to capture an image or idea. Boring! I believe an artist should do whatever it takes to make a successful painting. Tradition is great, but it can shut the door on innovation. At a workshop I taught I asked the students to experiment and complete a sheet of textural samples. All were good, using techniques that might be expected. Sponge, palette knife and salt were among the favorites. The youngest student, a teenager, presented her sheet and left everyone in silence. Textures ranged from sand glued to the paper, coffee grounds, crayon, bicycle tracks—I could go on. Not all the samples were usable or permanent, but they were creative. Her work was the hit of the class and let everyone know that they had not even scratched the surface of what could be done.

Wet-Into-Wet
Wet-into-wet watercolor wash on 180-lb. (385gsm) Yupo

Gesso
Gesso and watercolor on 180-lb. (385gsm) Yupo

Salt
Salt and watercolor on 180-lb. (385gsm) Yupo

Masking Fluid
Masking fluid and watercolor on 180-lb. (360gsm) Yupo

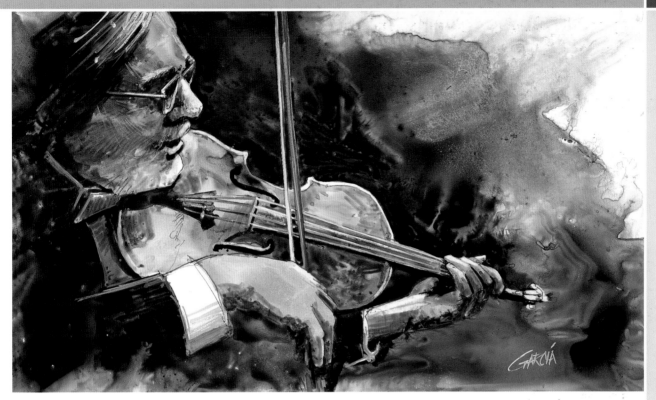

Experiment on Yupo

Music Man was a total experiment. I had seen paintings and read articles about Yupo, a synthetic paper, but had never used it. The quality that intrigued me was the way the paint layered on the surface. Yupo is nonabsorbent, allowing you to lift the paint to the white of the paper. If you do not like your painting, put it under the faucet and wash everything off. The paper will be as good as new. I also used colored pencils and opaque paint on *Music Man*. Try a sheet of Yupo. It was fun and creative. Remember, if you do not like the painting you can "wash your troubles away!"

MUSIC MAN Joe Garcia 7" × 13" (18cm × 33cm)

Using Plastic Wrap and Yupo

What is it? Use your imagination. I see ice on a window or river's edge. I used plastic wrap on still-wet, painted Yupo. Since this is a nonabsorbent surface, the plastic wrap worked well.

PLASTIC WRAP Joe Garcia 5" × 9" (13cm × 23cm)

CREATIVE FORMATTING **TIPS** AND **SOLUTIONS**

by Joe Garcia

The definition of format *is the general plan or arrangement of something. For the artist, this refers to the layout or composition of the painting. The subject and composition should dictate the format. There is no rule that says a painting must be a particular size, shape or dimension.*

394 Don't Get Trapped by Standard Sizes

Standard sizes should not be ignored as they offer certain benefits, especially to the beginning painter. Standard-sized paintings can be less expensive to frame, and packing, shipping and storage can be easier to manage. Also, the standard size layout is familiar and easy. However, do not get trapped by standard sizes.

395 Continue to Explore

Be creative with formats. Try new ideas. Look at ordinary subjects in a fresh way. Part of learning is exploring and taking chances. Growth should be a constant ingredient of your work. All these ideas sound good, but how do you apply them to your artwork? With repetition you will learn to do a wash perfectly. With practice, color can be mastered. Creativity and imagination are elusive and must be practiced everyday. Study other artists' paintings and ask questions. Keep your mind open to change and try other people's ideas. You may find something that works for you!

396 A White Background Accents Your Subject

Yellow Lanterns, right, was painted using white paper to dramatize the color and composition. The white eliminated all unnecessary information. The lanterns are flat washes of Aureolin Yellow and New Gamboge. The dark robe is a wet-into-wet wash with lifting to show the folds. The white background is the supporting actor who is there to assist the star.

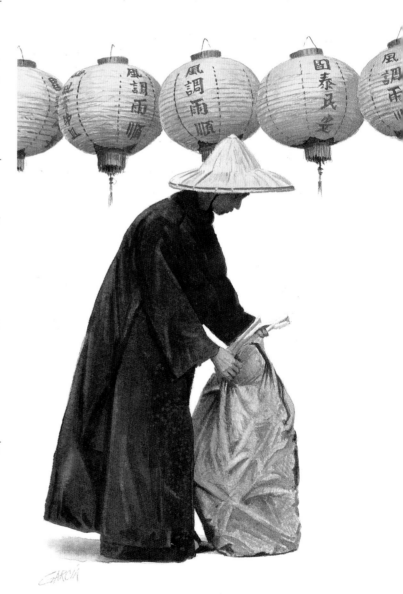

YELLOW LANTERNS Joe Garcia 11" × 8" (28cm × 20cm)

397 Compose With the White of the Paper

Fire Hydrant No. 1 (below) was painted for a concept and not for the subject. This painting is about the design of the rectangular shapes and the negative white spaces. The negative white shapes become a strong compositional element in the painting. It is the concept, not always the subject, that is important. Flat washes are used for the rectangular shapes. A light flat wash was used for the fire hydrant. Color is not a great concern.

398 Try a Long, Vertical Format

A good part of a nuthatch's life is spent upside down looking for grubs and insects. I felt the use of a tall, vertical format (right) would dramatize the bird's precarious perch. A gradated wash was used in the background to accent this feeling. The lichen is a wet-into-wet wash, with the shadows and texture drybrushed on the lichen. The bark was painted with a dry-brush technique. The trunk and branches help compose the long, vertical format.

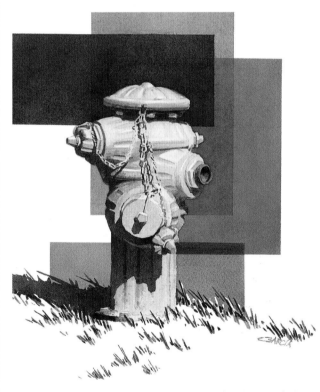

FIRE HYDRANT NO. 1 Joe Garcia 9" × 7" (23cm × 18cm)

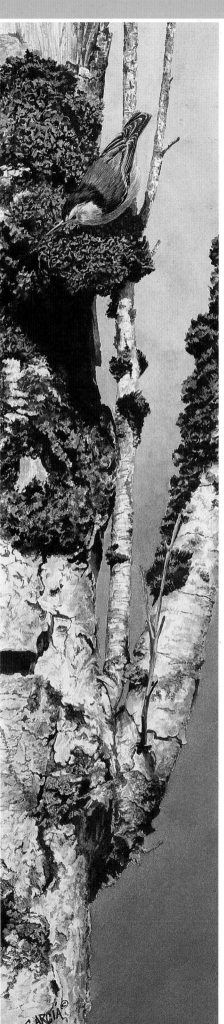

A DIFFERENT VIEW Joe Garcia
32" × 11" (81cm × 28cm)

TIPS FOR DISPLAYING YOUR ART

by Jan Fabian Wallake

399 Enhance Your Painting

How you decide to display your art will impact the overall image of the painting. If you frame it well, your painting will be enhanced, but remember that framing should never dominate. It must support the theme of the work without distracting from it.

400 Measure for a Mat

The first step is to measure the amount of artwork you want to show. You can cover as little as $\frac{1}{4}$ inch (6mm) on the edges of your painting with the mat, but I usually cover at least 1" (3cm) so the painting does not bow out under the mat. This measurement becomes the inside dimension of your mat.

401 Determine the Border Size

Generally, if your artwork is small, the mat borders will also be small. If I frame a painting done on a full sheet of watercolor paper, I use an extra-large mat, perhaps $4\frac{1}{2}$ inches (11cm) or 5 inches (13cm). The smallest mat recommended is a 2-inch (5cm) border. Traditionally, mat borders have equal top and sides, but they increase an extra $\frac{1}{2}$ inch (1cm) on the bottom. This gives an implied visual weight to the bottom for a more balanced feel to the art in the frame.

402 Select the Mat Color

The most common preference for color on a top mat is white or a light neutral shade. If you want to add some color to your matting, choose a color that will match the colors at your center of interest and use that color on a liner mat. That is a mat placed under the top mat. Usually, only $\frac{1}{8}$ inch (3mm) to $\frac{1}{4}$ inch (6mm) of it shows as a thin liner around the inside dimension of your matting.

403 Consider Conservation

The primary consideration in choosing a mat should be its pH rating. The pH measurement is the rating of the chemical activity of acid in the board. A neutral pH is most desirable because using a mat board with even slight acidity may deteriorate your art. Various degrees of conservation are available:

Good. Regular, acid-free mat boards are good. They are made of treated wood pulp. The backing paper and core of these boards have been buffered with calcium carbonate to neutralize the acidity. The top facing papers have not been buffered.

Better. Rag boards have backing paper and a core made of 100-percent rag and/or alpha pulp (wood pulp that has had the acid removed).

Measuring for a Mat

The image area (artwork) will be $11\frac{1}{2}$" × 16" (29cm × 40cm). The outside dimension of the mat (which will be the frame size) is 16" × 20" (40cm × 50cm). The top and sides of the mat are 2" (5cm) wide and the bottom is $2\frac{1}{2}$" (6cm) deep. It's best to add up all of the vertical measurements in one column and then add the horizontal measurements in a separate column.

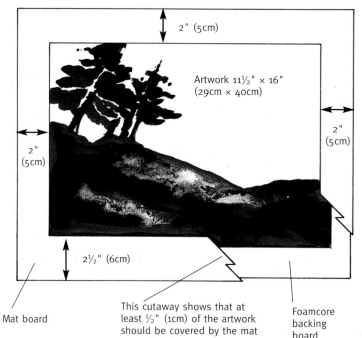

2" (5cm)

Artwork $11\frac{1}{2}$" × 16" (29cm × 40cm)

2" (5cm)

2" (5cm)

$2\frac{1}{2}$" (6cm)

Mat board

This cutaway shows that at least $\frac{1}{2}$" (1cm) of the artwork should be covered by the mat on each side.

Foamcore backing board

The outside dimension of the mat is 16" × 20" (40cm × 50cm). The frame should be ordered as a 16" × 20" (40cm × 50cm) frame.

Add the vertical measurements:
2" + $11\frac{1}{2}$" + $2\frac{1}{2}$" = 16" (5cm + 29cm + 6cm = 40cm)

Add the horizontal measurements: 2" + 16" + 2" = 20" (5cm + 40cm + 5cm = 50cm)

The facing paper is made from alpha pulp. They are buffered with calcium carbonate for added protection. The colors are fade resistant.

Best. A 100-percent rag board (also called a museum board) is a solid board made of cotton and linen rags that are made into pulp. These boards are completely acid free. The colors are fade resistant. A 100-percent rag board is the best protection you can put on your artwork. They are the only boards used by museums and fine art galleries.

404 Backing Material

Acid-free foamcore boards are a good backing support for works on paper. They come in ⅛ inch (3mm) to ³⁄₁₆ inch (5mm) sizes. These boards have a dense foam center between acid-free papers that have been buffered. Regular foam boards (not acid free) are available, but they will deteriorate your art over time.

Whatever backing material you choose, be sure to affix your artwork to it with two or three pieces of acid-free tape along the top edge.

405 Protect Your Artwork

The most commonly used material for protecting artwork on paper is glass. It is less expensive than other products, it is easy to clean and it doesn't scratch easily.

Acrylic, or Plexiglas, has the advantage of being virtually unbreakable, and it is lightweight. It does, however, scratch easily. When framing larger-sized pieces (over 15" × 20" [38cm × 51cm]), it is advisable to use acrylic to reduce the weight in the frame.

Glass is prone to condensation, so it should not touch artwork. Moisture can build up on the inside of the glass and deteriorate the art. A mat will separate the glass from the artwork.

406 Block Harmful Light Rays

Light rays can damage your artwork. Take care to protect watercolor paintings from ultraviolet (UV) rays. These rays are powerful enough to cause damage to organic materials, resulting in loss of color, yellowing and/or darkening. They can cause the paper to become brittle. UV-filtered glass or acrylic will block out most (but not all) harmful rays.

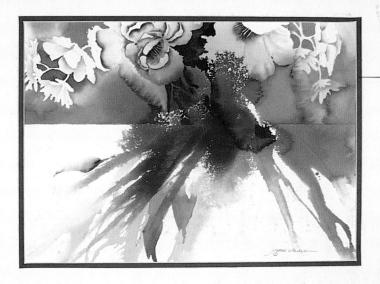

Color liner mat

White top mat

Framing and matting should enhance your painting, not dominate it.

BASIC FRAMING **TIPS**
by Jan Fabian Wallake

There are many options for framing. Should you choose a metal or wood frame? What width or profile would look best?

Begin with a few calculations to help determine the framing features that will best display your art.

407 Consider Face Size

The proportion of your artwork should be considered in choosing the profile size of the frame. For example, a large painting will need a sturdy frame to hold the weight. A small piece of art with a delicately painted subject would look best in a thinner frame that reflects the feel of the work. Choosing a frame is part of the creative process. Look for the size and molding profile that best enhance your art.

408 The Frame Needs Depth

If you use two, three or more mats on your artwork, choose a frame that has an inside depth (called the rabbet depth) that will accommodate those mats plus the glass, the artwork and the backing material.

409 Decide on the Style

If you have a painting of an old barn, a rustic wood frame may be appropriate. If you have a contemporary abstract, a metal frame may work best. The frame style should echo the style of the art, not distract from or dominate it.

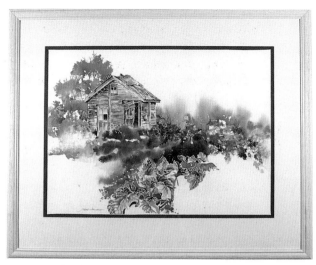

Art Framed With Wood

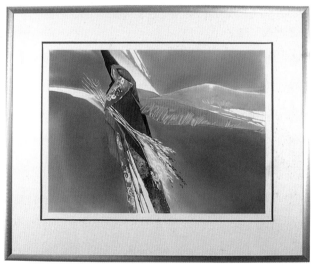

Art Framed With Metal

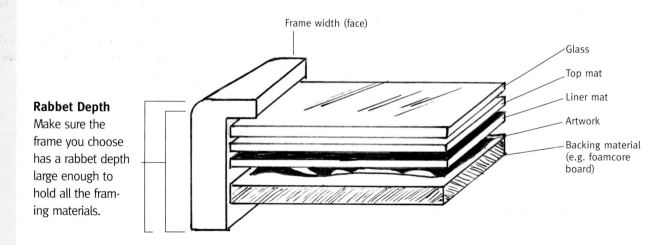

Frame width (face)

Glass

Top mat

Liner mat

Artwork

Backing material (e.g. foamcore board)

Rabbet Depth
Make sure the frame you choose has a rabbet depth large enough to hold all the framing materials.

Basic Framing Features

TIPS FOR MARKETING AND SELLING YOUR ART

by Jan Fabian Wallake

The purpose of marketing your art is to make prospective buyers aware of what you have to offer at what price and where and when the work is available for purchase. Start your marketing strategy by determining your intent, evaluating your artwork for its salability and setting a long-range marketing plan.

410 Determine Your Intent

Do you want to simply enjoy the process of painting without displaying your art? Do you want to display your paintings only in your own home? Do you want to enter local, regional or national shows? Do you want to place your art for sale in art fairs? Do you want to sell your art in galleries?

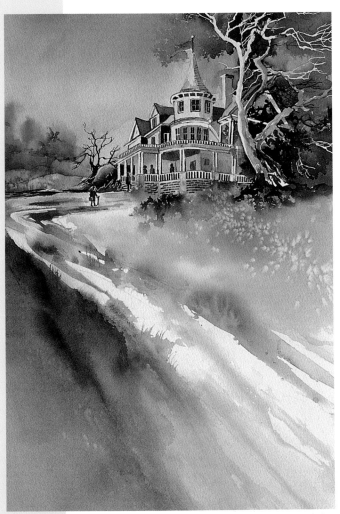

VICTORIAN HILLTOP Jan Fabian Wallake
20½" × 14" (52cm × 36cm) Private collection

411 Evaluate Your Artwork for Its Salability

Do you like to paint subjects that strike an emotional chord? Does your art incorporate the current décor colors? It bothers artists that many buyers choose art based on their décor, but that is often the reality.

Have you reached a level of competence that is competitive with other art at your marketing target? If you decide to show your work in a gallery, does your art compare with the quality of the other artists'? If not, try placing your paintings in shops or offices until you feel secure enough to approach a gallery.

Entering art show competitions may help you decide where your competence level is. You may not agree with the judge, but you will be able to compare your art to everyone else's.

412 Set a Long-Range Marketing Plan

Once you determine what type of art you are most interested in creating and in which direction you will proceed toward displaying, showing or selling your art, you will want to develop a plan to help you achieve those goals. I began publicizing my work by entering local shows, offering to hang my paintings in businesses and change the art every six months, entering my watercolor paintings in poster contests, writing articles about my art for newspapers and magazines, donating my art to a benefit auction, and networking at area art organizations.

413 Publicize Your Art

Take advantage of every opportunity to get your name and your work out to the public. I have found that in order to get something you want, you have to give something. Be prepared to donate your time and perhaps some of your art in order to put your art in front of the public where it will be noticed. I offered to work at and donate art to an annual charity function. A few years later, that organization commissioned me to do a special painting as their "featured artist of the year" with signed, limited-edition prints of my painting. My payment was a number of the prints that I could later sell, and a lot of free publicity.

414 Join Art Organizations

Enter their shows; write press releases for their newsletters; get involved in the group.

415 Donate Your Art

Donate your art to local charities; in return, ask them for a press release about your donation.

416 Enter Exhibitions

Enter every art exhibition you can.

417 Display Your Art

Offer to display your paintings at local banks, beauty shops, doctor's offices, restaurants—anywhere that people wait for services. Be sure to ask permission to post your card with your name and the price of the art on it.

418 Stay In Tune

Study current trends, colors and designs. Stay in tune with what type of art buyers are looking for.

419 Create a Portfolio

Develop a resumé and a portfolio of your very best work. Carry this packet with you to show business owners with potential exhibit opportunities, gallery owners or even possible buyers.

420 Do Your Research

If you decide to sell your paintings, consider the following questions:

Who is going to buy your art? Part of your marketing strategy should include a profile of your most likely buyers. List the age, income level, education and social status of your target buyer.

Where will you display your art for optimal exposure to your target audience? For example, wildlife art would probably sell better at sport shows and sport banquets than it would in a beauty salon.

How will you price your art to increase sales? It will be necessary to research the price tags on comparable art in your area. This is an important aspect of marketing. In pricing a painting, consider all of your costs: materials, overhead, transportation, insurance and, of course, a profit. Does the final tally compare to other art of similar style and artistic competence? Finally, you must consider what the market will bear.

421 Exhibit Quality Art

No matter how you decide to display your art, your finished product should be original and show your own unique artistic expression and a maturity of painting competence. It must exhibit quality in its presentation.

Publicize Your Art

Develop a Resumé and Portfolio

TIPS FOR TRAVELING WITH WATERCOLOR
by Joe Garcia

422 The Basics

When I travel I often take watercolors; if I have limited luggage space, watercolors are ideal. A few brushes, a palette with plenty of paint, and paper are all I need. The paper can be individual sheets cut to any desired size, watercolor blocks or watercolor sketchbooks. I can fit this into a briefcase, backpack or suitcase with very little problem.

423 Additional Equipment

If I have space I prefer to travel with additional equipment. The palette I use in my studio and travel with is the Pike Palette. It is a strong, rigid palette with a cover that fits snugly over the pigments. It has a large working area with individual wells to keep the colors separate. The palette and five or six brushes rolled into a bamboo mat start the list of equipment. Various sizes and kinds of paper or a watercolor sketchbook, water, paper towels or tissues, pencil and a tote bag add to the list if room (or memory) allows. I bring a hat, stool and water container. It seems like a lot of equipment, but almost all will fit into the tote bag. Appropriate clothing, sunblock and bug spray won't hurt either. Comfort is essential to success, so be prepared.

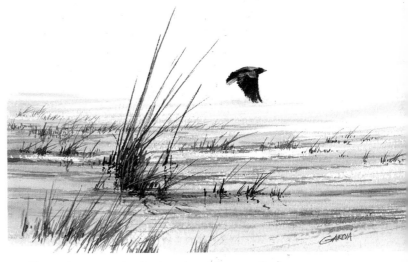

RED-WINGED BLACKBIRD Joe Garcia 5" × 7" (13cm × 18cm)

Equipment for Outdoor Painting
Here are some of the supplies you will need when painting in the field.

MATERIALS

BRUSHES Flats | *1-inch (25mm)* | *³/₄-inch (19mm)*
Rounds | *Nos. 2, 4 and 6*

OTHER Bamboo mat | Bug spray | Erasers | Good attitude (should be number one on the list!) | Hat | Masking tape | Paints—bring extra | Palette | Palette knife | Paper or watercolor sketchbook | Paper towels or tissues | Pencils | Ruler | Sketchbook | Stool | Sunblock | Tote bag | Trash bag | Umbrella | Water

424 Leave a Legacy

Painting while you travel is a memorable way to record your trip. A stack of sketchbooks is a wonderful legacy to leave behind.

425 Paint What Surrounds You

I enjoy painting on location. *Red-Winged Blackbird* (above) started as a painting with mountains, trees, a lake and cattails. As I sat and sketched, the continual flight of birds caught my attention. I finally realized that I was overlooking the obvious and decided to paint a more intimate setting. I focused on the water, grass and blackbird, who had been letting me know I was in his territory!

CONCLUSION
by Joe Garcia

" *A journey of a thousand miles must begin with a single step.* **"**

— Lao-tzu, from *Way of Lao-tzu*

PIWAKAWAKA Joe Garcia 6" × 29" (15cm × 74cm)

This is so true for any artist. Watercolor painting is a journey and from the first learning brushstrokes to the final signature, an artist must set a direction. A successful wash is one aspect of this expedition. A working knowledge of color, composition and value are also needed to complement this journey.

The reasons for painting are as personal as the style and technique you choose. There is no right way or wrong way, only different ways to paint. Let each painting be a new experience. Aspire to be a storyteller. If you do this the artist part will take care of itself.

"Practice, practice, practice" is the mantra for success. With success comes confidence. This book is meant to give you a starting point, not a conclusion. Set a series of goals. When one is reached, set another one to replace it. As your painting skills improve your goals should be more difficult to attain. As time passes you will find that ideas become more important in each painting. Your painting skills will be used to tell a story.

Compare and exchange ideas with friends and fellow artists. Use books and magazines as reference tools. Use the paintings and demonstrations in this book to help develop your skills. Colors and subjects can be changed; skills are the foundation. If you become discouraged it is often because you are trying to do too much, too soon. There are no shortcuts to becoming an artist. Take a step-by-step approach and there will be fewer bumps to cross over. Lift your brush and let the journey begin.

ABOUT THE AUTHORS

JAN FABIAN WALLAKE is a nationally known professional artist. She has a Bachelor of Fine Arts degree from Bowling Green State University in Ohio. Jan was a graphic designer and art director for many years before becoming a full-time artist. She has taught in the field of design at the college level and now instructs painting workshops throughout the world. Her dramatic painting style of contemporary expressionism is based on geometric shapes balanced with organic forms and the incorporation of glowing color glazes.

Jan has a six-part TV series on painting. She is listed in *Who's Who in American Art* and has authored several articles for *American Artist*, *The Artist's Magazine* and *Watercolor*.

Affiliated with several artist organizations, such as the Red River Watercolor Society, Northern Plains Watercolor Society and American Watercolor Society, Jan is a past president of the Minnesota Watercolor Society. She is also a signature member of the Midwest Watercolor Society. Her award-winning paintings are in many corporate and private collections internationally.

PENNY SOTO is a native of California who lives and works in beautiful Pollock Pines near Lake Tahoe with her husband, Paul. She pursued a career in fine art and illustration at the San Francisco Academy of Art and has been professionally painting, teaching and lecturing since 1980. Penny has had many gallery and museum exhibits in her career. She has earned over 250 awards and honors, including the prestigious San Francisco Academy of Art Scholarship award.

Penny's work has been featured in *The Artist's Magazine*, *The Decorative Magazine* and *Air Brush Action*. She has also appeared in *The Best of Flower Painting 2* (North Light Books, 1999) and *Creative Computer Tools for Artists* (Watson-Guptill Publications, 2002). She writes a monthly step-by-step article for www.worldofwatercolor.com and www.artmagazine.co.uk. Her profound use and love of color prompted her to design, patent and produce a special watercolor palette that holds eighty-four colors and spins for easy access. Her palette and her artwork can be seen on her Web site, www.sotofineart.com.

LINDA STEVENS MOYER holds a bachelor's degree in art as well as two master's degrees. She has exhibited in numerous juried, group and invitational shows as well as eleven solo shows.

Linda's work has been featured in numerous books, including *Make Your Watercolors Look Professional* by Carole Katchen, *Enliven Your Paintings With Light* by Phil Metzger, *Splash 1* and *Splash 2* (published by North Light Books), *Understanding Transparent Watercolor* and *Exploring Painting* by Gerald F. Brommer, and various publications of *The Artist's Magazine* and *American Artist*. She is listed in *Who's Who in American Art*, *Who's Who of American Women*, *Who's Who in the West* and *Who's Who in the World*.

Linda is co-founder of the Internet Web site Watercolor Online (www.watercolor-online.com), which is dedicated to the promotion of aquamedia and aquamedia artists. She is a signature member of the National Watercolor Society and Watercolor West and is a past president of Watercolor West. An experienced educator, lecturer and juror, she has instructed in college and university classes as well as workshops nationwide.

Native Californian **JOE GARCIA** lives and works near Julian, California, where the forest of oaks and pines shelter an abundance of birds, deer and other wildlife. It is an area of varied landscapes and a perfect setting for an artist who specializes in painting those subjects.

Joe earned a Bachelor of Fine Arts degree with an advertising/illustration emphasis from the Art Center College of Design in Los Angeles in 1970. He worked as an illustrator and graphic designer for thirteen years, during which time he spent his free hours honing his watercolor painting skills. Since 1983 Joe has painted full time, leaving the commercial work behind. He generally portrays his subjects tightly, yet delicately in the center of interest, complemented by a loose, interpretive background. In recent years Joe's direction has included more complicated, controlled compositions. He also has expanded his choice of mediums to include oil paints, working on location and in the studio. His original paintings and prints may be found in galleries and private collections throughout the United States and Canada.

BETTY CARR received her Master of Fine Arts degree from San Jose State University in California.

Betty is represented by Mountain Trails Gallery in Sedona, Arizona; El Presidio Gallery in Tucson, Arizona; Lee Rommel Gallery in Santa Fe, New Mexico; Taos Gallery in Scottsdale, Arizona; Judith Hale Gallery in Los Olivos, California; Oscar Gallery in Ketchum, Idaho; and The Lady Bug Gallery in Bishop, California.

Betty lives in Arizona with her husband, painter Howard Carr. They spend half the year traveling and painting scenes around the country.

PAT WEAVER is a national watercolor teacher with over thirty years of teaching experience. Her own education in art has been through workshops and disciplined practice. She is past president and signature life member of the Florida Watercolor Society, a signature member of the Georgia Watercolor Society, and a member of the Miniature Society of Florida.

Pat has been featured in The *Artist's Magazine*, *Watercolor 96*, *Splash 7* and *Watercolor Magic*.

Pat teaches watercolor workshops in the U.S., France, Italy and Great Britain. Her workshops are so popular and well received that many students sign up for multiple workshops. She offers classes in many subjects including portrait and figure, landscapes, floral and still life, animals, drawing, and color theory.

She conducts a number of workshops in her studio in Dade City, Florida, and maintains a vigorous teaching schedule at various other venues. You can find Pat's watercolors and teaching schedule at the Web site www.watercolorplace.com. She is available to teach a workshop at your location.

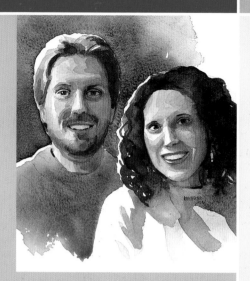

MARK WILLENBRINK was trained as a commercial artist and worked in advertising and then as a freelance illustrator. Mark currently teaches watercolor classes and is a contributing editor for *Watercolor Magic* magazine.

MARY WILLENBRINK obtained a master's degree in counseling and worked as a drug and alcohol counselor. Besides her work as a writer, she currently home-schools their two children.

As a husband-and-wife team, Mark and Mary have been writing together for over five years. They reside in Cincinnati, Ohio, with their two children, one cat and a rescued greyhound.

DONALD CLEGG is a professional artist residing in Spokane, Washington. He began painting when he was twenty-three, completely ignoring the fact that he didn't have any training at the time. He's now been at it for half his life, and somewhere along the way, he acquired the skills that people call talent. Except for a twice-a-week class, repeated several times, Don is a self-taught painter. He taught painting and drawing for a decade at local art schools and now holds occasional workshops.

His work has appeared in several magazines, including features in *The Artist's Magazine*, *Southwest Art Magazine* and *Watercolor Magic*. His work can be found in collections across the country.

In addition to his painting, Don is a longtime organic gardener and wields a deft brush in the kitchen. He shares his home with his wife, Kat, and three spoiled cats.

You can learn more about Don and see his work at www.donaldclegg.com.

INDEX

THE BEST IN WATERCOLOR INSTRUCTION COMES FROM NORTH LIGHT BOOKS!

Whether you paint in your kitchen or backyard, you'll learn how to use light to create depth, form, mood and atmosphere in watercolor and oil. You will learn to master light using exercises, twelve complete step-by-step demonstrations, close-up painting details and keys of "seeing" light and true color. You will come away with the ability to harness the power of light!

ISBN 1-58180-342-7, HARD COVER, 144 PAGES, #32312-K

This unique book helps you paint splendid watercolor still lifes that capture the look, feel and spirit of each season using a selection of fresh flowers, fruits, vegetables and other beautiful items from your home and garden.

There is a chapter devoted to each season, including mini-demonstrations that show you how to paint the details of your still life objects. A final chapter takes you through the steps you'll need to create two beautiful finished paintings overflowing with seasonal abundance and mood.

ISBN 1-58180-285-4, HARD COVER, 144 PAGES, #32160-K

Joe Garcia provides clear, simple step-by-step instructions that teach the four basic washes: flat, gradated, wet-into-wet and streaked.

You will find plenty of guidelines and 33 demonstrations that combine these techniques to create light and shadow effects. You'll also learn how to develop unique textures and special effects using salt, a palette knife, masking fluid, sponges, dry brushes, spattering and lifting techniques.

ISBN 1-58180-486-5, PAPERBACK, 144 PAGES, #32824-K

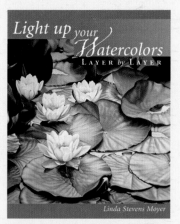

Linda Stevens Moyer provides must-have advice on color theory and the basics of painting light and texture—the individual parts that make up the "language of light."

Moyer then shows you how to put this "language" to use to create beautiful, luminous paintings by layering with watercolor. Five mini-demos allow you to practice the layering process on simple subjects. Three larger demonstrations further help you practice your skills on a complete painting.

ISBN 1-58180-189-0, HARD COVER, 128 PAGES, #31961-K

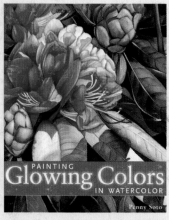

In this essential guide, you will learn why you should create value drawings, how pigments react with paper, the basics of color washes and temperature and how to use an underpainting to make colors glow.

This book gives you a complete color education in an illustrated instruction style that makes it easy to follow along with the demonstrations. It's an idea reference for any painter who wants richer, more vibrant colors.

ISBN 1-58180-215-3, HARD COVER, 144 PAGES, #31993-K

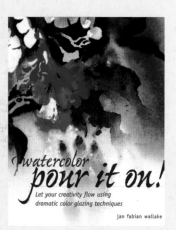

You'll be led through the process of planning, preparing and applying glazes, covering composition, elimination, repetition and contrast. Also inside are 30 methods for producing watercolor images and 5 complete demos.

These new techniques will not only improve your abilities, they will make the act of painting a more fulfilling and liberating experience.

ISBN 1-58180-487-3, PAPERBACK, 128 PAGES, #32825-K

This is the only title on the market that gives you a comprehensive look at negative painting, working with the areas around a subject. Linda Kemp shows you how to harness the power of these often overlooked areas surrounding a painting's focal point.

Watercolor Painting Outside the Lines is brimming with easy-to-follow interactive elements. You will come away with the skills you need to make your next work more striking than ever!

ISBN 1-58180-350-8, HARD COVER, 128 PAGES, #32321-K

Even if you've never picked up a brush, you'll be amazed at how easy it is to complete your first project. This book walks you through such essential topics as materials, value, color and composition. There are also helpful demonstrations on proper brush technique and planning a painting.

The Willenbrinks then lead you through 15 rewarding projects. You are sure to come away with a painting you'll be proud to give as a gift or hang on the wall!

ISBN 1-58180-341-9, PAPERBACK, 128 PAGES, #32310-K

These books and other fine North Light titles are available from your local art & craft retailer, bookstore, online supplier or by calling 1-800-448-0915.

3 1170 00687 5466